THE STONES OF
VENICE

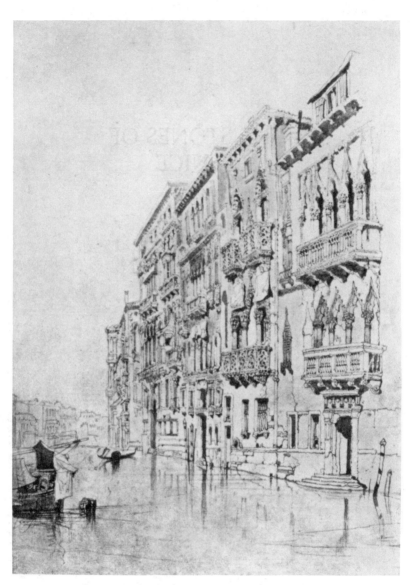

THE CONTARINI FASAN PALACE
ON THE GRAND CANAL
Drawn by Ruskin in 1841

THE STONES OF VENICE

JOHN RUSKIN

Edited and abridged by
J. G. Links

A DA CAPO PAPERBACK

Library of Congress Cataloging in Publication Data

Ruskin, John, 1819–1900.
 The stones of Venice.

 (A Da Capo paperback)
 Reprint. Originally published: New York: Hill and
Wang, 1960.
 1. Architecture—Italy—Venice. I. Links, J. G.
II. Title.
NA1121.V4R7 1985 720'.945'31 84-26753
ISBN 0-306-80244-9

Published by Da Capo Press, Inc.
A Subsidiary of Plenum Publishing Corporation
233 Spring Street, New York, N.Y. 10013

CONTENTS

CONTENTS

Part Two: The Gothic Period

Part Three: The Renaissance Period

LIST OF PLATES

Except where otherwise indicated
footnotes are from the original
edition

INTRODUCTION

" If Mr. Ruskin be right," wrote a reviewer soon after the publication of this book in 1853, " all the architects, and all the architectural teaching of the last three hundred years, must have been wrong." " That is indeed precisely the fact," replied Ruskin in a later edition, " and the very thing I meant to say, which indeed I thought I had said over and over again. I believe the architects of the last three centuries to have been wrong ; wrong without exception ; wrong totally, and from the foundation. This is exactly the point I have been endeavouring to prove, from the beginning of this work to the end of it."

No one, Ruskin complained, believed a word he said, though everybody praised his manner of saying it, the "stippling and labouring which got the sentences often into pleasant sounding tune." But they did worse than fail " to praise the substance which indeed they never took the trouble to get at." They took a comparatively unimportant part of the book and " mottled our manufactory chimneys with black and red brick and dignified our banks and drapers' shops with Venetian tracery." Once, in Brentford, Ruskin was startled to find a piece of Italian Gothic in the style of its best time. " The architect had read his third part of the Stones of Venice to purpose ; and the modern brickwork would have been in no discord with the tomb of Can Grande, had it been set beside it at Verona. But this good and true piece of brickwork was the porch of a public house, and its total motive was the provocation of thirst and the encouragement of idleness."

Alas for Ruskin, the battle against " this pestilent art of the Renaissance " has long been lost. The architects of our banks and (until very recently) our drapers' shops dream of the Acropolis or of Rome when away from their drawing-boards, not of Byzantium or Rouen. Spirited efforts are made to preserve the Regent's Park Terraces whereas St. Pancras Station and All Saints, Margaret Street, would, but for Mr. John Betjeman, be nothing but jokes. But Gilbert

Scott and Butterfield never, in fact, had their tongues in their cheeks whereas Nash may well have had his. What has gone wrong?

The reader of to-day may well be curious to know the "other" point of view in a controversy which engendered such passion. Moreover, he may wish to place himself for a time under the tutelage of one of the greatest teachers—of anything—of all time. Contemporary opinion was right; whatever the value may be of what Ruskin had to say, his manner of saying it carried utter conviction.

This is not the first abridgment of the Stones of Venice. Ruskin himself realised that the 450,000 words of the original was a lot, even for "the readers, few and uninfluential, who still read books through, and wish to understand them," and he published his own "abstract" as the Traveller's edition in 1877. He managed to reduce it to a quarter of its original length, but only by omitting the whole of the first volume with its fascinating "do it yourself" exposition of the principles of architecture (this introduction, necessary to "establish some canons of judgment," took the author "more time and trouble to do" than he expected and ran to 140,000 words). Worse, he omitted the whole of the essay on "The Nature of Gothic" ("one of the noblest things written in the 19th century," as Sir Kenneth Clark described it[1]). On the other hand, the 30,000 word essay on "The Pride of the Renaissance" was left almost intact and the index occupied a third of the whole book.

I have included much that he omitted, especially in the first volume, and left out many of what were, no doubt, his favourite parts, especially on Decoration. It is surely unfortunate that, in spite of the spate of books about Venice, this, probably the best and certainly the most curious, should have been crushed by its own weight of words almost into oblivion. If this abridgment rescues it from that, may I hope its author's ghost will stay his hand before he comes down to haunt me for tampering with his work.

J. G. L.

[1] " Even now, when the ideas it expresses are accepted and the cause it advocates is dead, we cannot read it without a thrill, without a sudden resolution to reform the world." K. Clark, " The Gothic Revival."

BOOK ONE

CHAPTER I

THE QUARRY

SINCE FIRST the dominion of men was asserted over the ocean, three thrones, of mark beyond all others, have been set upon its sands : the thrones of Tyre, Venice, and England. Of the First of these great powers only the memory remains ; of the Second, the ruin ; the Third, which inherits their greatness, if it forget their example, may be led through prouder eminence to less pitied destruction.

The exaltation, the sin, and the punishment of Tyre have been recorded for us, in perhaps the most touching words ever uttered by the Prophets of Israel against the cities of the stranger. But we read them as a lovely song ; and close our ears to the sternness of their warning : for the very depth of the Fall of Tyre has blinded us to its reality, and we forget, as we watch the bleaching of the rocks between the sunshine and the sea, that they were once "as in Eden, the garden of God."

Her successor, like her in perfection of beauty, though less in endurance of dominion, is still left for our beholding in the final period of her decline : a ghost upon the sands of the sea, so weak—so quiet,—so bereft of all but her loveliness, that we might well doubt, as we watched her faint reflection in the mirage of the lagoon, which was the City, and which the Shadow.

I would endeavour to trace the lines of this image before it be for ever lost, and to record, as far as I may, the warning which seems to me to be uttered by every one of the fast-gaining waves, that beat like passing bells, against the STONES OF VENICE.

The state of Venice existed Thirteen Hundred and Seventy-six years, from the first establishment of a consular government on the island of the Rialto, to the moment when the General-in-chief of the French army of Italy pronounced the Venetian republic a thing of the past. Of this period, Two Hundred and Seventy-six years were passed in a nominal subjection to the cities of old Venetia, especially to Padua, and in an agitated form of democracy of which the executive appears to have been entrusted to tribunes, chosen, one by the inhabitants of each of the principal islands. For six hundred years, during which the power of Venice was continually on the increase, her government was an elective monarchy, her King or Doge possessing, in early times at least, as much independent authority as any other European sovereign, but an authority gradually subjected to limitation, and shortened almost daily of its prerogatives, while it increased in a spectral and incapable magnificence. The final government of the nobles under the image of a king lasted for five hundred years, during which Venice reaped the fruits of her former energies, consumed them,—and expired.

Let the reader therefore conceive the existence of the Venetian state as broadly divided into two periods : the first of nine hundred, the second of five hundred years, the separation being marked by what was called the " Serrar del Consiglio ; " that is to say, the final and absolute distinction of the nobles from the commonalty, and the establishment of the government in their hands to the exclusion alike of the influence of the people on the one side, and the authority of the Doge on the other.

Then the first period, of nine hundred years, presents us with the most interesting spectacle of a people struggling out of anarchy into order and power ; and then governed, for the most part, by the worthiest and noblest man whom they could find among them, called their Doge or Leader, with an aristocracy gradually and resolutely forming itself around him, out of which, and at last by which, he was chosen ; an aristocracy owing its

origin to the accidental numbers, influence, and wealth of some among the families of the fugitives from the older Venetia, and gradually organising itself, by its unity and heroism, into a separate body.

This first period includes the Rise of Venice, her noblest achievements, and the circumstances which determined her character and position among European powers ; and within its range, as might have been anticipated, we find the names of all her hero princes—of Pietro Urseolo, Ordalafo Falier, Domenico Michieli, Sebastiano Ziani, and Enrico Dandolo.

The second period opens with a hundred and twenty years, the most eventful in the career of Venice—the central struggle of her life—stained with her darkest crime, the murder of Carrara —disturbed by her most dangerous internal sedition, the conspiracy of Falier—oppressed by her most fatal war, the war of Chiozza—and distinguished by the glory of her two noblest citizens (for in this period the heroism of her citizens replaces that of her monarchs), Vittor Pisani and Carlo Zeno.

I date the commencement of the Fall of Venice from the death of Carlo Zeno, 8th May, 1418 ; the *visible* commencement from that of another of her noblest and wisest children, the Doge Tomaso Mocenigo, who expired five years later. The reign of Foscari followed, gloomy with pestilence and war ; a war in which large acquisitions of territory were made by subtle or fortunate policy in Lombardy, and disgrace, significant as irreparable, sustained in the battles on the Po at Cremona, and in the marshes of Caravaggio. In 1454, Venice, the first of the states of Christendom, humiliated herself to the Turk : in the same year was established the Inquisition of State, and from this period her government takes the perfidious and mysterious form under which it is usually conceived. In 1477, the great Turkish invasion spread terror to the shores of the lagoons ; and in 1508 the league of Cambrai marks the period usually assigned as the commencement of the decline of the Venetian power ; the commercial prosperity of Venice in the close of the fifteenth century

blinding her historians to the previous evidence of the diminution of her internal strength.

It is now necessary that the reader should have some general idea of the connection of the architecture of Venice with that of the rest of Europe, from its origin forwards.

All European architecture, bad and good, old and new, is derived from Greece through Rome, and coloured and perfected from the East. The history of architecture is nothing but the tracing of the various modes and directions of this derivation. Understand this, once for all : if you hold fast this great connecting clue, you may string all the types of successive architectural invention upon it like so many beads. The Doric and the Corinthian orders are the roots, the one of all Romanesque, massy-capitalled buildings—Norman, Lombard, Byzantine, and what else you can name of the kind ; and the Corinthian of all Gothic, Early English, French, German, and Tuscan. Now observe : those old Greeks gave the shaft ; Rome gave the arch ; the Arabs pointed and foliated the arch.

There is high probability that the Greek received his shaft system from Egypt ; but I do not care to keep this earlier derivation in the mind of the reader. It is only necessary that he should be able to refer to a fixed point of origin, when the form of the shaft was first perfected. But it may be incidentally observed, that if the Greeks did indeed receive their Doric from Egypt, then the three families of the earth have each contributed their part to its noblest architecture.

I have said that the two orders, Doric and Corinthian, are the roots of all European architecture. You have, perhaps, heard of five orders : but there are only two real orders ; and there never can be any more until doomsday. On one of these orders the ornament is convex : those are Doric, Norman, and what else you recollect of the kind. On the other the ornament is concave : those are Corinthian, Early English, Decorated, and what else you recollect of that kind. The transitional form, in which the ornamental line is straight, is the centre or root of

both. All other orders are varieties of these, or phantasms and grotesques, altogether indefinite in number and species.

This Greek architecture, then, with its two orders, was clumsily copied and varied by the Romans with no particular result, until they began to bring the arch into extensive practical service; except only that the Doric capital was spoiled in endeavours to mend it, and the Corinthian much varied and enriched with fanciful, and often very beautiful imagery. And in this state of things came Christianity: seized upon the arch as her own: decorated it, and delighted in it: invented a new Doric capital to replace the spoiled Roman one: and all over the Roman empire set to work, with such materials as were nearest at hand, to express and adorn herself as best she could. This Roman Christian architecture is the exact expression of the Christianity of the time, very fervid and beautiful—but very imperfect; in many respects ignorant, and yet radiant with a strong, childish light of imagination, which flames up under Constantine, illumines all the shores of the Bosphorus and the Ægean and the Adriatic Sea, and then gradually, as the people give themselves up to idolatry, becomes corpse-light. The architecture, like the religion it expressed, sinks into a settled form—a strange, gilded, and embalmed repose; and so would have remained for ever,—so *does* remain, where its languor has been undisturbed. But rough wakening was ordained for it.

This Christian art of the declining empire is divided into two great branches, western and eastern; one centred at Rome, the other at Byzantium, of which the one is the early Christian Romanesque, properly so called, and the other, carried to higher imaginative perfection by Greek workmen, is distinguished from it as Byzantine. But I wish the reader, for the present, to class these two branches of art together in his mind, they being, in points of main importance, the same; that is to say, both of them a true continuance and sequence of the art of old Rome itself, flowing uninterruptedly down from the fountain-head, and entrusted always to the best workmen who could be found—

Latins in Italy and Greeks in Greece; and thus both branches may be ranged under the general term of Christian Romanesque, an architecture which had lost the refinement of Pagan art in the degradation of the Empire, but which was elevated by Christianity to higher aims, and by the fancy of the Greek work-men endowed with brighter forms. And this art the reader may conceive as extending in its various branches over all the central provinces of the empire, taking aspects more or less refined, according to its proximity to the seats of government; dependent for all its power on the vigour and freshness of the religion which animated it; and as that vigour and purity departed, losing its own vitality, and sinking into nerveless rest, not deprived of its beauty, but benumbed, and incapable of advance or change.

Meantime there had been preparation for its renewal. While in Rome and Constantinople, and in the districts under their immediate influence, this Roman art of pure descent was practised in all its refinement, an impure form of it—a patois of Romanesque—was carried by inferior workmen into distant provinces; and still ruder imitations of this patois were executed by the barbarous nations on the skirts of the Empire. But these barbarous nations were in the strength of their youth; and while, in the centre of Europe, a refined and purely descended art was sinking into graceful formalism, on its confines a barbarous and borrowed art was organising itself into strength and consistency. The reader must therefore consider the history of the work of the period as broadly divided into two great heads; the one embracing the elaborately languid succession of the Christian art of Rome; and the other, the imitations of it executed by nations in every conceivable phase of early organisation, on the edges of the Empire, or included in its now merely nominal extent.

Some of the barbaric nations were, of course, not susceptible of this influence; and, when they burst over the Alps, appear like the Huns, as scourges only, or mix, as the Ostrogoths, with the enervated Italians, and give physical strength to the mass

with which they mingle, without materially affecting its intellectual character. But others, both south and north of the Empire, had felt its influence, back to the beach of the Indian ocean on the one hand, and to the ice creeks of the North Sea on the other. On the north and west the influence was of the Latins ; on the south and east, of the Greeks. Two nations, pre-eminent above all the rest, represent to us the force of derived mind on either side. As the central power is eclipsed, the orbs of reflected light gather into their fulness ; and when sensuality and idolatry had done their work, and the religion of the Empire was laid asleep in a glittering sepulchre, the living light rose upon both horizons, and the fierce swords of the Lombard and Arab were shaken over its golden paralysis.

The work of the Lombard was to give hardihood and system to the enervated body and enfeebled mind of Christendom ; that of the Arab was to punish idolatry, and to proclaim the spirituality of worship. The Lombard covered every church which he built with the sculptured representations of bodily exercises—hunting and war. The Arab banished all imagination of creature form from his temples, and proclaimed from their minarets, " There is no god but God." Opposite in their character and mission, alike in their magnificence of energy, they came from the North and from the South, the glacier torrent and the lava stream : they met and contended over the wreck of the Roman empire ; and the very centre of the struggle, the point of pause of both, the dead water of the opposite eddies, charged with embayed fragments of the Roman wreck, is VENICE.

The Ducal palace of Venice contains the three elements in exactly equal proportions—the Roman, Lombard, and Arab. It is the central building of the world.

The reader will now begin to understand something of the importance of the study of the edifices of a city which concludes, within the circuit of some seven or eight miles, the field of contest between the three pre-eminent architectures of the world : —each architecture expressing a condition of religion ; each an

erroneous condition, yet necessary to the correction of the others, and corrected by them.

It will be part of my endeavour in the following work, to mark the various modes in which the northern and southern architectures were developed from the Roman : here I must pause only to name the distinguishing characteristics of the great families. The Christian Roman and Byzantine work is round-arched, with single and well-proportioned shafts ; capitals imitated from classical Roman ; mouldings more or less so ; and large surfaces of walls entirely covered with imagery, mosaic, and paintings, whether of scripture history or of sacred symbols.

The Arab school is at first the same in its principal features, the Byzantine workmen being employed by the caliphs ; but the Arab rapidly introduces characters half Persepolitan, half Egyptian, into the shafts and capitals : in his intense love of excitement he points the arch and writhes it into extravagant foliations ; he banishes the animal imagery, and invents an ornamentation of his own (called Arabesque) to replace it : this not being adapted for covering large surfaces, he concentrates it on features of interest, and bars his surfaces with horizontal lines of colour, the expression of the level of the Desert. He retains the dome and adds the minaret. All is done with exquisite refinement.

The changes effected by the Lombard are more curious still, for they are in the anatomy of the building, more than its decoration. The Lombard architecture represents, as I said, the whole of that of the northern barbaric nations. And this I believe was, at first, an imitation in wood of the Christian Roman churches or basilicas. Without staying to examine the whole structure of a basilica, the reader will easily understand thus much of it : that it had a nave and two aisles, the nave much higher than the aisles ; that the nave was separated from the aisles by rows of shafts, which supported, above, large spaces of flat or dead wall, rising above the aisles, and forming

the upper part of the nave, now called the clerestory, which had a gabled wooden roof.

These high dead walls were, in Roman work, built of stone ; but in the wooden work of the North, they must necessarily have been made of horizontal boards or timbers attached to uprights on the top of the nave pillars, which were themselves also of wood. Now, these uprights were necessarily thicker than the rest of the timbers, and formed vertical square pilasters above the nave piers. As Christianity extended and civilization increased, these wooden structures were changed into stone ; but they were literally petrified, retaining the form which had been made necessary by their being of wood. The upright pilaster above the nave pier remains in the stone edifice, and is the first form of the great distinctive feature of Northern architecture—the vaulting shaft. In that form the Lombards brought it into Italy in the seventh century, and it remains to this day in St. Ambrogio of Milan, and St. Michele of Pavia.

When the vaulting shaft was introduced in the clerestory walls, additional members were added for its support to the nave piers. Perhaps two or three pine trunks, used for a single pillar, gave the first idea of the grouped shaft. Be that as it may, the arrangement of the nave pier in the form of a cross accompanies the superimposition of the vaulting shaft ; together with correspondent grouping of minor shafts in doorways and apertures of windows. Thus, the whole body of the Northern architecture, represented by that of the Lombards, may be described as rough but majestic work, round arched, with grouped shafts, added vaulting shafts, and endless imagery of active life and fantastic superstitions.

The glacier stream of the Lombards, and the following one of the Normans, left their erratic blocks wherever they had flowed ; but without influencing, I think, the Southern nations beyond the sphere of their own presence. But the lava stream of the Arab, even after it ceased to flow, warmed the whole of the Northern air ; and the history of Gothic architecture is the

history of the refinement and spiritualisation of Northern work under its influence. The noblest buildings of the world, the Pisan-Romanesque, Tuscan (Giottesque) Gothic, and Veronese Gothic, are those of the Lombard schools themselves, under its close and direct influence; the various Gothics of the north are the original forms of the architecture which the Lombards brought into Italy, changing under the less direct influence of the Arab.

Understanding thus much of the formation of the great European styles, we shall have no difficulty in tracing the succession of architectures in Venice herself. From what I said of the central character of Venetian art, the reader is not, of course, to conclude that the Roman, Northern, and Arabian elements met together and contended for the mastery at the same period. The earliest element was the pure Christian Roman; but few, if any, remains of this art exist at Venice; for the present city was in the earliest times only one of many settlements formed on the chain of marshy islands which extend from the mouths of the Isonzo to those of the Adige, and it was not until the beginning of the ninth century that it became the seat of government; while the cathedral of Torcello, though Christian Roman in general form, was rebuilt in the eleventh century, and shows evidence of Byzantine workmanship in many of its details. This cathedral, however, with the church of Santa Fosca at Torcello, San Giacomo di Rialto at Venice, and the crypt of St. Mark's, form a distinct group of building, in which the Byzantine influence is exceedingly slight; and which is probably very sufficiently representative of the earliest architecture on the islands.

The Ducal residence was removed to Venice in 809, and the body of St. Mark was brought from Alexandria twenty years later. The first church of St. Mark's was, doubtless, built in imitation of that destroyed at Alexandria, and from which the relics of the Saint had been obtained. During the ninth, tenth, and eleventh centuries, the architecture of Venice seems to have

been formed on the same model, and is almost identical with that of Cairo under the caliphs, it being quite immaterial whether the reader chooses to call both Byzantine or both Arabic; the workmen being certainly Byzantine, but forced to the invention of new forms by their Arabian masters, and bringing these forms into use in whatever other parts of the world they were employed.

To this style succeeds a transitional one of a character much more distinctly Arabian : the shafts become more slender, and the arches consistently pointed, instead of round ; certain other changes, not to be enumerated in a sentence, taking place in the capitals and mouldings. This style is almost exclusively secular. It was natural for the Venetians to imitate the beautiful details of the Arabian dwelling-house, while they would with reluctance adopt those of the mosque for Christian churches.

I have not succeeded in fixing limiting dates for this style. It appears in part contemporary with the Byzantine manner, but outlives it. Its position is, however, fixed by the central date, 1180, that of the elevation of the granite shafts of the Piazzetta, whose capitals are the two most important pieces of detail in this transitional style in Venice. Examples of its application to domestic buildings exist in almost every street of the city.

The Venetians were always ready to receive lessons in art from their enemies (else had there been no Arab work in Venice). But their especial dread and hatred of the Lombards appear to have long prevented them from receiving the influence of the art which that people had introduced on the mainland of Italy. Nevertheless, during the practice of the two styles above distinguished, a peculiar and very primitive condition of pointed Gothic had arisen in ecclesiastical architecture. It appears to be a feeble reflection of the Lombard-Arab forms, which were attaining perfection upon the continent, and would probably, if left to itself, have been soon merged in the Venetian-Arab school, with which it had from the first so close a fellowship, that it will be found difficult to distinguish the Arabian ogives

23

from those which seem to have been built under this early Gothic influence. The churches of San Giacopo dell' Orio, San Giovanni in Bragora, the Carmine, and one or two more, furnish the only important examples of it. But, in the thirteenth century, the Franciscans and Dominicans introduced from the continent their morality and their architecture, already a distinct Gothic, curiously developed from Lombardic and Northern (German ?) forms ; and the influence of the principles exhibited in the vast churches of St. Paul and the Frari began rapidly to affect the Venetian-Arab school. Still the two systems never became united; the Venetian policy repressed the power of the church, and the Venetian artists resisted its example ; and thenceforward the architecture of the city becomes divided into ecclesiastical and civil : the one an ungraceful yet powerful form of the Western Gothic, common to the whole peninsula, and only showing Venetian sympathies in the adoption of certain characteristic mouldings ; the other a rich, luxuriant, and entirely original Gothic, formed from the Venetian-Arab by the influence of the Dominican and Franciscan architecture, and especially by the engrafting upon the Arab forms of the most novel feature of the Franciscan work, its traceries. These various forms of Gothic, the *distinctive* architecture of Venice are chiefly represented by the churches of St. John and Paul, the Frari, and San Stefano, on the ecclesiastical side, and by the Ducal palace, and the other principal Gothic palaces, on the secular side.

Now observe. The transitional (or especially Arabic) style of the Venetian work is centralised by the date 1180, and is transformed gradually into the Gothic, which extends in its purity from the middle of the thirteenth to the beginning of the fifteenth century ; that is to say, over the precise period which I have described as the central epoch of the life of Venice. I dated her decline from the year 1418 ; Foscari became doge five years later, and in his reign the first marked signs appear in architecture of that mighty change to which London owes St. Paul's, Rome St. Peter's, Venice and Vicenza the edifices

commonly supposed to be their noblest, and Europe in general the degradation of every art she has since practised.

This change appears first in a loss of truth and vitality in existing architecture all over the world. All the Gothics in existence, southern or northern, were corrupted at once : the German and French lost themselves in every species of extravagance ; the English Gothic was confined, in its insanity, by a strait-waistcoat of perpendicular lines ; the Italian effloresced on the mainland into the meaningless ornamentation of the Certosa of Pavia and the Cathedral of Como (a style sometimes ignorantly called Italian Gothic), and at Venice into the insipid confusion of the Porta della Carta and wild crockets of St. Mark's. This corruption of all architecture, especially ecclesiastical, corresponded with, and marked the state of religion over all Europe.

Now Venice, as she was once the most religious, was in her fall the most corrupt, of European states ; and as she was in her strength the centre of the pure currents of Christian architecture, so she is in her decline the source of the Renaissance. It was the originality and splendour of the palaces of Vicenza and Venice which gave this school its eminence in the eyes of Europe ; and the dying city, magnificent in her dissipation, and graceful in her follies, obtained wider worship in her decrepitude than in her youth, and sank from the midst of her admirers into the grave.

It is in Venice, therefore, and in Venice only, that effectual blows can be struck at this pestilent art of the Renaissance. Destroy its claims to admiration there, and it can assert them nowhere else. This, therefore, will be the final purpose of the following essay. I shall, in my account of the earlier architecture, compare the forms of all its leading features with those into which they were corrupted by the Classicalists ; and pause, in the close, on the edge of the precipice of decline, so soon as I have made its depth discernible. In doing this I shall depend upon two distinct kinds of evidence :—the first, the testimony

borne by particular incidents and facts to a want of thought or of feeling in the builders; from which we may conclude that their architecture must be bad :—the second, the sense, which I doubt not I shall be able to excite in the reader, of a systematic ugliness in the architecture itself.

There is much evidence on which I shall depend for the proof of the inferiority of character in the Renaissance workmen. But the proof of the inferiority of the work itself is not so easy, for in this I have to appeal to judgments which the Renaissance work has itself distorted. I felt this difficulty very forcibly as I read a slight review of my former work, " The Seven Lamps," in " The Architect :" the writer noticed my constant praise of St. Mark's : " Mr. Ruskin thinks it a very beautiful building ! We," said the Architect, " think it a very ugly building." I was not surprised at the difference of opinion, but at the thing being considered so completely a subject of opinion. My opponents in matters of painting always assume that there *is* such a thing as a law of right, and that I do not understand it : but my architectural adversaries appeal to no law, they simply set their opinion against mine; and indeed there is no law at present to which either they or I can appeal. No man can speak with rational decision of the merits or demerits of buildings : he may with obstinacy; he may with resolved adherence to previous prejudices; but never as if the matter could be otherwise decided than by majority of votes, or pertinacity of partizanship. I had always, however, a clear conviction that there *was* a law in this matter : that good architecture might be indisputably discerned and divided from the bad ; that the opposition in their very nature and essence was clearly visible ; and that we were all of us just as unwise in disputing about the matter without reference to principle, as we should be for debating about the genuineness of a coin without ringing it. I felt also assured that this law must be universal if it were conclusive : that it must enable us to reject all foolish and base work, and to accept all noble and wise work, without reference to style or national

feeling; that it must sanction the design of all truly great
nations and times, Gothic or Greek or Arab; that it must cast
off and reprobate the design of all foolish nations and times,
Chinese or Mexican or modern European; and that it must be
easily applicable to all possible architectural inventions of human
mind. I set myself, therefore, to establish such a law, in full
belief that men are intended, without excessive difficulty, and
by use of their general common sense, to know good things
from bad; and that it is only because they will not be at the
pains required for the discernment, that the world is so widely
encumbered with forgeries and basenesses. I found the work
simpler than I had hoped; the reasonable things ranged them-
selves in the order I required, and the foolish things fell aside,
and took themselves away so soon as they were looked in the
face. I had then, with respect to Venetian architecture, the
choice, either to establish each division of law in a separate form,
as I came to the features with which it was concerned, or else to
ask the reader's patience, while I followed out the general inquiry
first, and determined with him a code of right and wrong, to
which we might together make retrospective appeal. I thought
this the best, though perhaps the dullest way; and in these first
following pages I have therefore endeavoured to arrange those
foundations of criticism, on which I shall rest in my account of
Venetian architecture, in a form clear and simple enough to be
intelligible even to those who never thought of architecture
before. To those who have, much of what is stated in them
will be well-known or self-evident; but they must not be
indignant at a simplicity on which the whole argument depends
for its usefulness. From that which appears a mere truism when
first stated, they will find very singular consequences sometimes
following,—consequences altogether unexpected, and of con-
siderable importance; I will not pause here to dwell on their
importance, nor on that of the thing itself to be done; for I
believe most readers will at once admit the value of a criterion
of right and wrong in so practical and costly an art as architec-

ture, and will be apt rather to doubt the possibility of its attainment than dispute its usefulness if attained. I invite them, therefore, to a fair trial, being certain that even if I should fail in my main purpose, and be unable to induce in my reader the confidence of judgment I desire, I shall at least receive his thanks for the suggestion of consistent reasons, which may determine hesitating choice, or justify involuntary preference. And if I should succeed, as I hope, in making the Stones of Venice touchstones, and detecting, by the mouldering of her marble, poison more subtle than ever was betrayed by the rending of her crystal; and if thus I am enabled to show the baseness of the schools of architecture and nearly every other art, which have for three centuries been predominant in Europe, I believe the result of the inquiry may be serviceable for proof of a more vital truth than any at which I have hitherto hinted.

THE VIRTUES OF ARCHITECTURE

WE ADDRESS ourselves, then, first to the task of determining some law of right, which we may apply to the architecture of all the world and of all time ; and by help of which, and judgment according to which, we may as easily pronounce whether a building is good or noble, as, by applying a plumb-line, whether it be perpendicular.

The first question will of course be, What are the possible Virtues of architecture ?

In the main, we require from buildings, as from men, two kinds of goodness : first, the doing their practical duty well: then that they be graceful and pleasing in doing it ; which last is itself another form of duty.

Then the practical duty divides itself into two branches,— acting and talking :—acting, as to defend us from weather or violence ; talking, as the duty of monuments or tombs, to record facts and express feelings ; or of churches, temples, public edifices, treated as books of history, to tell such history clearly and forcibly.

We have thus, altogether, three great branches of architectural virtue, and we require of any building.

1. That it act well, and do the things it was intended to do in the best way.
2. That it speak well, and say the things it was intended to say in the best words.
3. That it look well, and please us by its presence, whatever it has to do or say.

Now, as regards the second of these virtues, it is evident that we can establish no general laws. First, because it is not a virtue required in all buildings; there are some which are only for covert or defence, and from which we ask no conversation. Secondly, because there are countless methods of expression, some conventional, some natural : each conventional mode has its own alphabet, which evidently can be no subject of general laws. Every natural mode is instinctively employed and instinctively understood, wherever there is true feeling; and this instinct is above law. The choice of conventional methods depends on circumstances out of calculation, and that of natural methods on sensations out of control ; so that we can only say that the choice is right, when we feel that the means are effective ; and we cannot always say that it is wrong when they are not so.

A building which recorded the Bible history by means of a series of sculptural pictures, would be perfectly useless to a person unacquainted with the Bible beforehand ; on the other hand, the text of the Old and New Testaments might be written on its walls, and yet the building be a very inconvenient kind of book, not so useful as if it had been adorned with intelligible and vivid sculpture. So, again, the power of exciting emotion must vary or vanish, as the spectator becomes thoughtless or cold ; and the building may be often blamed for what is the fault of its critic, or endowed with a charm which is of its spectator's creation. It is not therefore possible to make expressional character any fair criterion of excellence in buildings, until we can fully place ourselves in the position of those to whom their expression was originally addressed, and until we are certain that we understand every symbol, and are capable of being touched by every association which its builders employed as letters of their language. I shall continually endeavour to put the reader into such sympathetic temper, when I ask for his judgment of a building ; and in every work I may bring before him I shall point out, as far as I am able, whatever is peculiar in its expression : nay, I must even depend on such peculiarities for

much of my best evidence respecting the character of the builders. But I cannot legalise the judgment for which I plead, nor insist upon it if it be refused. I can neither force the reader to feel this architectural rhetoric, nor compel him to confess that the rhetoric is powerful, if it have produced no impression on his own mind.

I leave therefore, the expression of buildings for incidental notice only. But their other two virtues are proper subjects of law,—their performance of their common and necessary work, and their conformity with universal and divine canons of loveliness : respecting these there can be no doubt, no ambiguity. I would have the reader discern them so quickly that, as he passes along a street, he may by a glance of the eye, distinguish the noble from the ignoble work. He can do this, if he permit free play to his natural instincts ; and all that I have to do for him is to remove from those instincts the artificial restraints which prevent their action, and to encourage them to an unaffected and unbiased choice between right and wrong.

We have, then, two qualities of buildings for subjects of separate inquiry : their action, and aspect, and the sources of virtue in both ; that is to say, Strength and Beauty, both of these being less admired in themselves, than as testifying the intelligence or imagination of the builder.

For we have a worthier way of looking at human than at divine architecture ; much of the value both of construction and decoration, in the edifices of men, depends upon our being led by the thing produced or adorned, to some contemplation of the powers of mind concerned in its creation or adornment. We are not so led by divine work, but are content to rest in the contemplation of the thing created. I wish the reader to note this especially ; we take pleasure, or *should* take pleasure, in architectural construction altogether as the manifestation of an admirable human intelligence ; it is not the strength, not the size, not the finish of the work which we are to venerate : rocks are always stronger, mountains always larger, all natural objects

31

more finished; but it is the intelligence and resolution of man in overcoming physical difficulty which are to be the source of our pleasure and subject of our praise. And again, in decoration or beauty, it is less the actual loveliness of the thing produced than the choice and invention concerned in the production, which are to delight us; the love and the thoughts of the workman more than his work; his work must always be imperfect, but his thoughts and affections may be true and deep.

The origin of our pleasure in architecture I must insist upon at somewhat greater length, for I would fain do away with some of the ungrateful coldness which we show towards the good builders of old time. In no art is there closer connection between our delight in the work, and our admiration of the workman's mind, than in architecture, and yet we rarely ask for a builder's name. The patron at whose cost, the monk through whose dreaming, the foundation was laid, we remember occasionally; never the man who verily did the work. Did the reader ever hear of William of Sens as having had anything to do with Canterbury Cathedral? or of Pietro Basegio as in anywise connected with the Ducal palace of Venice? there is much ingratitude and injustice in this; and therefore I desire my reader to observe carefully how much of his pleasure in building is derived, or should be derived, from admiration of the intellect of men whose names he knows not.

The two virtues of architecture which we can justly weigh, are, we said, its strength or good construction, and its beauty or good decoration. Consider first, therefore, what you mean when you say a building is well constructed or well built; you do not merely mean that it answers its purpose,—this is much, and many modern buildings fail of this much; but if it be verily well built; it must answer this purpose in the simplest way, and with no over-expenditure of means. We require of a lighthouse, for instance, that it shall stand firm and carry a light; if it do not this, assuredly it has been ill built; but it may do it to the end of time, and yet not be well built. It may have hundreds of

tons of stone in it more than were needed, and have cost thousands of pounds more than it ought. To pronounce it well or ill built, we must know the utmost forces it can have to resist, and the best arrangements of stone for encountering them, and the quickest ways of effecting such arrangements : then only, so far as such arrangements have been chosen, and such methods used, is it well built. Then the knowledge of all difficulties to be met, and of all means of meeting them, and the quick and true fancy or invention of the modes of applying the means to the end, are what we have to admire in the builder, even as he is seen through this first or inferior part of his work. Mental power, observe : not muscular, nor mechanical, not technical, nor empirical,—pure, precious, majestic, massy intellect ; not to be had at vulgar price, nor received without thanks, and without asking from whom.

Suppose, for instance, we are present at the building of a bridge : the bricklayers or masons have had their centering erected for them, and that centering was put together by a carpenter, who had the line of its curve traced for him by the architect : the masons are dexterously handling and fitting their bricks, or, by the help of machinery, carefully adjusting stones which are numbered for their places. There is probably in their quickness of eye and readiness of hand something admirable : but this is not what I ask the reader to admire : not the carpentering, nor the bricklaying, nor anything that he can presently see and understand, but the choice of the curve, and the shaping of the numbered stones, and the appointment of that number ; there were many things to be known and thought upon before these were decided. The man who chose the curve and numbered the stones, had to know the times and tides of the river, and the strength of its floods, and the height and flow of them, and the soil of the banks, and the endurance of it, and the weight of the stones he had to build with, and the kind of traffic that day by day would be carried on over his bridge, all this especially, and all the great general laws of force and weight, and their working ;

and in the choice of the curve and numbering of stones are expressed not only his knowledge of these, but such ingenuity and firmness as he had, in applying special means to overcome the special difficulties about his bridge. There is no saying how much wit, how much depth of thought, how much fancy, presence of mind, courage, and fixed resolution there may have gone to the placing of a single stone of it. This is what we have to admire,—this grand power and heart of man in the thing; not his technical or empirical way of holding the trowel and laying mortar.

Now, there is in everything properly called art this concernment of the intellect, even in the province of the art which seems merely practical. For observe : in this bridge-building I suppose no reference to architectural principles ; all that I suppose we want is to get safely over the river ; the man who has taken us over is still a mere bridge-builder,—a *builder*, not an architect ; he may be a rough, artless, feelingless man, incapable of doing any one truly fine thing all his days. I shall call upon you to despise him presently in a sort, but not as if he were a mere smoother of mortar ; perhaps a great man, infinite in memory, indefatigable in labour, exhaustless in expedient, unsurpassable in quickness of thought. Take good heed you understand him before you despise him.

But why is he to be in anywise despised ? By no means despise him, unless he happen to be without a soul, or at least to show no signs of it ; which possibly he may not in merely carrying you across the river. He may be merely what Mr. Carlyle rightly calls a human beaver after all ; and there may be nothing in all that ingenuity of his greater than a complication of animal faculties, an intricate bestiality,—nest or hive building in its highest development. You need something more than this, or the man is despicable ; you need that virtue of building through which he may show his affections and delights ; you need its beauty or decoration.

Not that, in reality, one division of the man is more human

than another; all the divisions of humanity are noble or brutal, immortal or mortal, according to the degree of their sanctification: and there is no part of the man which is not immortal and divine when it is once given to God, and no part of him which is not mortal by the second death, and brutal before the first, when it is withdrawn from God. For to what shall we trust for our distinction from the beasts that perish? To our higher intellect?—yet are we not bidden to be wise as the serpent, and to consider the ways of the ant? Or to our affections? nay; these are more shared by the lower animals than our intelligence:—Hamlet leaps into the grave of his beloved, and leaves it,—a dog would have stayed. Humanity and immortality consist neither in reason, nor in love; not in the body, nor in the animation of the heart of it, nor in the thoughts and stirrings of the brain of it,—but in the dedication of them all to Him who will raise them up at the last day.

It is not, therefore, that the signs of his affections, which man leaves upon his work, are indeed more ennobling than the signs of his intelligence; but it is the balance of both whose expression we need, and the signs of the government of them all by Conscience; and Discretion, the daughter of Conscience. So, then, the intelligent part of man being eminently, if not chiefly, displayed in the structure of his work, his affectionate part is to be shown in its decoration; and, that decoration may be indeed lovely, two things are needed: first, that the affections be vivid, and honestly shown; secondly, that they be fixed on the right things.

You think, perhaps, I have put the requirements in wrong order. Logically I have; practically I have not: for it is necessary first to teach men to speak out, and say what they like, truly; and in the second place, to teach them which of their likings are ill set, and which justly. If a man is cold in his likings and dislikings, or if he will not tell you what he likes, you can make nothing of him. Only get him to feel quickly and to speak plainly, and you may set him right. And the fact is,

that the great evil of all recent architectural effort has not been that men liked wrong things ; but that they either cared nothing about any, or pretended to like what they did not. Do you suppose that any modern architect likes what he builds, or enjoys it ? Not in the least. He builds it because he had been told that such and such things are fine, and that he *should* like them. He pretends to like them, and gives them a false relish of vanity. Do you seriously imagine, reader, that any living soul in London likes triglyphs ?[1]—or gets any hearty enjoyment out of pediments ?[2] You are much mistaken. Greeks did : English people never did,—never will. Do you fancy that the architect of old Burlington Mews, in Regent Street, had any particular satisfaction in putting the blank triangle over the archway, instead of a useful garret window ? By no manner of means. He had been told it was right to do so, and thought he should be admired for doing it. Very few faults of architecture are mistakes of honest choice : they are almost always hypocrisies.

So, then, the first thing we have to ask of the decoration is that it should indicate strong liking, and that honestly. It matters not so much what the thing is, as that the builder should really love it and enjoy it, and say so plainly. The architect of Bourges Cathedral liked hawthorns ; so he has covered his porch with hawthorn,—it is a perfect Niobe of May. Never was such hawthorn ; you would try to gather it forthwith, but for fear of being pricked. The old Lombard architects liked hunting ; so they covered their work with horses and hounds, and men blowing trumpets two yards long. The base Renaissance architects of Venice liked masquing and fiddling ; so they covered their work with comic masks and musical instruments. Even that was better than our English way of liking nothing, and professing to like triglyphs.

But the second requirement in decoration, is that it should

[1] Triglyph. Literally, " Three Cut." The awkward upright ornament with two notches in it, and a cut at each side, to be seen everywhere at the tops of Doric colonnades, ancient and modern.

[2] Pediment. The triangular space above Greek porticoes, as on the Mansion House or Royal Exchange.

show we like the right thing. And the right thing to be liked is God's work, which He made for our delight and contentment in this world. And all noble ornamentation is the expression of man's delight in God's work.

So, then, these are the two virtues of building : first, the signs of man's own good work; secondly, the expression of man's delight in better work than his own. And these are the two virtues of which I desire my reader to be able quickly to judge, at least in some measure ; to have a definite opinion up to a certain point. Beyond a certain point he cannot form one. When the science of the building is great, great science is of course required to comprehend it ; and, therefore, of difficult bridges, and lighthouses, and harbour walls, and river dykes, and railway tunnels, no judgment may be rapidly formed. But of common buildings, built in common circumstances, it is very possible for every man, or woman, or child, to form judgment both rational and rapid. Their necessary, or even possible, features are but few ; the laws of their construction are as simple as they are interesting. The labour of a few hours is enough to render the reader master of their main points ; and from that moment he will find in himself a power of judgment which can neither be escaped nor deceived, and discover subjects of interest where everything before had appeared barren. For though the laws are few and simple, the modes of obedience to them are not so. Every building presents its own requirements and difficulties ; and every good building has peculiar appliances or contrivances to meet them. Understand the laws of structure, and you will feel the special difficulty in every new building which you approach ; and you will know also, or feel instinctively, whether it has been wisely met or otherwise. And an enormous number of buildings, and of styles of building, you will be able to cast aside at once, as at variance with these constant laws of structure, and therefore unnatural and monstrous.

Then, as regards decoration, I want you only to consult

your own natural choice and liking. There is a right and wrong in it; but you will assuredly like the right if you suffer your natural instinct to lead you. Half the evil in this world comes from people not knowing what they do like;—not deliberately setting themselves to find out what they really enjoy. All people enjoy giving away money, for instance : they don't know *that*,—they rather think they like keeping it;—and they *do* keep it, under this false impression, often to their great discomfort. Everybody likes to do good; but not one in a hundred finds *this* out. Multitudes think they like to do evil; yet no man ever really enjoyed doing evil since God made the world.

So in this lesser matter of ornament. It needs some little care to try experiments upon yourself; it needs deliberate question and upright answer. But there is no difficulty to be overcome, no abstruse reasoning to be gone into; only a little watchfulness needed, and thoughtfulness, and so much honesty as will enable you to confess to yourself, and to all men, that you enjoy things, though great authorities say you should not.

This looks somewhat like pride; but it is true humility, a trust that you have been so created as to enjoy what is fitting for you, and a willingness to be pleased, as it was intended you should be. It is the child's spirit, which we are most happy when we most recover; remaining wiser than children in our gratitude that we can still be pleased with a fair colour, or a dancing light. And, above all, do not try to make all these pleasures reasonable, nor to connect the delight which you take in ornament with that which you take in construction of usefulness. They have no connection; and every effort that you make to reason from one to the other will blunt your sense of beauty, or confuse it with sensations altogether inferior to it. You were made for enjoyment, and the world was filled with things which you will enjoy, unless you are too proud to be pleased by them, or too grasping to care for what you cannot turn to other account than mere delight. Remember that the most beautiful things in the world are the most useless; peacocks and lilies for instance; at least

I suppose this quill I hold in my hand writes better than a peacock's would, and the peasants of Vevay, whose fields in spring time are as white with lilies as the Dent du Midi is with its snow, told me the hay was none the better for them.

Our task therefore divides itself into two branches, and these I shall follow in succession. I shall first consider the construction of buildings, dividing them into their really necessary members or features ; and I shall endeavour so to lead the reader forward from the foundation upwards, as that he may find out for himself the best way of doing everything, and having so discovered it, never forget it. I shall give him stones, and bricks, and straw, chisels and trowels, and the ground, and then ask him to build ; only helping him, as I can, if I find him puzzled. And when he has built his house or church, I shall ask him to ornament it, and leave it to him to choose the ornaments as I did to find out the construction : I shall use no influence with him whatever, except to counteract previous prejudices, and leave him, as far as may be, free. And when he has thus found out how to build, and chosen his forms of decoration, I shall do what I can to confirm his confidence in what he has done. I shall assure him that no one in the world could, so far, have done better, and require him to condemn, as futile or fallacious, whatever has no resemblance to his own performances.

THE SIX DIVISIONS OF ARCHITECTURE

THE practical duties of buildings are twofold. They have either (1), to hold and protect something; or (2), to place or carry something.

1. Architecture of Protection. This is architecture intended to protect men or their possessions from violence of any kind, whether of men or of the elements. It will include all churches, houses, and treasuries; fortresses, fences, and ramparts; the architecture of the hut and sheepfold; of the palace and citadel; of the dyke, breakwater, and sea-wall. And the protection, when of living creatures, is to be understood as including commodiousness and comfort of habitation, wherever these are possible under the given circumstances.

2. Architecture of Position. This is architecture intended to carry men or things to some certain places, or to hold them there. This will include all bridges, aqueducts, and road architecture; lighthouses, which have to hold light in appointed places; chimneys, to carry smoke or direct currents of air; staircases; towers, which are to be watched from or cried from, as in mosque, or to hold bells, or to place men in positions of offence, as ancient movable attacking towers, and most fortress towers.

Protective architecture has to do one or all of three things : to wall a space, to roof it, and to give access to it, of persons,

light, and air; and it is therefore to be considered under the three divisions of walls, roofs and apertures.

1. *Walls*—A wall is an even and united fence, whether of wood, earth, stone, or metal. When meant for purposes of mere partition or enclosure, it remains a wall proper; but it has generally also to sustain a certain vertical or lateral pressure, for which its strength is at first increased by some general addition to its thickness; but if the pressure becomes very great, it is gathered up into *piers* to resist vertical pressure, and supported by *buttresses* to resist lateral pressure.

If its functions of partition or enclosure are continued, together with that of resisting vertical pressure, it remains as a wall veil between the piers into which it has been partly gathered; but if it is required only to resist the vertical or roof pressure, it is gathered up into piers altogether, loses its wall character, and becomes a group or line of piers.

On the other hand, if the lateral pressure be slight, it may retain its character of a wall, being supported against the pressure by buttresses at intervals; but if the lateral pressure be very great, it is supported against such pressure by a continuous buttress, loses its wall character, and becomes a dyke or rampart.

We shall have therefore (A) first to get a general idea of a wall, and of right construction of walls; then (B) to see how this wall is gathered into piers, and to get a general idea of piers and the right construction of piers; then (C) to see how a wall is supported by buttresses, and to get a general idea of buttresses and the right construction of buttresses. This is surely very simple, and it is all we shall have to do with walls and their divisions.

2. *Roofs*—A roof is the covering of a space, narrow or wide. It will be most conveniently studied by first considering the forms in which it may be carried over a narrow space, and then expanding these on a wide plan; only there is some difficulty here in the nomenclature, for an arched roof over a narrow space

is called an arch; but a flat roof over a narrow space has (I
believe) no name, except that which belongs properly to the
piece of stone or wood composing such a roof, namely, lintel.
But the reader will have no difficulty in understanding that he
is first to consider roofs on the section only, thinking how
best to construct a narrow bar or slice of them, of whatever

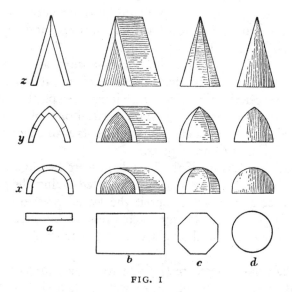

FIG. I

form; as, for instance, x, y, or z, over the plan or area a, Fig. I.
Having done this, let him imagine these several divisions, first
moved along (or set side by side) over a rectangle, b, Fig. I, and
then revolved round a point (or crossed at it) over a polygon,
c, or circle, d, and he will have every form of simple roof;
the arched section giving successively the vaulted roof and
dome, and the gabled section giving the gabled roof and
spire.

Now, it also happens, from its place in buildings, that the
sectional roof over a narrow space will need to be considered

before we come to the expanded roof over a broad one. For when a wall has been gathered, as above explained, into piers, that it may better bear vertical pressure, it is generally necessary that it should be expanded again at the top into a continuous wall before it carries the true roof. Arches or lintels are, therefore, thrown from pier to pier, and a level preparation for carrying the real roof is made above them. After we have examined the structure of piers, therefore, we shall have to see how lintels or arches are thrown from pier to pier, and the whole prepared for the superincumbent roof; this arrangement being universal in all good architecture prepared for vertical pressures : and we shall then examine the condition of the great roof itself. And because the structure of the roof very often introduces certain lateral pressures which have much to do with the placing of buttresses, it will be well to do all this before we examine the nature of buttresses, and, therefore, between parts (B) and (C) of the above plan. So now we shall have to study : (A) the construction of walls ; (B) that of piers ; (C) that of lintels or arches prepared for roofing ; (D) that of roofs proper ; and (E) that of buttresses.

3. *Apertures*—There must either be intervals between the piers, of which intervals the character will be determined by that of the piers themselves, or else doors or windows in the walls proper. And, respecting doors or windows, we have to determine three things : first, the proper shape of the entire aperture ; secondly, the way in which it is to be filled with valves or glass ; and, thirdly, the modes of protecting it on the outside, and fitting appliances of convenience to it, as porches or balconies. And this will be our division F ; and if the reader will have the patience to go through these six heads, which include every possible feature of protective architecture, and to consider the simple necessities and fitnesses of each, I will answer for it, he shall never confound good architecture with bad any more. For, as to architecture of position, a great part of it involves necessities of construction with which the spectator

cannot become generally acquainted, and of the compliance with which he is therefore never expected to judge,—as in chimneys, lighthouses, etc.: and the other forms of it are so closely connected with those of protective architecture, that a few words in Chap. X respecting staircases and towers, will contain all with which the reader need be troubled on the subject.

THE WALL BASE

OUR FIRST business, then, is with Wall, and to find out wherein lies the true excellence of the " Wittiest Partition." For it is rather strange that, often as we speak of a "dead" wall, and that with considerable disgust, we have not often, since Snout's time, heard of a living one. But the common epithet of opprobrium is justly bestowed, and marks a right feeling. A wall has no business to be dead. It ought to have members in its make, and purposes in its existence, like an organised creature, and to answer its ends in a living and energetic way; and it is only when we do not choose to put any strength nor organization into it, that it offends us by its deadness. Every wall ought to be a "sweet and lovely wall." I do not care about its having ears ; but, for instruction and exhortation, I would often have it to " hold up its fingers." What its necessary members and excellences are, it is our present business to discover.

A wall has been defined to be an even and united fence of wood, earth, stone or metal. Metal fences, however, seldom, if ever, take the form of walls, but of railings ; and, like all other metal constructions, must be left out of our present investigation ; as may be also walls composed merely of light planks or laths for purposes of partition or enclosure. Substantial walls, whether of wood or earth (I use the word earth as including clay, baked or unbaked, and stone), have, in their perfect form, three distinct members ;—the Foundation, Body or Veil, and Cornice.

The foundation is to the wall what the paw is to an animal. It is a long foot, wider than the wall, on which the wall is to

stand, and which keeps it from settling into the ground. It is most necessary that this great element of security should be visible to the eye, and therefore made a part of the structure above ground. Sometimes, indeed, it becomes incorporated with the entire foundation of the building, a vast table on which walls or piers are alike set: but even then, the eye, taught by the reason, requires some additional preparation or foot for the wall, and the building is felt to be imperfect without it. This foundation we shall call the Base of the wall.

The body of the wall is of course the principal mass of it, formed of mud or clay, of bricks or stones, of logs or hewn timber; the condition of structure being, that it is of equal thickness everywhere below and above. It may be half a foot thick, or six feet thick, or fifty feet thick; but if of equal thickness everywhere, it is still a wall proper: if to its fifty feet of proper thickness there be added so much as an inch of thickness in particular parts, that added thickness is to be considered as some form of buttress or pier, or other appliance.

In perfect architecture, however, walls are generally kept of moderate thickness, and strengthened by piers or buttresses; and the part of the wall between these, being generally intended only to secure privacy, or keep out the slighter forces of weather, may be properly called a Wall Veil. I shall always use this word "Veil" to signify the even portion of a wall, it being more expressive than the term Body.

When the materials with which this veil is built are very loose, or of shapes which do not fit well together, it sometimes becomes necessary, or at least adds to security, to introduce courses of more solid material. Thus, bricks alternate with rolled pebbles in the old walls of Verona, and hewn stones with brick in its Lombard churches. A banded structure, almost a stratification of the wall, is thus produced; and the courses of more solid material are sometimes decorated with carving. Even when the wall is not thus banded through its whole height, it frequently becomes expedient to lay a course of stone, or at least

of more carefully chosen materials, at regular heights; and such belts or bands we may call String courses. These are a kind of epochs in the wall's existence; something like periods of rest and reflection in human life, before entering on a new career. Or else, in the building, they correspond to the divisions of its stories within, express its internal structure, and mark off some portion of the ends of its existence already attained.

Finally, on the top of the wall some protection from the weather is necessary, or some preparation for the reception of superincumbent weight, called a coping, or Cornice. I shall use the word Cornice for both; for, in fact, a coping is a roof to the wall itself, and is carried by a small cornice as the roof of the building by a large one. In either case, the cornice, small or large, is the termination of the wall's existence, the accomplishment of its work. When it is meant to carry some superincumbent weight, the cornice may be considered as its hand, opened to carry something above its head; as the base was considered its foot; and the three parts should grow out of each other and form one whole, like the root, stalk, and bell of a flower.

These three parts we shall examine in succession; and, first, the Base.

It may be sometimes in our power, and it is always expedient, to prepare for the whole building some settled foundation, level and firm, out of sight. But this has not been done in some of the noblest buildings in existence. It cannot always be done perfectly, except at enormous expense; and, in reasoning upon the superstructure, we shall never suppose it to be done. The mind of the spectator does not conceive it; and he estimates the merits of the edifice on the supposition of its being built upon the ground. Even if there be a vast tableland of foundation elevated for the whole of it, accessible by steps all round, as at Pisa, the surface of this table is always conceived as capable of yielding somewhat to superincumbent weight, and generally is so; and we shall base all our arguments on the widest possible supposition, that is to say, that the building stands on a surface

either of earth, or, at all events, capable of yielding in some degree to its weight.

Now let the reader simply ask himself how, on such a surface, he would set about building a substantial wall, that should be able to bear weight and to stand for ages. He would assuredly look about for the largest stones he had at his disposal, and, rudely levelling the ground, he would lay these well together over a considerably larger width than he required the wall to be (suppose as at *a*, Fig. II), in order to equalise the pressure of the

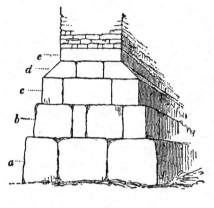

FIG. II

wall over a large surface, and form its foot. On the top of these he would perhaps lay a second tier of large stones, *b*, or even a third, *c*, making the breadth somewhat less each time, so as to prepare for the pressure of the wall on the centre, and, naturally or necessarily, using somewhat smaller stones above than below (since we supposed him to look about for the largest first), and cutting them more neatly. His third tier, if not his second, will probably appear a sufficiently secure foundation for finer work; for if the earth yield at all, it will probably yield pretty equally under the great mass of masonry now knit together over it. So he will prepare for the wall itself at once by sloping off the next tier of stones to the right diameter, as at *d*. If there be any joints in this tier within the wall, he may perhaps, for further security, lay a binding stone across them, *e*, and then begin the work of the wall veil itself, whether in bricks or stones.

I have supposed the preparation here to be for a large wall, because such a preparation will give us the best general type.

But it is evident that the essential features of the arrangement are only two, that is to say, one tier of massy work for foundation, suppose *c*, missing the first two ; and the receding tier or real foot of the wall, *d*. The reader will find these members, though only of brick, in most of the considerable and independent walls in the suburbs of London.

It is evident, however, that the general type, Fig. II, will be subject to many different modifications in different circumstances. Sometimes the ledges of the tiers *a* and *b* may be of greater width ; and when the building is in a secure place, and of finished masonry, these may be sloped off also like the main foot *d*. In Venetian buildings these lower ledges are exposed to the sea, and therefore left rough hewn ; but in fine work and in important positions the lower ledges may be levelled and decorated like the upper, or another added above *d* ; and all these parts may be in different proportions, according to the disposition of the building above them. But we have nothing to do with any of these variations at present, they being all more or less dependent upon decorative considerations, except only one of very great importance, that is to say, the widening of the lower ledge into a stone seat, which may be often done in buildings of great size with most beautiful effect : it looks kind and hospitable, and preserves the work above from violence. In St. Mark's at Venice, which is a small and low church, and needing no great foundation for the wall veils of it, we find only the three members, *b*, *c*, and *d*. Of these the first rises about a foot above the pavement of St. Mark's Place, and forms an elevated dais in some of the recesses of the porches, chequered red and white ; *c* forms a seat which follows the line of the walls, while its basic character is marked by its also carrying certain shafts with which we have here no concern ; *d* is of white marble ; and all are enriched and decorated in the simplest and most perfect manner possible. And thus much may serve to fix the type of wall bases, a type oftener followed in real practice than any other we shall hereafter be enabled to deter-

mine : for wall bases of necessity must be solidly built, and the architect is therefore driven into the adoption of the right form ; or if he deviate from it, it is generally in meeting some necessity of peculiar circumstances, as in obtaining cellars and underground room, or in preparing for some grand features or particular parts of the wall, or in some mistaken idea of decoration,—into which errors we had better not pursue him until we understand something more of the rest of the building : let us therefore proceed to consider the wall veil.

THE WALL VEIL

A FRAGMENT of building among the Alps is singularly illustrative
of the chief feature which I have at present to develop as
necessary to the perfection of the wall veil. It is a fragment of
some size ; a group of broken walls, one of them overhanging ;
crowned with a cornice, nodding some hundred and fifty feet
over its massive flank, three thousand above its glacier base, and
fourteen thousand above the sea,—a wall truly of some majesty,
at once the most precipitous and the strongest mass in the whole
chain of the Alps, the Mont Cervin (or Matterhorn). Its northern
spur is one of the few points from which its mass is in anywise
approachable. It is a continuation of the masonry of the
mountain itself, and affords us the means of examining the
character of its materials.

Few architects would like to build with them. The slope of
the rocks to the north-west is covered two feet deep with their
ruins, a mass of loose and slaty shale, of a dull brick-red colour,
which yields beneath the foot like ashes, so that, in running
down, you step one yard, and slide three. The rock is indeed
hard beneath, but still disposed in thin courses of these cloven
shales, so finely laid that they look in places more like a heap of
crushed autumn leaves than a rock ; and the first sensation is one
of unmitigated surprise, as if the mountain were upheld by
miracle ; but surprise becomes more intelligent reverence for
the great Builder, when we find, in the middle of the mass of
these dead leaves, a course of living rock, of quartz as white as
the snow that encircles it, and harder than a bed of steel.

It is one only of a thousand iron bands that knit the strength of the mighty mountain. Through the buttress and the wall alike, the courses of its varied masonry are seen in their successive order, smooth and true as if laid by line and plummet,[1] but of thickness and strength continually varying, and with silver cornices glittering along the edge of each, laid by the snowy winds and carved by the sunshine.

I do not, however, bring this forward as an instance of any universal law of natural building ; there are solid as well as coursed masses of precipice, but it is somewhat curious that the most noble cliff in Europe, which this eastern front of the Cervin is, I believe, without dispute, should be to us an example of the utmost possible stability of precipitousness attained with materials of imperfect and variable character ; and, what is more, there are very few cliffs which do not display alternations between compact and friable conditions of their material, marked in their contours by bevelled slopes when the bricks are soft, and vertical steps when they are harder. And, although we are not hence to conclude that it is well to introduce courses of bad materials when we can get perfect material, I believe we may conclude with great certainty that it is better and easier to strengthen a wall necessarily of imperfect substance, as of brick, by introducing carefully laid courses of stone, than by adding to its thickness ; and the first impression we receive from the unbroken aspect of a wall veil, unless it be of hewn stone throughout, is that it must be both thicker and weaker than it would have been, had it been properly coursed. The decorative reasons for adopting the coursed arrangement are so weighty, that they would alone be almost sufficient to enforce it : and the constructive ones will apply universally, except in the rare cases in which the choice of perfect or imperfect material is entirely open to us, or where the general system of the decoration of the building requires absolute unity in its surface.

As regards the arrangement of the intermediate parts them-

[1] On the eastern side : violently contorted on the northern and western.

selves, it is regulated by certain conditions of bonding and fitting
the stones or bricks, which the reader need hardly be troubled
to consider, and which I wish that bricklayers themselves were
always honest enough to observe. But I hardly know whether
to note under the head of æsthetic or constructive law, this
important principle, that masonry is always bad which appears
to have arrested the attention of the architect more than absolute
conditions of strength require. Nothing is more contemptible
in any work than an appearance of the slightest desire on the part
of the builder to *direct attention* to the way its stones are put
together, or of any trouble taken either to show or to conceal it
more than was rigidly necessary : it may sometimes, on the one
hand, be necessary to conceal it as far as may be, by delicate and
close fitting, when the joints would interfere with lines of sculp-
ture or of mouldings ; and it may often, on the other hand, be
delightful to show it, as it is delightful in places to show the
anatomy even of the most delicate human frame : but *studiously*
to conceal it is the error of vulgar painters, who are afraid to
show that their figures have bones ; and studiously to display
it is the error of the base pupils of Michael Angelo, who turned
heroes' limbs into surgeons' diagrams,—but with less excuse
than theirs, for there is less interest in the anatomy displayed.

There is, however, no excuse for errors in disposition of
masonry, for there is but one law upon the subject, and that
easily complied with, to avoid all affectation and all unnecessary
expense, either in showing or concealing. Every one knows a
building is built of separate stones ; nobody will ever object to
seeing that it is so, but nobody wants to count them. The
divisions of a church are much like the divisions of a sermon ;
they are always right, so long as they are necessary to edification,
and always wrong when they are thrust upon the attention as
divisions only. There may be neatness in carving when there is
richness in feasting ; but I have heard many a discourse, and
seen many a church wall, in which it was all carving and no meat.

THE WALL CORNICE

WE HAVE lastly to consider the close of the wall's existence or its cornice. It was above stated, that a cornice has one of two offices : if the walls have nothing to carry, the cornice is its roof, and defends it from the weather ; if there is weight to be carried above the wall, the cornice is its hand, and is expanded to carry the said weight.

There are several ways of roofing or protecting independent walls, according to the means nearest at hand : sometimes the wall has a true roof all to itself ; sometimes it terminates in a small gabled ridge, made of bricks set slanting, as constantly in the suburbs of London ; or of hewn stone, in stronger work ; or in a single sloping face, inclined to the outside. We need not trouble ourselves at present about these small roofings, which are merely the diminutions of large ones ; but we must examine the important and constant member of the wall structure, which prepares it either for these small roofs or for weight above, and is its true cornice.

The reader will, perhaps, as heretofore, be kind enough to think for himself, how, having carried up his wall veil as high as it may be needed, he will set about protecting it from weather, or preparing it for weight. Let him imagine the top of the unfinished wall, as it would be seen from above, with all the joints, perhaps uncemented, or imperfectly filled up with cement, open to the sky ; and small broken materials filling gaps between large ones, and leaving cavities ready for the rain to soak into, and loosen and dissolve the cement, and split, as it froze, the

whole to pieces. I am much mistaken if his first impulse would not be to take a great flat stone and lay it on the top; or rather a series of such, side by side, projecting well over the edge of the wall veil. If, also, he proposed to lay a weight (as, for instance, the end of a beam) on the wall, he would feel at once that the pressure of this beam on, or rather among, the small stones of the wall veil, might very possibly dislodge or disarrange some of them; and his first impulse would be, in this case, also to lay a large flat stone on the top of all to receive the beam, or any other weight, and distribute it equally among the small stones below, as at *a*, Fig. III (p. 56).

We must therefore have our flat stone in either case; and let *b*, Fig. III, be the section or side of it, as it is set across the wall. Now, evidently, if by any chance this weight happen to be thrown more on the edges of this stone than the centre, there will be a chance of these edges breaking off. Had we not better, therefore, put another stone, sloped off to the wall, beneath the projecting one, as at *c*? But now our cornice looks somewhat too heavy for the wall; and as the upper stone is evidently of needless thickness, we will thin it somewhat, and we have the form *d*. Now observe: the lower or bevelled stone here at *d* corresponds to *d* in the base (Fig. II, page 48). That was the foot of the wall; this is its hand. And the top stone here, which is a constant member of cornices, corresponds to the under stone *c* in Fig. II, which is a constant member of bases. The reader has no idea at present of the enormous importance of these members; but as we shall have to refer to them perpetually, I must ask him to compare them, and fix their relations well in his mind: and, for convenience, I shall call the bevelled or sloping stone, X, and the upright-edged stone, Y. The reader may remember easily which is which; for X is an intersection of two slopes, and may therefore properly mean either of the two sloping stones; and Y is a figure with a perpendicular line and two slopes, and may therefore fitly stand for the upright stone in relation to each of the sloping ones.

Now the form at *d*, Fig. III, is the great root and primal type of all cornices whatsoever. In order to see what forms may be developed from it, let us take its profile a little larger—*a*, Fig. IV, with X and Y duly marked. Now this form, being the root of all cornices, may either have to finish the wall, and so keep off rain; or, as so often stated, to carry weight. If the former, it is evident that, in its present profile, the rain will run back down the slope of X; and if the latter, that the sharp angle or edge of X, at *k*, may be a little too weak for its work, and run a chance of giving way. To avoid the evil in the first case, suppose we hollow the slope of X inwards, as at *b*; and to avoid it in the second case, suppose we strengthen X by letting it bulge outwards, as at *c*.

FIG. III

These (*b* and *c*) are the profiles of two vast families of cornices, springing from the same root, which, with a third arising from their combination (owing its origin to æsthetic considerations, and inclining sometimes to the one, sometimes to the other), have been employed, each on its third part of the architecture of the whole world throughout all ages, and must continue to be so employed through such time as is yet to come. We do not at present speak of the third or combined group; but the relation of the two main branches to each other, and to the line of origin, is given at *e*, Fig. IV; where the dotted lines are the representatives of the two families, and the straight line of the root. The slope of this right line, as well as the nature of the curves, here drawn as segments of circles, we leave undetermined: the slope, as well as the proportion of the depths of X and Y to each other, vary according to the weight to be carried, the strength of the stone, the size of the cornice, and a thousand

other accidents ; and the nature of the curves according to æsthetic laws. It is in these infinite fields that the invention of the architect is permitted to expatiate, but not in the alteration of primitive forms.

But to proceed. It will doubtless appear to the reader, that, even allowing for some of these permissible variations in the curve or slope of X, neither the form at *b*, nor any approximation to that form, would be sufficiently undercut to keep the rain from running back upon it. This is true; but we have to consider that the cornice, as the close of the wall's life, is of all its features

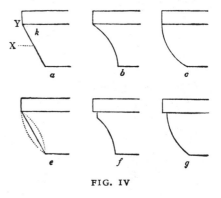

FIG. IV

that which is best fitted for honour and ornament. But it is evident that, as it is high above the eye, the fittest place to receive the decoration is the slope of X, which is inclined towards the spectator ; and if we cut away or hollow out this slope more than we have done at *b*, all decoration will be hid in the shadow. If, therefore, the climate be fine, and rain of long continuance not to be dreaded, we shall not hollow the stone X further, adopting the curve at *b*, merely as the most protective in our power. But if the climate be one in which rain is frequent and dangerous, as in alternations with frost, we may be compelled to consider the cornice in a character distinctly protective, and to hollow out X farther, so as to enable it thoroughly to accomplish its purpose. A cornice thus treated loses its character as the crown or honour of the wall, takes the office of its protector, and is called a DRIPSTONE. The dripstone is naturally the attribute of Northern buildings, and therefore especially of Gothic architecture ; the true cornice is the attribute of Southern buildings, and therefore of Greek and Italian architecture : and

it is one of their peculiar beauties, and eminent features of superiority.

Before passing to the dripstone, however, let us examine a little farther into the nature of the true cornice. We cannot, indeed, render either of the forms, *b* or *c*. Fig. IV, perfectly protective from rain, but we can help them a little in their duty by a slight advance of their upper ledge. This, with the form *b*, we can best manage by cutting off the sharp upper point of its curve, which is evidently weak and useless; and we shall have the form *f*. By a slight advance of the upper stone in *c*, we shall have the parallel form *g*.

These two cornices, *f* and *g*, are characteristic of early Byzantine work, and are found on all the most lovely examples of it in Venice. The type *a* is rarer, but occurs pure in the most exquisite piece of composition in Venice—the northern portico of St. Mark's.

Now the reader has doubtless noticed that these forms of cornice result, from considerations of fitness and necessity, far more neatly and decisively than the forms of the base, which we left only very generally determined. The reason is, that there are many ways of building foundations, and many *good* ways, dependent upon the peculiar accidents of the ground and nature of accessible materials. There is also room to spare in width, and a chance of a part of the arrangement being concealed by the ground, so as to modify height. But we have no room to spare in width on the top of a wall, and all that we do must be thoroughly visible; and we can but have to deal with bricks or stones of a certain degree of fineness, and not with mere gravel or sand, or clay,—so that as the conditions are limited, the forms become determined; and our steps will be more clear and certain the farther we advance. The sources of a river are usually half lost among moss and pebbles, and its first movements doubtful in direction; but, as the current gathers force, its banks are determined, and its branches are numbered.

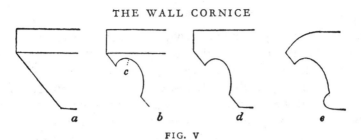

FIG. V

So far of the true cornice : we have still to determine the form of the dripstone.

We go back to our primal type or root of cornice, *a* of Fig. IV. We take this at *a* in Fig. V, and we are to consider it entirely as a protection against rain. Now the only way in which the rain 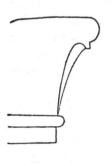 can be kept from running back on the slope of X is by a bold hollowing out of it up-wards, *b*. But clearly, by thus doing, we shall so weaken the projecting part of it that the least shock would break it at the neck, *c* ; we must therefore cut the whole out of one stone which will give us the form *d*. That the water may not lodge on the upper ledge of this, we had better round it off ; and it will better protect the joint at the bottom of the slope if we let the stone project over it in a roll, cutting the recess deeper above. These two changes are made in *e ; e* is the type of dripstones ; the projecting part being, however, more or less rounded into an approximation to the shape of a falcon's beak, and often reaching it completely. But the essential part of the arrangement is the up and under cutting of the curve. Wherever we find this, we are sure that the climate is wet, or that the builders have been *bred* in a wet country, and that the rest of the building will be prepared for rough weather. The up cutting of the curve is sometimes all the distinction between the mouldings of far-distant countries and utterly strange nations.

FIG. VI

Fig. VI represents a moulding with an outer and inner curve, the latter under-cut. Take the outer line, and this moulding is one constant in Venice, in architecture traceable to Arabian types, and chiefly to the early mosques of Cairo. But take the inner line ; it is a dripstone at Salisbury. In that narrow interval between the curves there is, when we read it rightly, an expression of another and a mightier curve,—the orbed sweep of the earth and sea, between the desert of the Pyramids, and the green and level fields through which the clear streams of Sarum wind so slowly.

And so delicate is the test, that though pure cornices are often found in the North,—borrowed from classical models,—so surely as we find a true dripstone moulding in the South, the influence of Northern builders has been at work : for the true Byzantine and Arab mouldings are all open to the sky and light, but the Lombards brought with them from the North the fear of rain, and in all the Lombardic Gothic we instantly recognise the shadowy dripstone : *a*, Fig. VII, is from a noble fragment at Milan, in the Piazza dei Mercanti ; *b*, from the Broletto of Como. Compare them with *c* and *d*, both from Salisbury ; *e* and *f*, from Lisieux, Normandy ; *g* and *h*, from Wenlock Abbey, Shropshire.

The reader is now master of all that he need know about the construction of the general wall cornice, fitted either to become a crown of the wall, or to carry weight above. If, however, the weight above become considerable, it may be necessary to support the cornice at intervals with brackets ; especially if it be required to project far, as well as to carry weight ; as, for instance, if there be a gallery on the top of the wall. This kind of bracket-cornice, deep or shallow, forms a separate family, essentially connected with roofs and galleries ; for if there be no superincumbent weight, it is evidently absurd to put brackets to a plain cornice or dripstone (though this is sometimes done in carrying out a style); so that, as soon as we see a bracket put to a cornice, it implies, or should imply, that there is a roof or gallery above it. Hence this family of cornices I shall consider

in connection with roofing, calling them "roof cornices," while what we have hitherto examined are proper "wall cornices."

We are not, however, as yet nearly ready for our roof. We have only obtained that which was to be the object of our first division (A); we have got, that is to say, a general idea of a wall and of the three essential parts of a wall ; and we have next, it will be remembered, to get an idea of a pier and the essential parts of a pier, which were to be the subjects of our second division (B).

FIG. VII

It has been stated that when a wall had to sustain an addition of vertical pressure, it was first fitted to sustain it by some addition to its own thickness ; but if the pressure became very great, by being gathered up into piers.

I must first make the reader understand what I mean by a wall's being gathered up. Take a piece of tolerably thick drawing-paper, or thin Bristol board, five or six inches square. Set it on its edge on the table, and put a small octavo book on the edge or top of it, and it will bend instantly. Tear it into four strips all across, and roll up each strip tightly. Set these rolls on end on the table, and they will carry the small octavo perfectly well. Now the thickness or substance of the paper employed to carry the weight is exactly the same as it was before, only it is differently arranged, that is to say, "gathered up." If, therefore, a wall be gathered up like the Bristol board, it will bear greater weight than it would if it remained a wall veil. The sticks into which you gather it are called *Piers*. A pier is a coagulated wall.

Now you cannot quite treat the wall as you did the Bristol

board, and twist it up at once ; but let us see how you *can* treat it. Let A, Fig. VIII, be the plan of a wall which you have made inconveniently and expensively thick, and which still appears to be slightly too weak for what it must carry ; divide it, as at B, into equal spaces, *a, b, a, b,* etc. Cut out a thin slice of it at every *a* on each side, and put the slices you cut out on at every

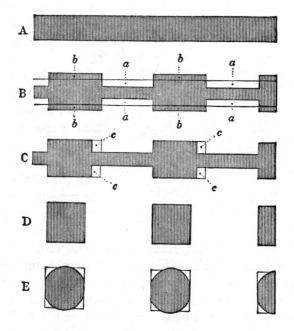

FIG. VIII

b on each side, and you will have the plan at B, with exactly the same quantity of bricks. But your wall is now so much con-centrated, that, if it was only slightly too weak before it will be stronger now than it need be ; so you may spare some of your space as well as your bricks by cutting off the corners of the thicker parts, as suppose *c, c, c, c,* at C: and you have now a

series of square piers connected by a wall veil, which, on less space and with less materials, will do the work of the wall at A perfectly well.

I do not say *how much* may be cut away in the corners *c, c,*—that is a mathematical question with which we need not trouble ourselves : all that we need know is, that out of every slice we take from the "*a*'s" and put on at the "*b*'s," we may keep a certain percentage of room and bricks, until, supposing that we do not want the wall veil for its own sake, this latter is thinned entirely away, like the girdle of the Lady of Avenel, and finally breaks, and we have nothing but a row of square piers, D.

But have we yet arrived at the form which will spare most room, and use fewest materials ? No ; and to get farther we must apply the general principle to our wall, which is equally true in morals and mathematics, that the strength of materials or of men, or of minds, is always most available when it is applied as closely as possible to a single point.

Let the point to which we wish the strength of our square piers to be applied, be chosen. Then we shall of course put them directly under it, and the point will be in their centre. But now some of their materials are not so near or close to this point as others. Those at the corners are farther off than the rest.

Now, if every particle of the pier be brought as near as possible to the centre of it, the form it assumes is the circle.

The circle must be, therefore, the best possible form of plan for a pier, from the beginning of time to the end of it. A circular pier is called a pillar or column, and all good architecture adapted to vertical support is made up of pillars, has always been so, and must ever be so, as long as the laws of the universe hold.

The final condition is represented at E, in its relation to that at D. It will be observed that though each circle projects a little beyond the side of the square out of which it is formed, the space cut off at the angles is greater than that added at the sides ; for, having our materials in a more concentrated arrangement, we

can afford to part with some of them in this last transformation, as in all the rest.

And now, what have the base and the cornice of the wall been doing while we have been cutting the veil to pieces and gathering it together?

The base is also cut to pieces, gathered together, and becomes the base of the column.

The cornice is cut to pieces, gathered together, and becomes the capital of the column. Do not be alarmed at the new word; it does not mean a new thing; a capital is only the cornice of a column, and you may, if you like, call a cornice the capital of a wall.

THE ARCH

WE HAVE seen how our means of vertical support may, for the sake of economy both of space and material, be gathered into piers or shafts, and directed to the sustaining of particular points. The next question is how to connect these points or tops of shafts with each other, so as to be able to lay on them a continuous roof. This the reader, as before, is to favour me by finding out for himself under these following conditions.

Let s, s, Fig. IX be two shafts, with their capitals ready prepared for their work ; and a, b, b, and c, c, c, be six stones of different sizes, one very long and large, and two smaller, and three smaller still, of which the reader is to choose which he likes best, in order to connect the tops of the shafts.

I suppose he will first try if he can lift the great stone a, and if he can, he will put it very simply on the tops of the two pillars, as at A.

Very well indeed : he has done already what a number of Greek architects have been thought very clever for having done. But suppose he *cannot* lift the great stone a, or suppose I will not give it to him, but only the two smaller stones at b, b; he will doubtless try to put them up, tilted against each other, as at d. Very awkward this ; worse than card-house building. But if he cuts off the corners of the stones, so as to make each of them of the form e, they will stand up very securely as at B.

But suppose he cannot lift even these less stones, but can raise those at c, c, c. Then, cutting each of them into the form at e, he will doubtless set them up as at f.

This last arrangement looks a little dangerous. Is there not a chance of the stone in the middle pushing the others out, or tilting them up and aside, and slipping down itself between

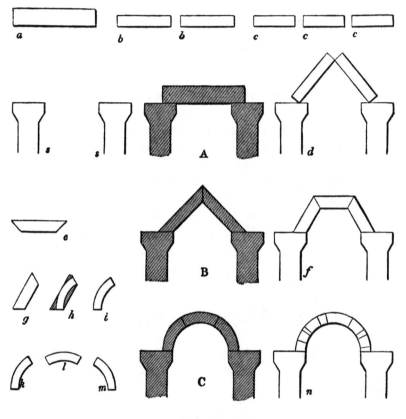

FIG. IX

them? There is such a chance: and if, by somewhat altering the form of the stones, we can diminish this chance, all the better. I must say "we" now, for perhaps I may have to help the reader a little.

The danger is, observe, that the midmost stone at *f* pushes

66

out the side ones : then if we can give the side ones such a shape as that, left to themselves, they would fall heavily forward, they will resist this push *out* by their weight, exactly in proportion to their own particular inclination or desire to tumble *in*. Take one of them separately, standing up as at *g*; it is just possible it may stand up as it is, like the Tower of Pisa ; but we want it to fall forward. Suppose we cut away the parts that are shaded at *h* and leave it as at *i*, it is very certain it cannot stand alone now, but will fall forward to our entire satisfaction.

Farther : the midmost stone at *f* is likely to be troublesome chiefly by its weight, pushing down between the others : the more we lighten it the better ; so we will cut it into exactly the same shape as the side ones, chiselling away the shaded parts, as at *h*. We shall then have all the three stones, *k*, *l*, *m*, of the same shape ; and now putting them together, we have, at C, what the reader, I doubt not, will perceive at once to be a much more satisfactory arrangement than at *f*.

We have now got three arrangements ; in one using only one piece of stone, in the second two, and in the third three. The first arrangement has no particular name, except the " horizontal ": but the single stone (or beam, it may be), is called a lintel ; the second arrangement is called a " Gable "; the third an "Arch."

We might have used pieces of wood instead of stone in all these arrangements, with no difference in plan, so long as the beams were kept loose, like the stones ; but as beams can be securely nailed together at the ends, we need not trouble our- selves so much about their shape or balance, and therefore the plan at *f* is a peculiarly wooden construction (the reader will doubtless recognise in it the profile of many a farmhouse roof); and again, because beams are tough, and light, and long, as com- pared with stones, they are admirably adapted for the construc- tions at A and B, the plain lintel and gable, while that at C is, for the most part, left to brick and stone.

But farther. The constructions, A, B, and C, though very

conveniently to be first considered as composed of one, two, and three pieces, are by no means necessarily so. When we have once cut the stones of the arch into a shape like that of *k*, *l*, and *m*, they will hold together, whatever their number, place, or size, as at *n*; and the great value of the arch is, that it permits small stones to be used with safety instead of large ones, which are not always to be had. Stones cut into the shape of *k*, *l*, and *m*, whether they be short or long (I have drawn them all sizes at *n* on purpose), are called Voussoirs; this is a hard, ugly French name; but the reader will perhaps be kind enough to recollect it; it will save us both some trouble: and to make amends for this infliction, I will relieve him of the term *keystone*. One voussoir is as much a keystone as another; only people usually call the stone which is last put in the keystone; and that one happens generally to be at the top or middle of the arch.

Not only the arch, but even the lintel, may be built of many stones or bricks. The reader may see lintels built in this way over most of the windows of our brick London houses, and so also the gable: there are, therefore, two distinct questions respecting each arrangement;—First, what is the line, or direction of it, which gives it its strength? and, secondly, what is the manner of masonry of it, which gives it its consistence.

Now the arch line is the ghost or skeleton of the arch; or rather it is the spinal marrow of the arch, and the voussoirs are the vertebræ, which keep it safe and sound, and clothe it. This arch line the architect has first to conceive and shape in his mind, as opposed to, or having to bear, certain forces which will try to distort it this way and that; and against which he is first to direct and bend the line itself into as strong resistance as he may, and then, with his voussoirs and what else he can, to guard it, and help it, and keep it to its duty and in its shape. So the arch line is the moral character of the arch, and the adverse forces are its temptations; and the voussoirs, and what else we may help it with, are its armour and its motives to good conduct.

This moral character of the arch is called by architects its

" Line of Resistance." There is a great deal of nicety in calculating it with precision, just as there is sometimes in finding out very precisely what is a man's true line of moral conduct : but this, in arch morality and in man morality, is a very simple and easily to be understood principle,—that if either arch or man expose themselves to their special temptations or adverse forces, *outside* of their voussoirs or proper and appointed armour, both will fall. An arch whose line of resistance is in the middle of its voussoirs is perfectly safe :

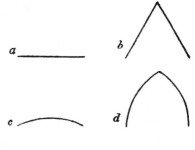

FIG. X

in proportion as the said line runs near the edge of its voussoirs, the arch is in danger, as the man is who nears temptation ; and the moment the line of resistance emerges out of the voussoirs the arch falls.

There are, therefore, properly speaking, two arch lines. One is the visible direction or curve of the arch, which may generally be considered as the under edge of its voussoirs, and which has often no more to do with the real stability of the arch, than a man's apparent conduct has with his heart. The other line, which is the line of resistance, or line of good behaviour, may or may not be consistent with the outward and apparent curves of the arch ; but if not, then the security of the arch depends simply upon this, whether the voussoirs which assume or pretend to the one line are wide enough to include the other.

Now when the reader is told that the line of resistance varies with every change either in place or quantity of the weight above the arch, he will see at once that we have no chance of arranging arches by their moral characters : we can only take the apparent arch line, or visible direction, as a ground of arrangement.

Look back to Fig. IX. Evidently the abstract or ghost line

of the arrangement at A is a plain horizontal line, as at *a*, Fig. X (p. 69). The abstract line of the arrangement at B, Fig. IX, is composed of two straight lines set against each other, as at *b*. The abstract line of C, Fig. IX, is a curve of some kind, not at present determined, suppose *c*, Fig. X. Then, as *b* is two of the straight lines at *a*, set up against each other, we may conceive an arrangement, *d*, made up of two of the curved lines at *c*, set against each other. This is called a pointed arch, which is a contradiction in terms ; it ought to be called a curved gable ; but it must keep the name it has got.

Now *a*, *b*, *c*, *d*, Fig. X, are the ghosts of the lintel, the gable, the arch, and the pointed arch. With the poor lintel ghost we need trouble ourselves no farther ; there are no changes in him ; but there is much variety in the other three, and the method of their variety will be best discerned by studying *b* and *d*, as subordinate to and connected with the simple arch at *c*.

Many architects, especially the worst, have been very curious in designing out of the way arches,—elliptical arches, and four-centred arches, so called, and other singularities. The good architects have generally been content, and we for the present will be so, with God's arch, the arch of the rainbow and of the apparent heaven, and which the sun shapes for us as it sets and rises. Let us watch the sun for a moment as it climbs ; when it is a quarter up, it will give us the arch *a*, Fig. XI ; when it is half up, *b*; and when three-quarters up, *c*. There will be an infinite number of arches between these, but we will take these as sufficient representatives of all. Then *a* is the low arch, *b* the central or pure arch, *c* the high arch, and the rays of the sun would have drawn for us their voussoirs.

We will take these several arches successively, and fixing the top of each accurately, draw two right lines thence to its base, *d*, *e*, *f*, Fig. XI. Then these lines give us the relative gables of each of the arches ; *d* is the Italian or southern gable, *e* the central gable, *f* the Gothic gable.

We will again take the three arches with their gables in

70

FIG. XI

succession, and on each of the sides of the gable, between it and the arch, we will describe another arch, as at *g, h, i*. Then the curves so described give the pointed arches belonging to each of the round arches; *g*, the flat pointed arch, *h*, the central pointed arch, and *i*, the lancet pointed arch.

If the radius with which these intermediate curves are drawn be the base of *f*, the last is the equilateral pointed arch, one of great importance in Gothic work. But between the gable and circle, in all the three figures, there are an infinite number of pointed arches, describable with different radii; and the three round arches, be it remembered, are themselves representatives of an infinite number, passing from the flattest conceivable curve, through the semicircle and horseshoe, up to the full circle.

The central and the last group are the most important. The central round, or semicircle, is the Roman, the Byzantine, and Norman arch; and its relative pointed includes one wide branch of Gothic. The horseshoe round is the Arabic and Moorish

71

arch, and its relative pointed includes the whole range of Arabic and lancet, or Early English and French Gothics. I mean of course by the relative pointed the entire group of which the equilateral arch is the representative. Between it and the outer horseshoe, as this latter rises higher, the reader will find, on experiment, the great families of what may be called the horseshoe pointed,—curves of the highest importance, but which are all included, with English lancet, under the term, relative pointed of the horseshoe arch (see Fig. XII).

The groups above described are all formed of circular arcs, and include all truly useful and beautiful arches for ordinary work. I believe that singular and complicated curves are made use of in modern engineering, but with these the general reader can have no concern : the Ponte della Trinita at Florence is the most graceful instance I know of such structure ; the arch made use of being very subtle, and approximating to the low ellipse ; for which, in common work a barbarous pointed arch, called four-centred, and composed of bits of circles, is substituted by the English builders. The high ellipse, I believe, exists in eastern architecture. I have never myself met with it on a large scale ; but it occurs in the niches of the later portions of the Ducal palace at Venice.

We are, however, concerned to notice the absurdity of another form of arch, which, with the four-centred, belongs to the English perpendicular Gothic.

Taking the gable of any of the groups in Fig. XI, (suppose the equilateral), here at b, in Fig. XIII, the dotted line representing the relative pointed arch, we may evidently conceive an arch formed by reversed curves on the inside of the gable, as here shown by the inner curved lines. I imagine the reader by this time knows enough of the nature of arches to understand that, whatever strength or stability was gained by the curve on the *outside* of the gable, exactly so much is lost by curves on the *inside*. The natural tendency of such an arch to dissolution by its own mere weight renders it a feature of detestable ugliness,

wherever it occurs on a large scale. It is eminently characteristic of Tudor work, and it is the profile of the Chinese roof; (I say on a large scale, because this, as well as all other capricious arches, may be made secure by their masonry when small, but not otherwise). Some allowable modifications of it will be noticed in the chapter on Roofs.

FIG. XII

There is only one more form of arch which we have to notice. When the last described arch is used, not as the principal arrangement, but as a mere heading to a common pointed arch, we have the form *c*, Fig. XIII. Now this is better than the entirely reversed arch for two reasons : first, less of the line is weakened by reversing ; secondly, the double curve has a very high æsthetic value, not existing in the mere segments of circles. For these reasons arches of this kind are not only admissible, but even of great desirableness, when their scale and masonry render them secure, but above a certain scale they are altogether

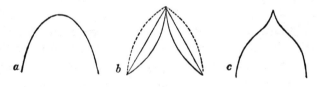

FIG. XIII

barbarous : and, with the reversed Tudor arch wantonly employed, are the characteristics of the worst and meanest schools of architecture, past or present.

This double curve is called the Ogee ; it is the profile of many German leaden roofs, of many Turkish domes (there more excusable, because associated and in sympathy with exquisitely managed arches of the same line in the walls below), of Tudor turrets, as in Henry the Seventh's Chapel and it is at the bottom or top of sundry other blunders all over the world.

On the subject of the stability of arches, volumes have been written, and volumes more are required. The reader will not, therefore, expect from me any very complete explanation of its conditions within the limits of a single chapter. But that which is necessary for him to know is very simple and very easy; and yet, I believe, some part of it is very little known, or noticed.

We must first have a clear idea of what is meant by an arch. It is a curved *shell* of firm materials, on whose back a burden is to be laid of *loose* materials. So far as the materials above it are *not loose*, but themselves hold together, the opening below is not an arch, but an *excavation*. Note this difference very carefully. If the King of Sardinia tunnels through the Mont Cenis, as he proposes,[1] he will not require to build a brick arch under his tunnel to carry the weight of the Mont Cenis: that would need scientific masonry indeed. The Mont Cenis will carry itself, by its own cohesion, and a succession of invisible granite arches, rather larger than the tunnel. But when Mr. Brunel tunnelled the Thames bottom,[2] he needed to build a brick arch to carry the six or seven feet of mud and the weight of water above. That is a type of all arches proper.

Now arches, in practice, partake of the nature of the two. So far as their masonry above is Mont-Cenisian, that is to say, colossal in comparison of them, and granitic, so that the arch is a mere hole in the rock substance of it, the form of the arch is of no consequence whatever: it may be rounded, or lozenged, or ogee'd, or anything else; and in the noblest architecture there is always *some* character of this kind given to the masonry. It is independent enough not to care about the holes cut in it, and does not subside into them like sand. But the theory of arches does not presume on any such condition of things: it allows itself only the shell of the arch proper; the vertebræ, carrying their marrow of resistance; and, above this shell, it assumes the wall to be in a state of flux, bearing down on the arch, like

[1] The Tunnel (through Mont Frejus, not the Mont Cenis) was begun in 1857, four years after this was written, and finished in 1870. Ed.

[2] The Thames Tunnel, from Wapping to Rotherhithe, completed in 1843. Ed.

water or sand, with its whole weight. And farther, the problem
which is to be solved by the arch builder is not merely to carry
this weight, but to carry it with the least thickness of shell. It
is easy to carry it by continually thickening your voussoirs : if
you have six feet depth of sand or gravel to carry, and you
choose to employ granite voussoirs six feet thick, no question
but your arch is safe enough. But it is perhaps somewhat too
costly : the thing to be done is to carry the sand or gravel with
brick voussoirs, six inches thick, or, at any rate, with the least
thickness of voussoir which will be safe; and to do this requires
peculiar arrangement of the lines of the arch. There are many
arrangements, useful all in their way, but we have only to do, in
the best architecture, with the simplest and most easily under-
stood.

What we have to say will apply to all arches, but the central
pointed arch is the best for general illustration. Let a, Fig. XIV,
(p.76), be the shell of a pointed arch with loose loading above ;
and suppose you find that shell not quite thick enough, and that
the weight bears too heavily on the top of the arch, and is likely
to break it in, you proceed to thicken your shell, but need you
thicken it all equally ? Not so; you would only waste your
good voussoirs. If you have any common sense you will thicken
it at the top, where a Mylodon's skull is thickened for the same
purpose (and some human skulls, I fancy), as at b. The pebbles
and gravel above will now shoot off it right and left, as the
bullets do off a cuirassier's breastplate, and will have no chance
of beating it in.

If still it be not strong enough, a farther addition may be
made, as at c, now thickening the voussoirs a little at the base
also. But as this may perhaps throw the arch inconveniently
high, or occasion a waste of voussoirs at the top, we may employ
another expedient.

I imagine the reader's common sense, if not his previous
knowledge, will enable him to understand that if the arch at a,
Fig. XIV, burst *in* at the top, it must burst *out* at the sides. Set

FIG. XIV

up two pieces of pasteboard, edge to edge, and press them down with your hand, and you will see them bend out at the sides. Therefore, if you can keep the arch from starting out at the points *p, p,* it *cannot* curve in at the top, put what weight on it you will, unless by sheer crushing of the stones to fragments.

Now you may keep the arch from starting out at *p* by loading it at *p*, putting more weight upon it and against it at that point ; and this, in practice, is the way it is usually done. But we assume at present that the weight above is sand or water, quite unmanageable, not to be directed to the points we choose ; and in practice, it may sometimes happen that we cannot put weight upon the arch at *p*. We may perhaps want an opening above it,

76

or it may be at the side of the building, and many other circumstances may occur to hinder us.

But if we are not sure that we can put weight above it, we are perfectly sure that we can hang weight under it. You may always thicken your shell inside, and put the weight upon it as at *x*, *x*, in *d*, Fig. XIV. Not much chance of its bursting out at *p* now, is there?

Whenever, therefore, an arch has to bear vertical pressure, it will bear it better when its shell is shaped as at *b* or *d*, than as at *a*: *b* and *d* are, therefore, the types of arches built to resist vertical pressure, all over the world, and from the beginning of architecture to its end. None others can be compared with them : all are imperfect except these.

The added projections at *x*, *x*, in *d*, are called CUSPS, and they are the very soul and life of the best northern Gothic ; yet never thoroughly understood nor found in perfection, except in Italy, the northern builders working often, even in the best times, with the vulgar form at *a*.

The form at *b* is rarely found in the north ; its perfection is in the Lombardic Gothic : and branches of it, good and bad according to their use, occur in Saracenic work.

The true and perfect cusp is single only. But it was probably invented (by the Arabs ?) not as a constructive, but a decorative feature, in pure fantasy ; and in early northern work it is only the application to the arch of the foliation, so called, of penetrated spaces in stone surfaces. It is degraded in dignity, and loses in usefulness, exactly in proportion to its multiplication on the arch. In later architecture, especially English Tudor, it is sunk into dotage, and becomes a simple excrescence, a bit of stone pinched up out of the arch, as a cook pinches the paste at the edge of a pie.

Now, in the arches *e*, *f*, *g*, a slight modification has been made in the form of the central piece, in order that it may continue the curve of the cusp. This modification is not to be given to it in practice without considerable nicety of workman-

ship; and some curious results took place in Venice from this difficulty.

At *h* (Fig. XIV) is the shape of the Venetian side stone, with its cusp; detached from the arch. Nothing can possibly be better or more graceful, or have the weight better disposed in order to cause it to nod forwards against the keystone, as above explained, where I developed the whole system of the arch from three pieces, in order that the reader might now clearly see the use of the weight of the cusp.

Now a Venetian Gothic palace has usually at least three stories; with perhaps ten or twelve windows in each story, and this on two or three of its sides, requiring altogether some hundred to a hundred and fifty side pieces.

I have no doubt, from observation of the way the windows are set together, that the side pieces were carved in pairs, like hooks, of which the keystones were to be the eyes; that these side pieces were ordered by the architect in the gross, and were used by him sometimes for wider, sometimes for narrower windows; bevelling the two ends as required, fitting in keystones as he best could, and now and then varying the arrangement by turning the side pieces *upside down*.

There are various conveniences in this way of working, one of the principal being that the side pieces with their cusps were always cut to their complete form, and that no part of the cusp was carried out into the keystone, which followed the curve of the outer arch itself. The ornaments of the cusp might thus be worked without any troublesome reference to the rest of the arch.

Now let us take a pair of side pieces, made to order, like that at *h*, and see what we can make of them. We will try to fit them first with a keystone which continues the curve of the outer arch as at *j*. This the reader suredly thinks an ugly arch. There are a great many of them in Venice, the ugliest things there, and the Venetian builders quickly began to feel them so. What could they do to better them? The arch at *j* has a central

78

piece of the form *l.* Substitute for it a piece of the form *m* and we have the arch at *k.*

This arch at *k* is not as strong as that at *j*; but, built of good marble, and with its pieces of proper thickness, it is quite strong enough for all practical purposes on a small scale. I have examined at least two thousand windows of this kind and of the other Venetian ogees, and I never found *one,* even in the most ruinous palaces (in which they had had to sustain the distorted weight of falling walls) in which the central piece was fissured; and this is the only danger to which the window is exposed; in other respects it is as strong an arch as can be built.

CHAPTER VIII

THE ROOF

HITHERTO our inquiry has been unembarrassed by any considerations relating exclusively either to the exterior or interior of buildings. But it can remain so no longer. As far as the architect is concerned, one side of a wall is generally the same as another; but in the roof there are usually two distinct divisions of the structure: one, a shell, vault, or flat ceiling internally visible, the other, an upper structure, built of timber. to protect the lower; or of some different form, to support it. Sometimes, indeed, the internally visible structure is the real roof, and sometimes there are more than two divisions, as in St. Paul's, where we have a central shell with a masque below and above. Still it will be convenient to remember the distinction between the part of the roof which is usually visible from within, and whose only business is to stand strongly, and not fall in, which I shall call the Roof Proper; and, secondly, the upper roof, which, being often partly-supported by the lower, is not so much concerned with its own stability as with the weather, and is appointed to throw off snow, and get rid of rain, as fast as possible, which I shall call the Roof Mask.

It is, however, needless for me to engage the reader in the discussion of the various methods of construction of Roofs Proper, for this simple reason, that no person without long experience can tell whether a roof be wisely constructed or not; nor tell at all, even with help of any amount of experience, without examination of the several parts and bearings of it, very different from any observation possible to the general critic : and

more than this, the inquiry would be useless to us in our Venetian studies, where the roofs are either not contemporary with the buildings, or flat, or else vaults of the simplest possible constructions.

The forms resulting from the other curves of the arch developed in the last chapter; that is to say, the various eastern domes and cupolas arising out of the revolution of the horseshoe and ogee curves, together with the well-known Chinese concave roof are of course purely decorative, the bulging outline, or concave surface being of no more use, or rather of less, in throwing off snow or rain, than the ordinary spire and gable; and it is rather curious, therefore, that all of them, on a small scale, should have obtained so extensive use in Germany and Switzerland, their native climate being that of the east, where their purpose seems rather to concentrate light upon their orbed surfaces. I much doubt their applicability, on a large scale, to architecture of any admirable dignity: their chief charm is, to the European eye, that of strangeness; and it seems to me possible that in the east the bulging form may be also delightful, from the idea of its enclosing a volume of cool air. I enjoy them in St. Mark's chiefly because they increase the fantastic and unreal character of St. Mark's Place; and because they appear to sympathise with an expression, common, I think, to all the buildings of that group, of a natural buoyancy, as if they floated in the air or on the surface of the sea. But assuredly, they are not features to be recommended for imitation.

Circumstance and sentiment aiding each other, the steep roof becomes generally adopted, and delighted in, throughout the north; and then, with the gradual exaggeration with which every pleasant idea is pursued by the human mind, it is raised into all manner of peaks, and points, and ridges; and pinnacle after pinnacle is added on its flanks, and the walls increased in height in proportion, until we get indeed a very sublime mass.

As the height of the walls increased, in sympathy with the rise of the roof, while their thickness remained the same, it

became more and more necessary to support them by buttresses ; but it is not the steep roof which requires the buttress, but the vaulting beneath it ; the roof mask being a mere wooden frame tied together by cross timbers, and in small buildings often put together on the ground, raised afterwards, and set on the walls like a hat, bearing vertically upon them ; and farther, I believe in most cases the northern vaulting requires its great array of external buttress, not so much from any peculiar boldness in its own forms, as from the greater comparative thinness and height of the walls, and more determined throwing of the whole weight of the roof on particular points.

THE BUTTRESS

BUTTRESSES ARE of many kinds, according to the character and direction of the lateral forces they are intended to resist. But their first broad division is into buttresses which meet and break the force before it arrives at the wall, and buttresses which stand on the lee side of the wall and prop it against the force.

The lateral forces which walls have to sustain are of three distinct kinds: dead weight, as of masonry or still water; moving weight, as of wind or running water; and sudden concussion, as of earthquakes, explosions, etc.

1. Clearly, dead weight can only be resisted by the buttress acting as a prop; for a buttress on the side of, or towards the weight, would only add to its effect. This, then, forms the first great class of buttressed architecture; lateral thrusts of roofing or arches being met by props of masonry outside—the thrust from within, the prop without; or the crushing force of water on a ship's side met by its cross timbers—the thrust here from without the wall, the prop within.

2. Moving weight may, of course, be resisted by the prop on the lee side of the wall, but is often more effectually met, on the side which is attacked, by buttresses of peculiar forms, cunning buttresses, which do not attempt to sustain the weight, but *parry* it, and throw it off in directions clear of the wall.

3. Concussions and vibratory motion, though in reality only supported by the prop buttress, must be provided for by

buttresses on both sides of the wall, as their direction cannot be foreseen, and is continually changing.

We shall briefly glance at these three systems of buttressing ; but the two latter, being of small importance to our present purpose, may as well be dismissed first.

Buttresses for guard against moving weight, set, therefore, towards the weight they resist—The most familiar instance of this kind of buttress we have in the sharp piers of a bridge in the centre of a powerful stream, which divide the current on their edges, and throw it to each side under the arches. A ship's bow is a buttress of the same kind, and so also the ridge of a breastplate, both adding to the strength of it in resisting a cross blow, and giving a better chance of a bullet glancing aside. In Switzerland, projecting buttresses of this kind are often built round churches, heading up hill, to divide and throw off the avalanches. The various forms given to piers and harbour quays, and to the bases of lighthouses, in order to meet the force of the waves, are all conditions of this kind of buttress. But in works of ornamental architecture such buttresses are of rare occurrence ; and I merely name them in order to mark their place in our architectural system, since in the investigation of our present subject we shall not meet with a single example of them, unless sometimes the angle of the foundation of a palace against the sweep of the tide, or the wooden piers of some canal bridge quivering in its current.

Buttresses for guard against vibratory motion—The whole formation of this kind of buttress resolves itself into mere expansion of the base of the wall, so as to make it stand steadier, as a man stands with his feet apart when he is likely to lose his balance. The approach to a pyramidal form is also of great use as a guard against the action of artillery ; that if a stone or tier of stones be battered out of the lower portions of the wall, the whole upper part may not topple over or crumble down at once. Various forms of this buttress, sometimes applied to particular points of the wall, sometimes forming a great sloping rampart

along its base, are frequent in buildings, of countries exposed to earthquake. They give a peculiarly heavy outline to much of the architecture of the kingdom of Naples, and they are of the form in which strength and solidity are first naturally sought, in the slope of the Egyptian wall. The base of Guy's tower at Warwick is a singularly bold example of their military use; and so, in general, bastion and rampart profiles, where, however, the object of stability against a shock is complicated with that of sustaining weight of earth in the rampart behind.

Prop buttresses against dead weight—This is the group with which we have principally to do; and a buttress of the kind acts in two ways, partly by its weight and partly by its strength. It acts by its weight when its mass is so great that the weight it sustains cannot stir it, but is lost upon it, buried in it, and annihilated: neither the shape of such a buttress nor the cohesion of its materials is of much consequence: a heap of stones or sandbags laid up against the wall will answer as well as a built and cemented mass.

But a buttress acting by its strength is not of mass sufficient to resist the weight by mere inertia; but it conveys the weight through its body to something else which is so capable; as, for instance, a man leaning against a door with his hands, and propping himself against the ground, conveys the force which would open or close the door against him through his body to the ground. A buttress acting in this way must be of perfectly coherent materials, and so strong that though the weight to be borne could easily move it, it cannot break it: this kind of buttress may be called a conducting buttress. Practically, however, the two modes of action are always in some sort united. Again, the weight to be borne may either act generally on the whole wall surface, or with excessive energy on particular points: when it acts on the whole wall surface, the whole wall is generally supported; and the arrangement becomes a continuous rampart, as a dyke, or bank of reservoir.

It is, however, very seldom that lateral force in architecture

is equally distributed. In most cases the weight of the roof, or the force of any lateral thrust, is more or less confined to certain points and directions. In an early state of architectural science this definiteness of direction is not yet clear, and it is met by uncertain application of mass or strength in the buttress, some-times by mere thickening of the wall into square piers, which are partly piers, partly buttresses, as in Norman keeps and towers. But as science advances, the weight to be borne is designedly and decisively thrown upon certain points ; the direction and degree of the forces which are then received are exactly calculated, and met by conducting buttresses of the smallest possible dimensions; themselves, in their turn, supported by vertical buttresses acting by weight, and these, perhaps, in their turn, by another set of conducting buttresses : so that, in the best examples of such arrangements, the weight to be borne may be considered as the shock of an electric fluid, which, by a hundred different rods and channels, is divided and carried away into the ground.

In order to give greater weight to the vertical buttress piers which sustain the conducting buttresses, they are loaded with pinnacles, which, however, are, I believe, in all the buildings in which they become very prominent, merely decorative : they are of some use, indeed, by their weight ; but if this were all for which they were put there, a few cubic feet of lead would much more securely answer the purpose, without any danger from exposure to wind. If the reader likes to ask any Gothic architect with whom he may happen to be acquainted, to substitute a lump of lead for his pinnacles, he will see by the expression of the face how far he considers the pinnacles decorative members. In the work which seems to me the great type of simple and masculine buttress structure, the apse of Beauvais, the pinnacles are altogether insignificant, and are evidently added just as exclusively to entertain the eye and lighten the aspect of the buttress, as the slight shafts which are set on its angles ; while in other very noble Gothic buildings the pinnacles are introduced as niches for statues, without any reference to construction at all ;

and sometimes even, as in the tomb of Can Signorio at Verona, on small piers detached from the main building.

I believe, therefore, that the development of the pinnacle is merely a part of the general erectness and picturesqueness of northern work above alluded to ; and that, if there had been no other place for the pinnacles, the Gothic builders would have put them on the tops of their arches (they often *did* on the tops of gables and pediments), rather than not have had them ; but the natural position of the pinnacle is, of course, where it adds to, rather than diminishes, the stability of the building ; that is to say, on its main wall-piers and the vertical piers of the buttresses. And thus the edifice is surrounded at last by a complete company of detached piers and pinnacles, each sustaining the inclined prop against the central wall, and looking something like a band of giants holding it up with the butts of their lances. This arrangement would imply the loss of an enormous space of ground, but the intervals of the buttresses are usually walled in below, and form minor chapels.

The science of this arrangement has made it the subject of much enthusiastic declamation among the Gothic architects, almost as unreasonable, in some respects, as the declamation of the Renaissance architects respecting Greek structure. The fact is, that the whole northern buttress-system is based on the grand requirement of tall windows and vast masses of light at the end of the apse. In order to gain this quantity of light, the piers between the windows are diminished in thickness until they are far too weak to bear the roof, and then sustained by external buttresses. In the Italian method the light is rather dreaded than desired, and the wall is made wide enough between the windows to bear the roof, and so left. In fact, the simplest expression of the difference in the systems is, that a northern apse is a southern one with its inter-fenestral piers set edgeways. Thus, *a*, Fig. XV, is the general idea of the southern apse ; take it to pieces, and set all its piers edgeways, as at *b*, and you have the northern one. You gain much light for the interior, but you cut the exterior

to pieces, and instead of a bold rounded or polygonal surface, ready for any kind of decoration, you have a series of dark and damp cells, which no device that I have yet seen has succeeded in decorating in a perfectly satisfactory manner. If the system be farther carried, and a second or third order of buttresses be added, the real fact is that we have a building standing on two or three rows of concentric piers, with the *roof off* the whole of

FIG. XV

it except the central circle, and only ribs left, to carry the weight of the bit of remaining roof in the middle; and after the eye has been accustomed to the bold and simple rounding of the Italian apse, the skeleton character of the disposition is painfully felt. After spending some months in Venice, I thought Bourges Cathedral looked exactly like a half-built ship on its shores. It is useless, however, to dispute respecting the merits of the two systems : both are noble in their place ; the northern decidedly the most scientific, or at least involving the greatest display of science, the Italian the calmest and purest ; this having in it the sublimity of a calm heaven or a windless noon, the other that of a mountain flank tormented by the north wind, and withering into grisly furrows of alternate chasm and crag.

If I have succeeded in making the reader understand the veritable action of the buttress, he will have no difficulty in determining its fittest form. He has to deal with two distinct kinds ; one, a narrow vertical pier, acting principally by its

weight, and crowned by a pinnacle ; the other, commonly called a Flying buttress, a cross bar set from such a pier (when detached from the building) against the main wall. This latter, then, is to be considered as a mere prop or shore, and its use by the Gothic architects might be illustrated by the supposition that we were to build all our houses with walls too thin to stand without wooden props outside, and then to substitute stone props for wooden ones. I have some doubts of the real dignity of such a proceeding, but at all events the merit of the form of the flying buttress depends on its faithfully and visibly performing this somewhat humble office ; it is, therefore, in its purity, a mere sloping bar of stone, with an arch beneath it to carry its weight, that is to say, to prevent the action of gravity from in any wise deflecting it, or causing it to break downwards under the lateral thrust ; it is thus found quite simple in Notre Dame of Paris, and in the Cathedral of Beauvais, while at Cologne the sloping bars are pierced with quatrefoils, and at Amiens with traceried arches. Both seem to me effeminate and false in principle ; not, of course, that there is any occasion to make the flying buttress heavy, if a light one will answer the purpose ; but it seems as if some security were sacrificed to ornament. At Amiens the arrangement is now seen to great disadvantage, for the early traceries have been replaced by base flamboyant ones, utterly weak and despicable.

The form of the common buttress must be familiar to the eye of every reader, sloping if low, and thrown into successive steps if they are to be carried to any considerable height. There is much dignity in them when they are of essential service ; but, even in their best examples, their awkward angles are among the least manageable features of the Northern Gothic, and the whole organisation of its system was destroyed by their unnecessary and lavish application on a diminished scale ; until the buttress became actually confused with the shaft, and we find strangely crystallised masses of diminutive buttresses applied, for merely vertical support, in the northern tabernacle-work ; while in

some recent copies of it the principle has been so far distorted that the tiny buttressings look as if they carried the super-structure on the points of their pinnacles, as in the Cranmer memorial at Oxford. Indeed, in most modern Gothic, the architects evidently consider buttresses as convenient breaks of blank surface, and general apologies for deadness of wall. They stand in the place of ideas, and I think are supposed also to have something of the odour of sanctity about them ; otherwise one hardly sees why a warehouse seventy feet high should have nothing of the kind, and a chapel, which one can just get into with one's hat off, should have a bunch of them at every corner ; and worse than this, they are even thought ornamental when they can be of no possible use ; and these stupid penthouse out-lines are forced upon the eye in every species of decoration : in some of our modern chapels I have actually seen a couple of buttresses at the end of every pew.

It is almost impossible, in consequence of these unwise repetitions of it, to contemplate the buttress without some degree of prejudice ; and I look upon it as one of the most justifiable causes of the unfortunate aversion with which many of our best architects regard the whole Gothic school. It may, however, always be regarded with respect, when its form is simple and its service clear ; but no treason to Gothic can be greater than the use of it in indolence or vanity, to enhance the intricacies of structure, or occupy the vacuities of design.

SUPERIMPOSITION

THE reader has now some knowledge of every feature of all possible architecture. Whatever the nature of the building which may be submitted to his criticism, if it be an edifice at all, if it be anything else than a mere heap of stones, like a pyramid or breakwater, or than a large stone hewn into shape, like an obelisk, it will be instantly and easily resolvable into some of the parts which we have been hitherto considering : its pinnacles will separate themselves into their small shafts and roofs ; its supporting members into shafts and arches, or walls penetrated by apertures of various shape, and supported by various kinds of buttresses. Respecting each of these several features I am certain that the reader feels himself prepared, by understanding their plain function, to form something like a reasonable and definite judgment whether they be good or bad ; and this right judgment of parts will, in most cases, lead him to just reverence or condemnation of the whole.

The various modes in which these parts are capable of combination, and the merits of buildings of different form and expression, are evidently not reducible into lists, nor to be estimated by general laws. The nobility of each building depends on its special fitness for its own purposes ; and these purposes vary with every climate, every soil, and every national custom : nay, there were never, probably, two edifices erected in which some accidental difference of condition did not require some difference of plan or of structure ; so that, respecting plan and distribution of parts, I do not hope to collect any universal law

of right; but there are a few points necessary to be noticed respecting the means by which height is attained in buildings of various plans, and the expediency and methods of superimposition of one story or tier of architecture above another.

For, in the preceding inquiry, I have always supposed either that a single shaft would reach to the top of the building, or that the farther height required might be added in plain wall above the heads of the arches; whereas it may often be rather expedient to complete the entire lower series of arches, or finish the lower wall, with a bold stringcourse or cornice, and build another series of shafts, or another wall, on the top of it.

This superimposition is seen in its simplest form in the interior shafts of a Greek temple; and it has been largely used in nearly all countries where buildings have been meant for real service. Outcry has often been raised against it, but the thing is so sternly necessary that it has always forced itself into acceptance; and it would, therefore, be merely losing time to refute the arguments of those who have attempted its disparagement. Thus far, however, they have reason on their side, that if a building can be kept in one grand mass, without sacrificing either its visible or real adaptation to its objects, it is not well to divide it into stories until it has reached proportions too large to be justly measured by the eye. It ought then to be divided in order to mark its bulk; and decorative divisions are often possible, which rather increase than destroy the expression of general unity.

Superimposition, wisely practised, is of two kinds, directly contrary to each other, of weight on lightness, and of lightness on weight; while the superimposition of weight on weight, or lightness on lightness, is nearly always wrong.

Firstly, weight on lightness: I do not say weight on *weakness*. The superimposition of the human body on its limbs I call weight on lightness; the superimposition of the branches on a tree trunk I call lightness on weight: in both cases the support is fully adequate to the work, the form of support being regulated

by the differences of requirement. Nothing in architecture is half so painful as the apparent want of sufficient support when the weight above is visibly passive ; for all buildings are not passive ; some seem to rise by their own strength, or float by their own buoyancy ; a dome requires no visibility of support, one fancies it supported by the air. But passive architecture without help for its passiveness is unendurable. In a lately built house, No. 86, in Oxford Street, three huge stone pillars in the second story are carried apparently by the edges of three sheets of plate-glass in the first. I hardly know anything to match the painfulness of this and some other of our shop structures, in which the iron-work is concealed ; nor even when it is apparent, can the eye ever feel satisfied of their security, when built, as at present, with fifty or sixty feet of wall above a rod of iron not the width of this page.

The proper forms of this superimposition of weight on lightness have arisen, for the most part, from the necessity or desirableness, in many situations, of elevating the inhabited portions of buildings considerably above the ground level, especially those exposed to damp or inundation, and the consequent abandonment of the ground story as unserviceable, or else the surrender of it to public purposes. Thus, in many market and town houses, the ground story is left open as a general place of sheltered resort, and the enclosed apartments raised on pillars. In almost all warm countries the luxury, almost the necessity, of arcades to protect the passengers from the sun, and the desirableness of large space in the rooms above, lead to the same construction. Throughout the Venetian islet group, the houses seem to have been thus, in the first instance, universally built ; all the older palaces appearing to have had the rez de chaussée perfectly open, the upper parts of the palace being sustained on magnificent arches, and the smaller houses sustained in the same manner on wooden piers, still retained in many of the cortiles, and exhibited characteristically throughout the main street of Murano. As ground became more valuable and house-

room more scarce, these ground-floors were enclosed with wall veils between the original shafts, and so remain ; but the type of the structure of the entire city is given in the Ducal Palace.

To this kind of superimposition we owe the most picturesque street effects throughout the world, and the most graceful, as well as the most grotesque, buildings, from the many-shafted fantasy of the Alhambra (a building as beautiful in disposition as it is base in ornamentation) to the four-legged stolidity of the Swiss Chalet :[1] nor these only, but great part of the effect of our cathedrals, in which, necessarily, the close triforium and clerestory walls are superimposed on the nave piers ; perhaps with most majesty where with greatest simplicity, as in the old basilican types, and the noble cathedral of Pisa.

For the sake of the delightfulness and security of all such arrangements, this law must be observed :—that in proportion to the height of wall above them, the shafts are to be short. You may take your given height of wall, and turn any quantity of that wall into shaft that you like ; but you must not turn it all into tall shafts, and then put more wall above. Thus, having a house five stories high, you may turn the lower story into shafts, and leave the four stories in wall ; or the two lower stories into shafts, and leave three in wall ; but, whatever you add to the shaft, you must take from the wall. Then also, of course, the shorter the shaft the thicker will be its *proportionate*, if not its actual, diameter. In the Ducal Palace of Venice the shortest shafts are always the thickest.

The second kind of superimposition, lightness on weight, is, in its most necessary uses, of stories of houses one upon another, where, of course, wall veil is required in the lower ones, and has to support wall veil above, aided by as much of shaft structure as is attainable within the given limits. The greatest, if not the

[1] I have spent much of my life among the Alps ; but I never pass, without some feeling of new surprise, the Chalet, standing on its four pegs (each topped with a flat stone), balanced in the fury of the Alpine winds. It is not, perhaps, generally known that the chief use of the arrangement is not so much to raise the building above the snow, as to get a draught of wind beneath it, which may prevent the drift from rising against its sides.

only, merit of the Roman and Renaissance Venetian architects is their graceful management of this kind of superimposition; sometimes of complete courses of external arches and shafts one above the other; sometimes of apertures with intermediate cornices at the levels of the floors, and large shafts from top to bottom of the building; always observing that the upper stories shall be at once lighter and richer than the lower ones. The entire value of such buildings depends upon the perfect and easy expression of the relative strength of the stories, and the unity obtained by the varieties of their proportions, while yet the fact of superimposition and separation by floors is frankly told.

But this superimposition of lightness on weight is still more distinctly the system of many buildings of the kind which I have above called Architecture of Position, that is to say, architecture of which the greater part is intended merely to keep something in a peculiar position; as in lighthouses, and many towers and belfries. The subject of spire and tower architecture, however, is so interesting and extensive, that I have thoughts of writing a detached essay upon it, and, at all events, cannot enter upon it here : but this much is enough for the reader to note for our present purpose, that, although many towers do in reality stand on piers or shafts, as the central towers of cathedrals, yet the expression of all of them, and the real structure of the best and strongest, are the elevation of gradually diminishing weight on massy or even solid foundation. Nevertheless, since the tower is in its origin a building for strength of defence, and faithfulness of watch, rather than splendour of aspect, its true expression is of just so much diminution of weight upwards as may be necessary to its fully balanced strength, not a jot more. There must be no lightheadedness in your noble tower : impregnable foundation, wrathful crest, with the vizor down, and the dark vigilance seen through the clefts of it; not the filigree crown or embroidered cap. No towers are so grand as the square browed ones, with massy cornices and rent battlements : next to these come the fantastic towers, with

their various forms of steep roof; the best, not the cone, but the plain gable thrown very high; last of all in my mind (of good towers), those with spires or crowns, though these, of course, are fittest for ecclesiastical purposes, and capable of the richest ornament. The paltry four or eight pinnacled things we call towers in England (as in York Minster), are mere confectioner's Gothic, and not worth classing.

But, in all of them, this I believe to be a point of chief necessity,—that they shall seem to stand, and shall verily stand, in their own strength; not by help of buttresses nor artful balancings on this side and on that. Your noble tower must need no help, must be sustained by no crutches, must give place to no suspicion of decrepitude. Its office may be to withstand war, look forth for tidings, or to point to heaven: but it must have in its own walls the strength to do this; it is to be itself a bulwark, not to be sustained by other bulwarks; to rise and look forth, " the tower of Lebanon that looketh toward Damascus," like a stern sentinel, not like a child held up in its nurse's arms. A tower may, indeed, have a kind of buttress, a projection, or subordinate tower at each of its angles; but these are to its main body like the satellites to a shaft, joined with its strength, and associated in its uprightness, part of the tower itself: exactly in the proportion in which they lose their massive unity with its body, and assume the form of true buttress walls set on its angles, the tower loses its dignity.

These two characters, then, are common to all noble towers, however otherwise different in purpose or feature,—the first, that they rise from massive foundation to lighter summits, frowning with battlements perhaps, but yet evidently more pierced and thinner in wall than beneath, and, in most ecclesiastical examples, divided into rich open work: the second, that whatever the form of the tower, it shall not appear to stand by help of buttresses. It follows from the first condition, as indeed it would have followed from ordinary æsthetic requirements, that we shall have continual variation in the arrangements of the

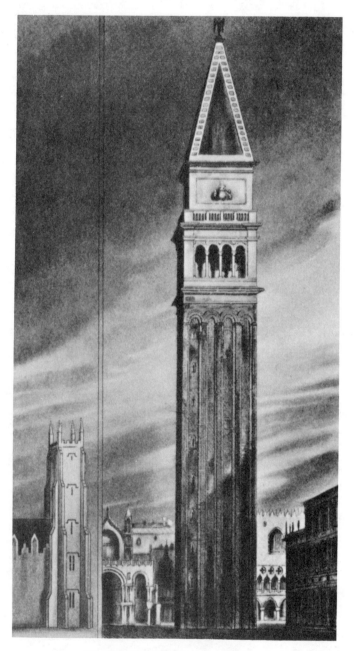

PLATE II: TYPES OF TOWERS
British and Venetian

stories, and the larger number of apertures towards the top,—a condition exquisitely carried out in the old Lombardic towers, in which, however small they may be, the number of apertures is always regularly increased towards the summit ; generally one window in the lowest stories, two in the second, then three, five, and six ; often, also, one, two, four, and six, with beautiful symmetries of placing, not at present to our purpose. We may sufficiently exemplify the general laws of tower building by placing side by side, drawn to the same scale, a mediæval tower, in which most of them are simply and unaffectedly observed, and one of our own modern towers, in which every one of them is violated in small space, convenient for comparison. (Plate II.)

The old tower is that of St. Mark's at Venice,[1] not a very perfect example, for its top is Renaissance, but as good Renaissance as there is in Venice ; and it is fit for our present purpose, because it owes none of its effect to ornament. It is built as simply as it well can be to answer its purpose : no buttresses ; no external features whatever, except some huts at the base, and the loggia, afterwards built, which, on purpose, I have not drawn ; one bold square mass of brickwork ; double walls, with an ascending inclined plane between them, with apertures as small as possible, and these only in necessary places, giving just the light required for ascending the stair or slope, not a ray more ; and the weight of the whole relieved only by the double pilasters on the sides, sustaining small arches at the top of the mass, each decorated with the scallop or cockle shell, frequent in Renaissance ornament, and here, for once, thoroughly well applied. Then, when the necessary height is reached, the belfry is left open, as in the ordinary Romanesque campanile, only the shafts more slender, but severe and simple, and the whole crowned by as much spire as the tower would carry, to render it more serviceable as a landmark. The arrangement is repeated in numberless campaniles throughout Italy.

[1] The Campanile. It fell to the ground on 14th July 1902 after a life, in part, of 1000 years, and was replaced in 1912 by the present reproduction. Ed.

The one beside it is one of those of the lately built college at Edinburgh.[1] I have not taken it as worse than many others (just as I have not taken the St. Mark's tower as better than many others); but it happens to compress our British system of tower building into small space. The Venetian tower rises 350 feet, and has no buttresses, though built of brick; the British tower rises 121 feet, and is built of stone, but is supposed to be incapable of standing without two huge buttresses on each angle. The St. Mark's tower has a high sloping roof, but carries it simply, requiring no pinnacles at its angles; the British tower has no visible roof, but has four pinnacles for mere ornament. The Venetian tower has its lightest part at the top, and is massy at the base; the British tower has its lightest part at the base, and shuts up its windows into a mere arrow-slit at the top. What the tower was built for at all must therefore, it seems to me, remain a mystery to every beholder; for surely no studious inhabitant of its upper chambers will be conceived to be pursuing his employments by the light of the single chink on each side; and had it been intended for a belfry, the sound of its bells would have been as effectually prevented from getting out, as the light from getting in.

We may, here, close our inquiries into the subject of construction; nor must the reader be dissatisfied with the simplicity or apparent barrenness of their present results. He will find, when he begins to apply them, that they are of more value than they now seem; but I have studiously avoided letting myself be drawn into any intricate question because I wished to ask from the reader only so much attention as it seemed that even the most indifferent would not be unwilling to pay to a subject which is hourly becoming of greater practical interest. Evidently it would have been altogether beside the purpose of this essay to have entered deeply into the abstract science, or closely into the mechanical detail, of construction: both have been illustrated by

[1] The United Free Church College of Scotland, built at the top of " The Mound." Ed.

writers far more capable of doing so than I, and may be studied at the reader's discretion; all that has been here endeavoured was the leading him to appeal to something like definite principle, and refer to the easily intelligible laws of convenience and necessity, whenever he found his judgment likely to be overborne by authority on the one hand, or dazzled by novelty on the other. If he has time to do more, and to follow out in all their brilliancy the mechanical inventions of the great engineers and architects of the day, I, in some sort, envy him, but must part company with him; for my way lies not along the viaduct, but down the quiet valley which its arches cross, not through the tunnel, but up the hill-side which its cavern darkens, to see what gifts Nature will give us, and with what imagery she will fill our thoughts, that the stones we have ranged in rude order may now be touched with life; nor lose for ever, in their hewn nakedness, the voices they had of old, when the valley streamlet eddied round them in palpitating light, and the winds of the hill-side shook over them the shadows of the fern.

THE MATERIAL OF ORNAMENT

WE enter now on the second division of our subject. We have no more to do with heavy stones and hard lines; we are going to be happy: to look round in the world and discover (in a serious manner always however, and under a sense of responsibility) what we like best in it, and to enjoy the same at our leisure: to gather it, examine it, fasten all we can of it into imperishable forms, and put it where we may see it for ever.

This it is to decorate architecture.

There are, therefore, three steps in the process; first, to find out in a grave manner what we like best; secondly, to put as much of this as we can (which is little enough) into form; thirdly, to put this formed abstraction into a proper place.

I said in Chapter II, that all noble ornamentation was the expression of man's delight in God's work. This implied that there was an *ig*noble ornamentation, which was the expression of man's delight in his *own*. There is such a school, chiefly degraded classic and Renaissance, in which the ornament is composed of imitations of things made by man. I think, before inquiring what we like best of God's work, we had better get rid of all this imitation of man's, and be quite sure we do not like *that*.

We shall rapidly glance, then, at the material of decoration hence derived. And now I cannot, as I before have done respecting construction, *convince* the reader of one thing being wrong, and another right. I have confessed as much again and again; I am now only to make appeal to him, and cross-

question him, whether he really does like things or not. If he likes the ornament on the base of the column of the Place Vendôme, composed of Wellington boots and laced frock-coats, I cannot help it ; I can only say I differ from him, and don't like it. And if, therefore, I speak dictatorially, and say this is base or degraded or ugly, I mean only that I believe men of the longest experience in the matter would either think it so, or would be prevented from thinking it so only by some morbid condition of their minds ; and I believe that the reader, if he examine himself candidly, will usually agree in my statements.

I conclude, then, with the reader's leave, that all ornament is base which takes for its subject human work, that it is utterly base,—painful to every rightly-toned mind, without perhaps immediate sense of the reason, but for a reason palpable enough when we *do* think of it. For to carve our own work, and set it up for admiration, is a miserable self-complacency, a contentment in our own wretched doings, when we might have been looking at God's doings. And all noble ornament is the exact reverse of this. It is the expression of man's delight in God's work.

For observe, the function of ornament is to make you happy. Now in what are you rightly happy ? Not in thinking of what you have done yourself; not in your own pride ; not your own birth ; not in your own being, or your own will, but in looking at God ; watching what He does ; what He is ; and obeying His law, and yielding yourself to His will.

You are to be made happy by ornaments ; therefore they must be the expression of all this. Not copies of your own handiwork; not boastings of your own grandeur; not heraldries; not king's arms, nor any creature's arms, but God's arm, seen in His work. Not manifestation of your delight in your own laws, or your own liberties, or your own inventions ; but in divine laws, constant, daily, common laws ;—not Composite laws, nor Doric laws, nor laws of the five orders, but of the Ten Commandments.

Then the proper material of ornament will be whatever God has created; and its proper treatment, that which seems in accordance with or symbolical of His laws. And, for material, we shall therefore have, first, the abstract lines which are most frequent in nature; and then, from lower to higher, the whole range of systematised inorganic and organic forms. We shall rapidly glance in order at their kinds; and, however absurd the elemental division of inorganic matter by the ancients may seem to the modern chemist, it is one so grand and simple for arrangements of external appearances, that I shall here follow it; noticing first, after abstract lines, the imitable forms of the four elements of Earth, Water, Fire, and Air, and then those of animal organisms. It may be convenient to the reader to have the order stated in a clear succession at first, thus :—

1. Abstract lines.
2. Forms of Earth (Crystals).
3. Forms of Water (Waves).
4. Forms of Fire (Flames and Rays).
5. Forms of Air (Clouds).
6. (Organic forms). Shells.
7. Fish.
8. Reptiles and insects.
9. Vegetation (A). Stems and Trunks.
10. Vegetation (B). Foliage.
11. Birds.
12. Mammalian animals and Man.

1. *Abstract lines*—I have not with lines named also shades and colours, for this evident reason, that there are no such things as abstract shadows, irrespective of the forms which exhibit them, and distinguished in their own nature from each other; and that the arrangement of shadows, in greater or less quantity, or in certain harmonical successions, is an affair of treatment, not of selection. And when we use abstract colours, we are in fact using a part of nature herself,—using a quality of her light, correspondent with that of the air, to carry sound;

and the arrangement of colour in harmonious masses is again a matter of treatment, not selection. Yet even in this separate art of colouring, as referred to architecture, it is very notable that the best tints are always those of natural stones. These can hardly be wrong ; I think I never yet saw an offensive introduction of the natural colours of marble and precious stones, unless in small mosaics, and in one or two glaring instances of the resolute determination to produce something ugly at any cost. On the other hand, I have most assuredly never yet seen a painted building, ancient or modern, which seemed to me quite right.

Our first constituents of ornament will therefore be abstract lines, that is to say, the most frequent contours of natural objects, transferred to architectural forms when it is not right or possible to render such forms distinctly imitative. For instance, the line or curve of the edge of a leaf may be accurately given to the edge of a stone, without rendering the stone in the least *like* a leaf, or suggestive of a leaf ; and this the more fully, because the lines of nature are alike in all her works ; simpler or richer in combination, but the same in character ; and when they are taken out of their combinations it is impossible to say from which of her works they have been borrowed, their universal property being that of ever-varying curvature in the most subtle and subdued transitions, with peculiar expressions of motion, elasticity, or dependence. But, that the reader may here be able to compare them for himself as deduced from different sources, I have drawn, as accurately as I can, on the following page, some ten or eleven lines from natural forms of very different substances and scale : the first, *ab*, is, in the original, I think, the most beautiful simple curve I have ever seen in my life ; it is a curve about three quarters of a mile long, formed by the surface of a small glacier of the second order, on a spur of the Aiguille de Blaitière (Chamouni). I have merely outlined the crags on the right of it, to show their sympathy and united action with the curve of the glacier, which is of course entirely dependent on

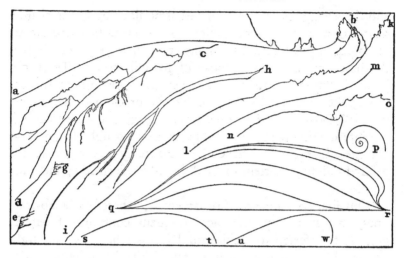

FIG. XVI

their opposition to its descent; softened, however, into unity by the snow, which rarely melts on this high glacier surface.

The line *d c* is some mile and a half or two miles long; it is part of the flank of the chain of the Dent d'Oche above the lake of Geneva, one or two of the lines of the higher and more distant ranges being given in combination with it.

h is a line about four feet long, a branch of spruce fir. I have taken this tree because it is commonly supposed to be stiff and ungraceful: its outer sprays are, however, more noble in their sweep than almost any that I know; but this fragment is seen at great disadvantage, because placed upside down in order that the reader may compare its curvatures with *c d, e g*, and *i k*, which are all mountain lines: *e g*, about five hundred feet of the southern edge of the Matterhorn; *i k*, the entire slope of the Aiguille Bouchard, from its summit into the valley of Chamouni, a line some three miles long; *l m* is the line of the side of a willow leaf traced by laying the leaf on the paper; *n o*, one of the innumerable groups of curves at the lip of a paper Nautilus;

p, a spiral, traced on the paper round a Serpula (worm); *q r*, the leaf of the Alisma Plantago with its interior ribs, half size ; *s t*, the side of a bay-leaf ; *u w*, of a salvia leaf : and it is to be carefully noted that these last curves, being never intended by nature to be seen singly, are more heavy and less agreeable than any of the others which would be seen as independent lines. But all agree in their character of changeful curvature, the mountain and glacier lines only excelling the rest in delicacy and richness of transition.

Why lines of this kind are beautiful, I endeavoured to show in the " Modern Painters ;" but one point, there omitted, may be mentioned here,—that almost all these lines are expressive of action or *force* of some kind, while the circle is a line of limitation or support. In leafage they mark the forces of its growth and expansion, but some among the most beautiful of them are described by bodies variously in motion, or subjected to force ; as by projectiles in the air, by the particles of water in a gentle current, by planets in motion in an orbit, by their satellites, if the actual path of the satellite in space be considered instead of its relation to the planet ; by boats, or birds, turning in the water or air, by clouds in various action upon the wind, by sails in the curvatures they assume under its force, and by thousands of other objects moving or bearing force. In the Alisma leaf, *q r*, the lines through its body, which are of peculiar beauty, mark the different expansions of its fibres, and are, I think, exactly the same as those which would be traced by the currents of a river entering a lake of the shape of the leaf, at the end where the stalk is, and passing out at its point. Circular curves, on the contrary, are always, I think, curves of limitation or support ; that is to say, curves of perfect rest. The cylindrical curve round the stem of a plant binds its fibres together ; while the *ascent* of the stem is in lines of various curvature : so the curve of the horizon and of the apparent heaven, of the rainbow, etc.: and though the reader might imagine that the circular orbit of any moving body, or the curve described by a sling, was a curve of motion, he

should observe that the circular character is given to the curve not by the motion, but by the confinement : the circle is the consequence not of the energy of the body, but of its being forbidden to leave the centre ; and whenever the whirling or circular motion can be fully impressed on it we obtain instant balance and rest with respect to the centre of the circle.

Hence the peculiar fitness of the circular curve as a sign of rest, and security of support, in arches ; while the other curves, belonging especially to action, are to be used in the more active architectural features—the hand and foot (the capital and base), and in all minor ornaments ; more freely in proportion to their independence of structural conditions.

2. *Forms of Earth* (*Crystals*)—It may be asked why I do not say rocks or mountains ? Simply, because the nobility of these depends, first, on their scale, and, secondly, on accident. Their scale cannot be represented, nor their accident systematised. No sculptor can in the least imitate the peculiar character of accidental fracture : he can obey or exhibit the laws of nature, but he cannot copy the felicity of her fancies, nor follow the steps of her fury.

But against crystalline form, which is the completely systematised natural structure of the earth, none of these objections hold good, and, accordingly, it is an endless element of decoration, where higher conditions of structure cannot be represented. The four-sided pyramid, perhaps the most frequent of all natural crystals, is called in architecture a dogtooth ; its use is quite limitless, and always beautiful : the cube and rhomb are almost equally frequent in chequers and dentils ; and all mouldings of the middle Gothic are little more than representations of the canaliculated crystals of the beryl, and such other minerals.

3. *Forms of Water* (*Waves*)—The reasons which prevent rocks from being used for ornament repress still more forcibly the portraiture of the sea. Yet the constant necessity of introducing some representation of water in order to explain the scene of events, or as a sacred symbol, has forced the sculptors of all ages

to the invention of some type or letter for it, if not an actual imitation. We find every degree of conventionalism or of naturalism in these types, the earlier being, for the most part, thoughtful symbols ; the later, awkward attempts at portraiture. The most conventional of all types is the Egyptian zigzag, preserved in the astronomical sign of Aquarius ; but every nation with any capacities of thought, has given, in some of its work, the same great definition of open water, as "an undulatory thing with fish in it."

4. *Forms of Fire* (*Flames and Rays*)—If neither the sea nor the rock can be imaged, still less the devouring fire. It has been symbolised by radiation both in painting and sculpture, for the most part in the latter very unsuccessfully. It was suggested to me, not long ago, that the zigzag decorations of Norman architects were typical of light springing from the half-set orb of the sun ; the resemblance to the ordinary sun type is indeed remarkable, but I believe accidental. The imitations of fire in the torches of Cupids and genii, and burning in tops of urns, which attest and represent the mephitic inspirations of the seventeenth century in most London churches, and in monuments all over civilized Europe, together with the gilded rays of Romanist altars, may be left to such mercy as the reader is inclined to show them.

5. *Forms of Air* (*Clouds*)—Hardly more manageable than flames, and of no ornamental use, their majesty being in scale and colour, and inimitable in marble.

6. *Shells*—I place these lowest in the scale (after inorganic forms) as being moulds or coats of organism ; not themselves organic. The sense of this, and of their being mere emptiness and deserted houses, must always prevent them, however beautiful in their lines, from being largely used in ornamentation. It is better to take the line and leave the shell. One form indeed, that of the cockle, has been in all ages used as the decoration of half-domes, which were named conchas from their shell form ; and I believe the wrinkled lip of the cockle, so used, to have

been the origin, in some parts of Europe at least, of the exuberant foliation of the round arch. The scallop also is a pretty radiant form, and mingles well with other symbols when it is needed. The crab is always as delightful as a grotesque, for here we suppose the beast inside the shell ; and he sustains his part in a lively manner among the other signs of the zodiac, with the scorpion ; or scattered upon sculptured shores, as beside the Bronze Boar of Florence. We shall find him in a basket at Venice, at the base of one of the Piazzetta shafts.

7. *Fish*—These, as beautiful in their forms as they are familiar to our sight, while their interest is increased by their symbolic meaning, are of great value as material of ornament. Love of the picturesque has generally induced a choice of some supple form with scaly body and lashing tail, but the simplest fish form is largely employed in mediæval work. We shall find the plain oval body and sharp head of the Thunny constantly at Venice ; and the fish used in the expression of sea-water, or water generally, are always plain-bodied creatures in the best mediæval sculpture. The Greek type of the dolphin, however, sometimes but slightly exaggerated from the real outline of the Delphinus Delphis, is one of the most picturesque of animal forms ; and the action of its slow revolving plunge is admirably caught upon the surface sea represented in Greek vases.

8. *Reptiles and Insects*—The forms of the serpent and lizard exhibit almost every element of beauty and horror in strange combination; the horror, which in an imitation is felt only as a pleasurable excitement, has rendered them favourite subjects in all periods of art ; and the unity of both lizard and serpent in the ideal dragon, the most picturesque and powerful of all animal forms, and of peculiar symbolical interest to the Christian mind, is perhaps the principal of all the materials of mediæval picturesque sculpture. By the best sculptors it is always used with this symbolic meaning, by the cinque-cento sculptors as an ornament merely. The best and most natural representations of mere viper or snake are to be found interlaced among their

confused groups of meaningless objects. The real power and horror of the snake-head has, however, been rarely reached.

Other less powerful reptile forms are not unfrequent. Small frogs, lizards, and snails almost always enliven the foregrounds and leafage of good sculpture. The tortoise is less usually employed in groups. Beetles are chiefly mystic and colossal. Various insects, like everything else in the world, occur in cinque-cento work; grasshoppers most frequently.

9. *Branches and stems of Trees*—I arrange these under a separate head: because, while the forms of leafage belong to all architecture, and ought to be employed in it always, those of the branch and stem belong to a peculiarly imitative and luxuriant architecture, and are only applicable at times. Pagan sculptors seem to have perceived little beauty in the stems of trees; they were little else than timber to them; and they preferred the rigid and monstrous triglyph, or the fluted column, to a broken bough or gnarled trunk. But with Christian knowledge came a peculiar regard for the forms of vegetation, from the root upwards. The actual representation of entire trees required in many Scripture subjects, familiarised the sculptors of bas-relief to the beauty of forms before unknown; for some time, nevertheless, the sculpture of trees was confined to bas-relief, but it at last affected even the treatment of the main shafts in Lombard Gothic buildings. It was then discovered to be more easy to carve branches than leaves; and, much helped by the frequent employment in later Gothic of the " Tree of Jesse " for traceries and other purposes, the system reached full development in a perfect thicket of twigs, which form the richest portion of the decoration of the porches of Beauvais. It had now been carried to its richest extreme; men wearied of it and abandoned it, and, like all other natural and beautiful things, it was ostracised by the mob of Renaissance architects. But it is interesting to observe how the human mind, in its acceptance of this feature of ornament, proceeded from the ground, and followed as it were, the natural growth of the tree. It began with the rude and solid

trunk, as at Genoa ; then the branches shot out, and became loaded with leaves ; autumn came, the leaves were shed, and the eye was directed to the extremities of the delicate branches ;— the Renaissance frosts came, and all perished.

10. *Foliage, Flowers, and Fruit*—It is necessary to consider these as separated from the stems ; not only, as above noted, because their separate use marks another school of architecture, but because they are the only organic structures which are capable of being so treated, and intended to be so, without strong effort of imagination. To pull animals to pieces, and use their paws for feet of furniture, or their heads for terminations of rods and shafts, is *usually* the characteristic of feelingless schools ; the greatest men like their animals whole : you cannot cut an animal to pieces as you can gather a flower or a leaf. These were intended for our gathering, and for our constant delight : wherever men exist in a perfectly civilized and healthy state, they have vegetation around them ; wherever their state approaches that of innocence or perfectness, it approaches that of Paradise, —it is a dressing of garden. And, therefore, where nothing else can be used for ornament, vegetation may ; vegetation in any form, however fragmentary, however abstracted. A single leaf laid upon the angle of a stone, or the mere form or framework of the leaf drawn upon it, or the mere shadow and ghost of the leaf,—the hollow " foil " cut out of it,—possesses a charm which nothing else can replace ; a charm not exciting, nor demanding laborious thought or sympathy, but perfectly simple, peaceful, and satisfying.

Fruit is, for the most part, more valuable in colour than form ; nothing is more beautiful as a subject of sculpture on a tree ; but, gathered and put in baskets, it is quite possible to have too much of it.

11. *Birds*—the perfect and simple grace of bird form, in general, has rendered it a favourite subject with early sculptors, and with those schools which loved form more than action ; but the difficulty of expressing action, where the muscular markings

are concealed, has limited the use of it in later art. The heads of birds of prey are always beautiful, and used as the richest ornaments in all ages.

12. *Quadrupeds and Men*—Of quadrupeds the horse has received an elevation into the primal rank of sculptural subject, owing to his association with men. The full value of other quadruped forms has hardly been perceived, or worked for, in late sculpture; and the want of science is more felt in these subjects than in any other branches of early work. The greatest richness of quadruped ornament is found in the hunting sculpture of the Lombards; but rudely treated (the most noble examples of treatment being the lions of Egypt, the Ninevite bulls, and the mediæval griffins). Quadrupeds of course form the noblest subjects of ornament next to the human form; this latter, the chief subject of sculpture, being sometimes the end of architecture rather than its decoration.

We have thus completed the list of the materials of architectural decoration, and the reader may be assured that no effort has ever been successful to draw elements of beauty from any other sources than these.

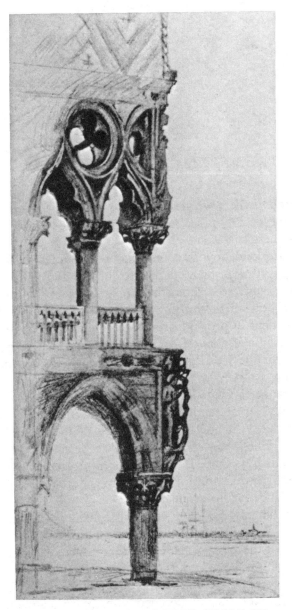

PLATE III: THE FIG-TREE ANGLE OF
THE DUCAL PALACE
Drawn by Ruskin in 1869

TREATMENT OF ORNAMENT

We now know where we are to look for subjects of decoration. The next question is, as the reader must remember, how to treat or express these subjects.

There are evidently two branches of treatment: the first being the expression, or rendering to the eye and mind, of the thing itself; and the second, the arrangement of the things so expressed: both of these being quite distinct from the placing of the ornament in proper parts of the building. For instance, suppose we take a vine-leaf for our subject. The first question is, how to cut the vine-leaf? Shall we cut its ribs and notches on the edge, or only its general outline? and so on. Then, how to arrange the vine-leaves when we have them; whether symmetrically, or at random; or unsymmetrically, yet within certain limits? All these I call questions of treatment. Then, whether the vine-leaves so arranged are to be set on the capital of a pillar or on its shaft, I call a question of place.

So, then, the questions of mere treatment are twofold: how to express, and how to arrange.

If, to produce a good or beautiful ornament, it were only necessary to produce a perfect piece of sculpture, and if a well-cut group of flowers or animals were indeed an ornament wherever it might be placed, the work of the architect would be comparatively easy. Sculpture and architecture would become separate arts: and the architect would order so many pieces of such subject and size as he needed, without troubling himself with any questions but those of disposition and proportion. But

this is not so. *No perfect piece either of painting or sculpture is an architectural ornament at all,* except in that vague sense in which any beautiful thing is said to ornament the place it is in. Thus we say that pictures ornament a room; but we should not thank an architect who told us that his design, to be complete, required a Titian to be put in one corner of it, and a Velasquez in the other; and it is just as unreasonable to call perfect sculpture, niched in, or encrusted on a building, a portion of the ornament of that building, as it would be to hang pictures by way of ornament on the outside of it. It is very possible that the sculptured work may be harmoniously associated with the building, or the building executed with reference to it; but in this latter case the architecture is subordinate to the sculpture, as in the Medicean chapel, and I believe also in the Parthenon. And so far from the perfection of the work conducing to its ornamental purpose, we may say, with entire security, that its perfection, in some degree, unfits it for its purpose, and that no absolutely complete sculpture can be decoratively right. We have a familiar instance in the flower-work of St. Paul's, which is probably, in the abstract, as perfect flower sculpture as could be produced at the time; and which is just as rational an ornament of the building as so many valuable Van Huysums, framed and glazed, and hung up over each window.

The especial condition of true ornament is, that it be beautiful in its place, and nowhere else, and that it aid the effect of every portion of the building over which it has influence; that it does not, by its richness, make other parts bald, or by its delicacy, make other parts coarse. Every one of its qualities has reference to its place and use: *and it is fitted for its service by what would be faults and deficiencies if it had no special duty.*

Next we have to consider that which is required when incompleteness or simplicity of execution necessary in architectural ornament is referred to the sight, and the various modifications of treatment which are rendered necessary by the variation of its distance from the eye. I say necessary: not merely

expedient or economical. It is foolish to carve what is to be seen forty feet off with the delicacy which the eye demands within two yards ; not merely because such delicacy is lost in the distance, but because it is a great deal worse than lost :—the delicate work has actually worse effect in the distance than rough work. This is a fact well known to painters, and, for the most part, acknowledged by the critics of painting, namely, that there is a certain distance for which a picture is painted ; and that the finish, which is delightful if that distance be small, is actually injurious if the distance be great : and, moreover, that there is a particular method of handling which none but consummate artists reach, which has its effect at the intended distance, and is altogether hieroglyphical and unintelligible at any other. This, I say, is acknowledged in painting, but it is not practically acknowledged in architecture ; nor until my attention was specially directed to it, had I myself any idea of the care with which this great question was studied by the mediæval architects. On my first careful examination of the capitals of the upper arcade of the Ducal Palace at Venice, I was induced, by their singular inferiority of workmanship, to suppose them posterior to those of the lower arcade. It was not till I discovered that some of those which I thought the worst above, were the best when seen from below, that I obtained the key to this marvellous system of adaptation ; a system which I afterwards found carried out in every building of the great times which I had opportunity of examining.

There are two distinct modes in which this adaptation is effected. In the first, the same designs which are delicately worked when near the eye, are rudely cut, and have far fewer details when they are removed from it. In this method it is not always easy to distinguish economy from skill, or slovenliness from science. But, in the second method, a different kind of design is adopted, composed of fewer parts and of simpler lines, and this is cut with exquisite precision. This is of course the higher method, and the more satisfactory proof of purpose ; but

an equal degree of imperfection is found in both kinds when they are seen close : in the first, a bald execution of a perfect design ; in the second, a baldness of design with perfect execution. And in these very imperfections lies the admirableness of the ornament.

Such are the main principles to be observed in the adaptation of ornament to the sight. We have lastly to inquire by what method, and in what quantities, the ornament, thus adapted to mental contemplation, and prepared for its physical position, may most wisely be arranged. The system of creation is one in which " God's creatures leap not, but express a feast, where all the guests sit close, and nothing wants."[1] It is also a feast where there is nothing redundant. So, then, in distributing our ornament, there must never be any sense of gap or blank, neither any sense of there being a single member, or fragment of a member, which could be spared. Whatever has nothing to do, whatever could go without being missed, is not ornament ; it is deformity and encumbrance. Away with it. And, on the other hand, care must be taken either to diffuse the ornament which we permit, in due relation over the whole building, or so to concentrate it, as never to leave a sense of its having got into knots, and curdled upon some points, and left the rest of the building whey. It is very difficult to give the rules, or analyse the feelings, which should direct us in this matter : for some shafts may be carved and others left unfinished, and that with advantage ; some windows may be jewelled like Aladdin's, and one left plain, and still with advantage ; the door or doors, or a single turret, or the whole western façade of a church, or the apse or transept, may be made special subjects of decoration, and the rest left plain, and still sometimes with advantage. But in all such cases there is either sign of the desire of rather doing some portion of the building as we would have it, and leaving the rest plain, than doing the whole imperfectly ; or else there is choice made of some important feature, to which, as more

[1] From *The Temple* by George Herbert. Ed.

honourable than the rest, the decoration is confined. The evil is when, without system, and without preference of the nobler members, the ornament alternates between sickly luxuriance and sudden blandness. In many of our Scotch and English abbeys, especially Melrose, this is painfully felt ; but the worst instance I have ever seen is the window in the side of the arch[1] under the Wellington statue, next St. George's Hospital. In the first place, a window has no business there at all ; in the second, the bars of the window are not the proper place for decoration, especially *wavy* decoration, which one instantly fancies of cast iron ; in the third, the richness of the ornament is a mere patch and eruption upon the wall, and one hardly knows whether to be most irritated at the affectation of severity in the rest, or at the vain luxuriance of the dissolute parallelogram.

Finally, as regards quantity of ornament, I have already said, again and again, you cannot have too much if it be good ; that is, if it be thoroughly united and harmonised by the laws hitherto insisted upon. But you may easily have too much, if you have more than you have sense to manage. For with every added order of ornament increases the difficulty of discipline. It is exactly the same as in war ; you cannot, as an abstract law, have too many soldiers, but you may easily have more than the country is able to sustain, or than your generalship is competent to command. And every regiment which you cannot manage will, on the day of battle, be in your way, and encumber the movements it is not in disposition to sustain.

As an architect, therefore, you are modestly to measure your capacity of governing ornament. Remember, its essence,—its being ornament at all, consists in its being governed. Lose your authority over it, let it command you, or lead you, or dictate to you in any wise, and it is an offence, an incumbrance, and a dishonour. And it is always ready to do this ; wild to get the bit in its teeth, and rush forth on its own devices. Measure,

[1] Removed to the end of Constitution Hill in 1883 ; the statue of Wellington was removed to Aldershot. Ed.

therefore, your strength; and as long as there is no chance of mutiny, add soldier to soldier, battalion to battalion; but be assured that all are heartily in the cause, and that there is not one of whose position you are ignorant, or whose service you could spare.

And now come with me, for I have kept you too long from your gondola: come with me, on an autumnal morning, through the dark gates of Padua, and let us take the broad road leading towards the East.

It lies level, for a league or two, between its elms, and vine festoons full laden, their thin leaves veined into scarlet hectic, and their clusters deepened into gloomy blue; then mounts an embankment above the Brenta, and runs between the river and the broad plain, which stretches to the north in endless lines of mulberry and maize. The Brenta flows slowly, but strongly; a muddy volume of yellowish-grey water, that neither hastens nor slackens, but glides heavily between its monotonous banks, with here and there a short, babbling eddy twisted for an instant into its opaque surface, and vanishing, as if something had been dragged into it and gone down. Dusty and shadeless, the road fares along the dyke on its northern side; and the tall white tower of Dolo is seen trembling in the heat mist far away, and never seems nearer than it did at first. Presently, you pass one of the much-vaunted "villas on the Brenta:" a glaring, spectral shell of brick and stucco, its windows with painted architraves like picture-frames, and a court-yard paved with pebbles in front of it, all burning in the thick glow of the feverish sunshine, but fenced from the high road, for magnificence' sake, with goodly posts and chains; then another, of Kew Gothic, with Chinese variations, painted red and green; a third composed for the greater part of dead wall, with fictitious windows painted upon it, each with a pea-green blind, and classical architrave in bad perspective; and a fourth, with stucco figures set on the top of its garden wall: some antique, like the kind to be seen at the

corner of the New Road,[1] and some of clumsy grotesque dwarfs, with fat bodies and large boots. This is the architecture to which her studies of the Renaissance have conducted modern Italy.

The sun climbs steadily, and warms into intense white the walls of the little piazza of Dolo, where we change horses. Another dreary stage among the now divided branches of the Brenta, forming irregular and half-stagnant canals ; with one or two more villas on the other side of them, but these of the old Venetian type, which we may have recognised before at Padua, and sinking fast into utter ruin, black, and rent, and lonely, set close to the edge of the dull water, with what were once small gardens beside them, kneaded into mud, and with blighted fragments of gnarled hedges and broken stakes for their fencing ; and here and there a few fragments of marble steps, which have once given them graceful access from the water's edge, now setting into the mud in broken joints, all aslope, and slippery with green weed. At last the road turns sharply to the north, and there is an open space, covered with bent grass, on the right of it : but do not look that way.

Five minutes more, and we are in the upper room of the little inn at Mestre, glad of a moment's rest in shade. The table is (always, I think) covered with a cloth of nominal white and perennial grey, with plates and glasses at due intervals, and small loaves of a peculiar white bread, made with oil, and more like knots of flour than bread. The view from its balcony is not cheerful : a narrow street, with a solitary brick church and barren campanile on the other side of it ; and some conventual buildings, with a few crimson remnants of fresco about their windows : and, between them and the street, a ditch with some slow current in it, and one or two small houses beside it, one with an arbour of roses at its door, as in an English tea-garden ; the air, however, about us having in it nothing of roses, but a close smell of garlic and crabs, warmed by the smoke of various

[1] Euston Road. Ed.

stands of hot chestnuts. There is much vociferation also going on beneath the window respecting certain wheelbarrows which are in rivalry for our baggage; we appease their rivalry with our best patience, and follow them down the narrow street.

We have but walked some two hundred yards when we come to a low wharf or quay at the extremity of a canal, with long steps on each side down to the water, which latter we fancy for an instant has become black with stagnation; another glance undeceives us,—it is covered with the black boats of Venice. We enter one of them, rather to try if they be real boats or not, than with any definite purpose, and glide away; at first feeling as if the water were yielding continually beneath the boat and letting her sink into soft vacancy. It is something clearer than any water we have seen lately, and of a pale green; the banks only two or three feet above it, of mud and rank grass, with here and there a stunted tree; gliding swiftly past the small casement of the gondola, as if they were dragged by upon a painted scene.

Stroke by stroke, we count the plunges of the oar, each heaving up the side of the boat slightly as her silver beak shoots forward. We lose patience, and extricate ourselves from the cushions: the sea air blows keenly by, as we stand leaning on the roof of the floating cell. In front, nothing to be seen but long canal and level bank; to the west, the tower of Mestre is lowering fast, and behind it there have risen purple shades, of the colour of dead rose-leaves, all round the horizon, feebly defined against the afternoon sky,—the Alps of Bassano. Forward still: the endless canal bends at last, and then breaks into intricate angles about some low bastions, now torn to pieces and staggering in ugly rents towards the water,—the bastions of the fort of Malghera. Another turn, and another perspective of canal; but not interminable. The silver beak cleaves it fast,— it widens: the rank grass of the banks sinks lower, and lower, and at last dies in tawny knots along an expanse of weedy shore. Over it, on the right, but a few years back, we might have seen the lagoon stretching to the horizon, and the warm southern sky

bending over Malamocco to the sea. Now we can see nothing but what seems a low and monotonous dockyard wall, with flat arches to let the tide through it;—this is the railroad bridge, conspicuous above all things. But at the end of those dismal arches there rises, out of the wide water, a struggling line of low and confused brick buildings, which, but for the many towers which are mingled among them, might be the suburbs of an English manufacturing town. Four or five domes, pale, and apparently at a greater distance, rise over the centre of the line; but the object which first catches the eye is a sullen cloud of black smoke brooding over the northern half of it, and which issues from the belfry of a church.

It is VENICE.

BOOK TWO

The Byzantine Period

THE THRONE

IN THE olden days of travelling, now to return no more, in which distance could not be vanquished without toil, but in which that toil was rewarded, partly by the power of deliberate survey of the countries through which the journey lay, and partly by the happiness of the evening hours, when from the top of the last hill he had surmounted, the traveller beheld the quiet village where he was to rest, scattered among the meadows beside its valley stream; or, from the long hoped for turn in the dusty perspective of the causeway, saw, for the first time, the towers of some famed city, faint in the rays of sunset hours of peaceful and thoughtful pleasure, for which the rush of the arrival in the railway station is perhaps not always, or to all men, an equivalent, —in those days, I say, when there was something more to be anticipated and remembered in the first aspect of each successive halting-place, than a new arrangement of glass roofing and iron girder, there were few moments of which the recollection was more fondly cherished by the traveller, than that which, as I endeavoured to describe in the close of the last chapter, brought him within sight of Venice, as his gondola shot into the open

lagoon from the canal of Mestre. Not but that the aspect of the city itself was generally the source of some slight disappointment, for, seen in this direction, its buildings are far less characteristic than those of the other great towns of Italy ; but this inferiority was partly disguised by distance, and more than atoned for by the strange rising of its walls and towers out of the midst, as it seemed, of the deep sea, for it was impossible that the mind or the eye could at once comprehend the shallowness of the vast sheet of water which stretched away in leagues of rippling lustre to the north and south, or trace the narrow line of islets bounding it to the east. The salt breeze, the white moaning sea-birds, the masses of black weed separating and disappearing gradually, in knots of heaving shoal, under the advance of the steady tide, all proclaimed it to be indeed the ocean on whose bosom the great city rested so calmly ; not such blue, soft, lake-like ocean as bathes the Neapolitan promontories, or sleeps beneath the marble rocks of Genoa, but a sea with the bleak power of our own northern waves, yet subdued into a strange spacious rest, and changed from its angry pallor into a field of burnished gold, as the sun declined behind the belfry tower of the lonely island church, fitly named " St. George of the Seaweed." As the boat drew nearer to the city, the coast which the traveller had just left sank behind him into one long, low, sad-coloured line, tufted irregularly with brushwood and willows : but, at what seemed its northern extremity, the hills of Arqua rose in a dark cluster of purple pyramids, balanced on the bright mirage of the lagoon ; two or three smooth surges of inferior hill extended themselves about their roots, and beyond these, beginning with the craggy peaks above Vicenza, the chain of the Alps girded the whole horizon to the north—a wall of jagged blue, here and there showing through its clefts a wilderness of misty precipices, fading far back into the recesses of Cadore, and itself rising and breaking away eastward, where the sun struck opposite upon its snow, into mighty fragments of peaked light, standing up behind the barred clouds of evening, one after another,

countless, the crown of the Adrian Sea, until the eye turned back from pursuing them, to rest upon the nearer burning of the campaniles of Murano, and on the great city, where it magnified itself along the waves, as the quick silent pacing of the gondola drew nearer and nearer. And at last, when its walls were reached, and the outmost of its untrodden streets was entered, not through towered gate or guarded rampart, but as a deep inlet between two rocks of coral in the Indian sea ; when first upon the traveller's sight opened the long ranges of columned palaces,—each with its black boat moored at the portal,—each with its image cast down, beneath its feet, upon that green pavement which every breeze broke into new fantasies of rich tessellation ; when first, at the extremity of the bright vista, the shadowy Rialto threw its colossal curve slowly forth from behind the palace of the Camerlenghi ; that strange curve, so delicate, so adamantine, strong as a mountain cavern, graceful as a bow just bent ; when first, before its moonlike circumference was all risen, the gondolier's cry, " Ah ! Stali," struck sharp upon the ear, and the prow turned aside under the mighty cornices that half met over the narrow canal, where the splash of the water followed close and loud, ringing along the marble by the boat's side ; and when at last that boat darted forth upon the breadth of silver sea, across which the front of the Ducal palace, flushed with its sanguine veins, looks to the snowy dome of Our Lady of Salvation, it was no marvel that the mind should be so deeply entranced by the visionary charm of a scene so beautiful and so strange, as to forget the darker truths of its history and its being. Well might it seem that such a city had owed her existence rather to the rod of the enchanter, than the fear of the fugitive ; that the waters which encircled her had been chosen for the mirror of her state, rather than the shelter of her nakedness ; and that all which in nature was wild or merciless,—Time and Decay, as well as the waves and tempests, —had been won to adorn her instead of to destroy, and might still spare, for ages to come, that beauty which seemed to have

fixed for its throne the sands of the hour-glass as well as of the sea.

And although the last few eventful years, fraught with change to the face of the whole earth, have been more fatal in their influence on Venice than the five hundred that preceded them; though the noble landscape of approach to her can now be seen no more, or seen only by a glance, as the engine slackens its rushing on the iron line; and though many of her palaces are for ever defaced, and many in desecrated ruins, there is still so much of magic in her aspect, that the hurried traveller, who must leave her before the wonder of that first aspect has been worn away, may still be led to forget the humility of her origin, and to shut his eyes to the depth of her desolation. They, at least, are little to be envied, in whose hearts the great charities of the imagination lie dead, and for whom the fancy has no power to repress the importunity of painful impressions, or to raise what is ignoble, and disguise what is discordant, in a scene so rich in its remembrances, so surpassing in its beauty. But for this work of the imagination there must be no permission during the task which is before us. The impotent feelings of romance, so singularly characteristic of this century, may indeed gild, but never save, the remains of those mightier ages to which they are attached like climbing flowers; and they must be torn away from the magnificent fragments, if we would see them as they stood in their own strength. Those feelings, always as fruitless as they are fond, are in Venice not only incapable of protecting, but even of discerning, the objects to which they ought to have been attached. The Venice of modern fiction and drama is a thing of yesterday, a mere efflorescence of decay, a stage dream which the first ray of daylight must dissipate into dust. No prisoner, whose name is worth remembering, or whose sorrow deserved sympathy, ever crossed that " Bridge of Sighs," which is the centre of the Byronic ideal of Venice; no great merchant of Venice ever saw that Rialto under which the traveller now passes with breathless interest: the statue which Byron makes

Faliero address as of one of his great ancestors was erected to a
soldier of fortune a hundred and fifty years after Faliero's death ;
and the most conspicuous parts of the city have been so entirely
altered in the course of the last three centuries, that if Henry
Dandolo or Francis Foscari could be summoned from their
tombs, and stood each on the deck of his galley at the entrance
of the Grand Canal, that renowned entrance, the painters
favourite subject, the novelist's favourite scene, where the water
first narrows by the steps of the church of La Salute,—the mighty
Doges would not know in what part of the world they stood,
would literally not recognise one stone of the great city, for
whose sake, and by whose ingratitude, their grey hairs had been
brought down with bitterness to the grave. The remains of *their*
Venice lie hidden behind the cumbrous masses which were the
delight of the nation in its dotage ; hidden in many a grass-
grown court, and silent pathway, and lightless canal, where the
slow waves have sapped their foundations for five hundred years,
and must soon prevail over them for ever. It must be our task
to glean and gather them forth, and restore out of them some
faint image of the lost city ; more gorgeous a thousandfold than
that which now exists, yet not created in the daydream of the
prince, nor by the ostentation of the noble, but built by iron
hands and patient hearts, contending against the adversity of
nature and the fury of man, so that its wonderfulness cannot be
grasped by the indolence of imagination, but only after frank
inquiry into the true nature of that wild and solitary scene,
whose restless tides and trembling sands did indeed shelter the
birth of the city, but long denied her dominion.

I will not tax the reader by insisting on the singular depression
of the surface of Lombardy, which appears for many centuries to
have taken place steadily and continually ; the main fact with
which we have to do is the gradual transport, by the Po and its
great collateral rivers, of vast masses of the finer sediment which
are at once thrown down as they enter the sea, forming a vast

belt of low land along the eastern coast of Italy. The powerful
stream of the Po of course builds forward the fastest ; on each
side of it, north and south, there is a tract of marsh, fed by more
feeble streams, and less liable to rapid change than the delta of
the central river. In one of these tracts is built RAVENNA, and
in the other VENICE.

What circumstances directed the peculiar arrangement of this
great belt of sediment in the earliest times, it is not here the
place to inquire. It is enough for us to know that from the
mouths of the Adige to those of the Piave there stretches, at a
variable distance of from three to five miles from the actual
shore, a bank of sand, divided into long islands by narrow
channels of sea. The space between this bank and the true shore
consists of the sedimentary deposits from these and other rivers,
a great plain of calcareous mud, covered, in the neighbourhood
of Venice, by the sea at high water, to the depth in most places
of a foot or a foot and a half, and nearly everywhere exposed
at low tide, but divided by an intricate network of narrow and
winding channels, from which the sea never retires. In some
places, according to the run of the currents, the land has risen
into marshy islets, consolidated, some by art, and some by time,
into ground firm enough to be built upon, or fruitful enough
to be cultivated : in others, on the contrary, it has not reached
the sea level ; so that, at the average low water, shallow lakelets
glitter among its irregularly exposed fields of seaweed. In the
midst of the largest of these, increased in importance by the
confluence of several large river channels towards one of the
openings in the sea bank, the city of Venice itself is built, on a
crowded cluster of islands ; the various plots of higher ground
which appear to the north and south of this central cluster,
have at different periods been also thickly inhabited, and now
bear, according to their size, the remains of cities, villages, or
isolated convents and churches, scattered among spaces of open
ground, partly waste and encumbered by ruins, partly under
cultivation for the supply of the metropolis.

The average rise and fall of the tide is about three feet (varying considerably with the seasons); but this fall, on so flat a shore, is enough to cause continual movement in the waters, and in the main canals to produce a reflux which frequently runs like a mill stream. At high water no land is visible for many miles to the north or south of Venice, except in the form of small islands crowned with towers or gleaming with villages : there is a channel, some three miles wide, between the city and the mainland, and some mile and a half wide between it and the sandy breakwater called the Lido, which divides the lagoon from the Adriatic, but which is so low as hardly to disturb the impression of the city's having been built in the midst of the ocean, although the secret of its true position is partly, yet not painfully, betrayed by the clusters of piles set to mark the deep-water channels, which undulate far away in spotty chains like the studded backs of huge sea-snakes, and by the quick glittering of the crisped and crowded waves that flicker and dance before the strong winds upon the unlifted level of the shallow sea. But the scene is widely different at low tide. A fall of eighteen or twenty inches is enough to show ground over the greater part of the lagoon ; and at the complete ebb the city is seen standing in the midst of a dark plain of sea-weed, of gloomy green, except only where the larger branches of the Brenta and its associated streams converge towards the port of the Lido. Through this salt and sombre plain the gondola and the fishing-boat advance by tortuous channels, seldom more than four or five feet deep, and often so choked with slime that the heavier keels furrow the bottom till their crossing tracks are seen through the clear sea water like the ruts upon a wintry road, and the oar leaves blue gashes upon the ground at every stroke, or is entangled among the thick weed that fringes the banks with the weight of its sullen waves, leaning to and fro upon the uncertain sway of the exhausted tide. The scene is often profoundly oppressive, even at this day, when every plot of higher ground bears some fragment of fair building : but, in order to know what it was

once, let the traveller follow in his boat at evening the windings of some unfrequented channel far into the midst of the melancholy plain ; let him remove, in his imagination, the brightness of the great city that still extends itself in the distance, and the walls and towers from the islands that are near ; and so wait, until the bright investiture and sweet warmth of the sunset are withdrawn from the waters, and the black desert of their shore lies in its nakedness beneath the night, pathless, comfortless, infirm, lost in dark languor and fearful silence, except where the salt runlets plash into the tideless pools, or the sea-birds flit from their margins with a questioning cry; and he will be enabled to enter in some sort into the horror of heart with which this solitude was anciently chosen by man for his habitation. They little thought, who first drove the stakes into the sand, and strewed the ocean reeds for their rest, that their children were to be the princes of that ocean, and their palaces its pride ; and yet, in the great natural laws that rule that sorrowful wilderness, let it be remembered what strange preparation had been made for the things which no human imagination could have foretold, and how the whole existence and fortune of the Venetian nation were anticipated or compelled, by the setting of those bars and doors to the rivers and the sea. Had deeper currents divided their islands, hostile navies would again and again have reduced the rising city into servitude ; had stronger surges beaten their shores, all the richness and refinement of the Venetian architecture must have been exchanged for the walls and bulwarks of an ordinary seaport. Had there been no tide, as in other parts of the Mediterranean, the narrow canals of the city would have become noisome, and the marsh in which it was built pestiferous. Had the tide been only a foot or eighteen inches higher in its rise, the water-access to the doors of the palaces would have been impossible : even as it is, there is sometimes a little difficulty, at the ebb, in landing without setting foot upon the lower and slippery steps ; and the highest tides sometimes enter the courtyards, and overflow the entrance halls.

Eighteen inches more of difference between the level of the flood and ebb would have rendered the doorsteps of every palace, at low water, a treacherous mass of weeds and limpets, and the entire system of water-carriage for the higher classes, in their easy and daily intercourse, must have been done away with. The streets of the city would have been widened, its network of canals filled up, and all the peculiar character of the place and the people destroyed.

TORCELLO

SEVEN miles to the north of Venice, the banks of sand, which near the city rise little above low-water mark, attain by degrees a higher level, and knit themselves at last into fields of salt morass, raised here and there into shapeless mounds, and intercepted by narrow creeks of sea. One of the feeblest of these inlets, after winding for some time among buried fragments of masonry, and knots of sunburnt weeds whitened with webs of fucus, stays itself in an utterly stagnant pool beside a plot of greener grass covered with ground ivy and violets. On this mound is built a rude brick campanile, of the commonest Lombardic type, which if we ascend towards evening (and there are none to hinder us, the door of its ruinous staircase swinging idly on its hinges), we may command from it one of the most notable scenes in this wide world of ours. Far as the eye can reach, a waste of wild sea moor, of a lurid ashen grey; not like our northern moors with their jet-black pools and purple heath, but lifeless, the colour of sackcloth, with the corrupted sea-water soaking through the roots of its acrid weeds, and gleaming hither and thither through its snaky channels. No gathering of fantastic mists, nor coursing of clouds across it; but melancholy clearness of space in the warm sunset, oppressive, reaching to the horizon of its level gloom. To the very horizon, on the northeast; but, to the north and west, there is a blue line of higher land along the border of it, and above this, but farther back, a misty band of mountains, touched with snow. To the east, the paleness and roar of the Adriatic, louder at momentary intervals

as the surf breaks on the bars of sand ; to the south, the widening branches of the calm lagoon, alternately purple and pale green, as they reflect the evening clouds or twilight sky ; and almost beneath our feet, on the same field which sustains the tower we gaze from, a group of four buildings, two of them little larger than cottages (though built of stone, and one adorned by a quaint belfry), the third an octagonal chapel, of which we can see but little more than the flat red roof with its rayed tiling, the fourth, a considerable church with nave and aisles, but of which, in like manner, we can see little but the long central ridge and lateral slopes of roof, which the sunlight separates in one glowing mass from the green field beneath and grey moor beyond. There are no living creatures near the buildings, nor any vestige of village or city round about them. They lie like a little company of ships becalmed on a far-away sea.

Then look farther to the south. Beyond the widening branches of the lagoon, and rising out of the bright lake into which they gather, there are a multitude of towers, dark, and scattered among square-set shapes of clustered palaces, a long and irregular line fretting the southern sky.

Mother and daughter, you behold them both in their widowhood,—TORCELLO, and VENICE.

Let us go down into that little space of meadow land. The inlet which runs nearest to the base of the campanile is not that by which Torcello is commonly approached. Another, somewhat broader, and overhung by alder copse, winds out of the main channel of the lagoon up to the very edge of the little meadow which was once the Piazza of the city, and there, stayed by a few grey stones which present some semblance of a quay, forms its boundary at one extremity. Hardly larger than an ordinary English farmyard, and roughly enclosed on each side by broken palings and hedges of honeysuckle and briar, the narrow field retires from the water's edge, traversed by a scarcely traceable footpath, for some forty or fifty paces, and then expanding into the form of a small square, with buildings on

three sides of it, the fourth being that which opens to the water. Two of these, that on our left and that in front of us as we approach from the canal, are so small that they might well be taken for the outhouses of the farm, though the first is a conventual building, and the other aspires to the title of the " Palazzo publico," both dating as far back as the beginning of the fourteenth century ; the third, the octagonal church of Santa Fosca, is far more ancient than either, yet hardly on a larger scale. Though the pillars of the portico which surrounds it are of pure Greek marble, and their capitals are enriched with delicate sculpture, they, and the arches they sustain, together only raise the roof to the height of a cattle-shed ; and the first strong impression which the spectator receives from the whole scene is, that whatever sin it may have been which has on this spot been visited with so utter a desolation, it could not at least have been ambition. Nor will this impression be diminished as we approach, or enter, the larger church, to which the whole group of building is subordinate. It has evidently been built by men in flight and distress, who sought in the hurried erection of their island church such a shelter for their earnest and sorrowful worship as, on the one hand, could not attract the eyes of their enemies by its splendour, and yet, on the other, might not awaken too bitter feelings by its contrast with the churches which they had seen destroyed. The exterior is absolutely devoid of decoration, with the exception only of the western entrance and the lateral door, of which the former has carved side posts and architrave, and the latter, crosses of rich sculpture ; while the massy stone shutters of the windows, turning on huge rings of stone, which answer the double purpose of stanchions and brackets, cause the whole building rather to resemble a refuge from Alpine storm than the cathedral of a populous city ; and, internally, the two solemn mosaics of the eastern and western extremities,—one representing the Last Judgment, the other the Madonna, her tears falling as her hands are raised to bless,—and the noble range of pillars which enclose the space between,

terminated by the high throne for the pastor and the semicircular raised seats for the superior clergy, are expressive at once of the deep sorrow and the sacred courage of men who had no home left them upon earth, but who looked for one to come, of men "persecuted but not forsaken, cast down but not destroyed."

I am not aware of any other early church in Italy which has this peculiar expression in so marked a degree; and it is so consistent with all that Christian architecture ought to express in every age that I would rather fix the mind of the reader on this general character than on the separate details, however interesting, of the architecture itself. I shall therefore examine these only so far as is necessary to give a clear idea of the means by which the peculiar expression of the building is attained.

The church is built on the usual plan of the Basilica, that is to say, its body divided into a nave and aisles by two rows of massive shafts, the roof of the nave being raised high above the aisles by walls sustained on two ranks of pillars, and pierced with small arched windows. At Torcello the aisles are also lighted in the same manner, and the nave is nearly twice their breadth. The capitals of all the great shafts are of white marble, and are among the best I have ever seen, as examples of perfectly calculated effect from every touch of the chisel; every one of them is different in design and their variations are as graceful as they are fanciful.

It is not, however, to be expected that either the mute language of early Christianity (however important a part of the expression of the building at the time of its erection), or the delicate fancies of the Gothic leafage springing into new life, should be read, or perceived, by the passing traveller who has never been taught to expect anything in architecture except five orders: yet he can hardly fail to be struck by the simplicity and dignity of the great shafts themselves; by the frank diffusion of light, which prevents their serenity from becoming oppressive; by the delicate forms and lovely carving of the pulpit and chancel screen; and, above all, by the peculiar aspect of the eastern

extremity of the church, which, instead of being withdrawn, as in later cathedrals, into a chapel dedicated to the Virgin, or contributing by the brilliancy of its windows to the splendour of the altar, and theatrical effect of the ceremonies performed there, is a simple and stern semicircular recess, filled beneath by three ranks of seats, raised one above the other, for the bishop and presbyters, that they might watch as well as guide the devotions of the people, and discharge literally in the daily service the functions of bishops or *overseers* of the flock of God.

Let us consider a little each of these characters in succession ; and first what is very peculiar to this church, its luminousness. This perhaps strikes the traveller more from its contrast with the excessive gloom of the Church of St. Mark's ; but it is remarkable when we compare the Cathedral of Torcello with any of the contemporary basilicas in South Italy or Lombardic churches in the North. St. Ambrogio at Milan, St. Michele at Pavia, St. Zeno at Verona, St. Frediano at Lucca, St. Miniato at Florence, are all like sepulchral caverns compared with Torcello, where the slightest details of the sculptures and mosaics are visible, even when twilight is deepening. And there is something especially touching in our finding the sunshine thus freely admitted into a church built by men in sorrow. They did not need the darkness ; they could not perhaps bear it. There was fear and depression upon them enough, without a material gloom. They sought for comfort in their religion, for tangible hopes and promises, not for threatenings or mysteries ; and though the subjects chosen for the mosaics on the walls are of the most solemn character, there are no artificial shadows cast upon them, nor dark colours used in them : all is fair and bright, and intended evidently to be regarded in hopefulness, and not with terror.

Nothing is more remarkable than the finish and beauty of all the portions of the building, which seem to have been actually executed for the place they occupy in the present structure ; the rudest are those which they brought with them from the main-

land, the best and most beautiful, those which appear to have been carved for their island church : of these, the new capital, and the exquisite panel ornaments of the chancel screen, are the most conspicuous ; the latter form a low wall across the church between six small shafts and serve to enclose a space raised two steps above the level of the nave, destined for the singers. The bas-reliefs on this low screen are groups of peacocks and lions, two face to face on each panel, rich and fantastic beyond description, though not expressive of very accurate knowledge either of leonine or pavonine forms. And it is not until we pass to the back of the stair of the pulpit, which is connected with the northern extremity of this screen, that we find evidence of the haste with which the church was constructed.

The pulpit, however, is not among the least noticeable of its features. It is sustained on four small detached shafts between the two pillars at the north side of the screen ; both pillars and pulpit studiously plain, while the staircase which ascends to it is a compact mass of masonry faced by carved slabs of marble ; the parapet of the staircase being also formed of solid blocks like paving-stones, lightened by rich, but not deep exterior carving. Now these blocks, or at least those which adorn the staircase towards the aisle, have been brought from the mainland ; and, being of size and shape not easily to be adjusted to the proportions of the stair, the architect has cut out of them pieces of the size he needed, utterly regardless of the subject or symmetry of the original design. The pulpit is not the only place where this rough procedure has been permitted ; at the lateral door of the church are two crosses, cut out of slabs of marble, formerly covered with rich sculpture over the whole surfaces, of which portions are left on the surface of the crosses ; the lines of the original design being, of course, just as arbitrarily cut by the incisions between the arms, as the patterns upon a piece of silk which has been shaped anew. The fact is, that in all early Romanesque work, large surfaces are covered with sculpture for the sake of enrichment only ; sculpture which indeed had always

meaning, because it was easier for the sculptor to work with some chain of thought to guide his chisel, than without any ; but it was not always intended, or at least not always hoped, that this chain of thought might be traced by the spectator. All that was proposed appears to have been the enrichment of surface, so as to make it delightful to the eye ; and this being once understood, a decorated piece of marble became to the architect just what a piece of lace or embroidery is to a dress-maker, who takes of it such portions as she may require, with little regard to the places where the patterns are divided.

The execution of the rest of the pulpit is studiously simple, and it is in this respect that its design possesses, it seems to me, an interest to the religious spectator greater than he will take in any other portion of the building. It is supported, as I said, on a group of four slender shafts ; itself of a slightly oval form, extending nearly from one pillar of the nave to the next, so as to give the preacher free room for the action of the entire person, which always gives an unaffected impressiveness to the eloquence of the southern nations. In the centre of its curved front, a small bracket and detached shaft sustain the projection of a narrow marble desk (occupying the place of a cushion in a modern pulpit), which is hollowed out into a shallow curve on the upper surface, leaving a ledge at the bottom of the slab, so that a book laid upon it, or rather into it, settles itself there, opening as if by instinct, but without the least chance of slipping to the side, or in any way moving beneath the preacher's hands. Six balls, or rather almonds, of purple marble veined with white are set round the edge of the pulpit, and form its only decoration. Perfectly graceful, but severe and almost cold in its simplicity, built for permanence and service, so that no single member, no stone of it, could be spared, and yet all are firm and uninjured as when they were first set together, it stands in venerable contrast both with the fantastic pulpits of mediæval cathedrals and with the rich furniture of those of our modern churches.

The severity which is so marked in the pulpit at Torcello is

still more striking in the raised seats and episcopal throne which occupy the curve of the apse. The arrangement at first somewhat recalls to the mind that of the Roman amphitheatres ; the flight of steps which lead up to the central throne divides the curve of the continuous steps or seats (it appears in the first three ranges questionable which were intended, for they seem too high for the one, and too low and close for the other), exactly as in an amphitheatre the stairs for access intersect the sweeping ranges of seats. But in the very rudeness of this arrangement, and especially in the want of all appliances of comfort (for the whole is of marble, and the arms of the central throne are not for convenience, but for distinction, and to separate it more conspicuously from the undivided seats), there is a dignity which no furniture of stalls nor carving of canopies ever could attain.

If the stranger would yet learn in what spirit it was that the dominion of Venice was begun, and in what strength she went forth conquering and to conquer, let him not seek to estimate the wealth of her arsenals or number of her armies, nor look upon the pageantry of her palaces, nor enter into the secrets of her councils ; but let him ascend the highest tier of the stern ledges that sweep round the altar of Torcello, and then, looking as the pilot did of old along the marble ribs of the goodly temple-ship, let him repeople its veined deck with the shadows of its dead mariners, and strive to feel in himself the strength of heart that was kindled within them, when first, after the pillars of it had settled in the sand, and the roof of it had been closed against the angry sky that was still reddened by the fires of their home-steads,—first, within the shelter of its knitted walls, amidst the murmur of the waste of waves and the beating of the wings of the sea-birds round the rock that was strange to them,—rose that ancient hymn, in the power of their gathered voices :

The sea is His, and He made it;
And His hands prepared the dry land.

ST. MARK'S

" And so Barnabas took Mark, and sailed unto Cyprus." If as the shores of Asia lessened upon his sight, the spirit of prophecy had entered into the heart of the weak disciple who had turned back when his hand was on the plough, and who had been judged, by the chiefest of Christ's captains, unworthy thenceforward to go forth with him to the work, how wonderful would he have thought it, that by the lion symbol in future ages he was to be represented among men! How woful, that the war-cry of his name should so often reanimate the rage of the soldier, on those very plains where he himself had failed in the courage of the Christian, and so often dye with fruitless blood that very Cypriot Sea, over whose waves, in repentance and shame, he was following the Son of Consolation!

That the Venetians possessed themselves of his body in the ninth century, there appears no sufficient reason to doubt, nor that it was principally in consequence of their having done so, that they chose him for their patron saint. There exists, however, a tradition that before he went into Egypt he had founded the church at Aquileia, and was thus in some sort the first bishop of the Venetian isles and people.

But whether St. Mark was first bishop of Aquileia or not, St. Theodore was the first patron of the city; nor can he yet be considered as having entirely abdicated his early right, as his statue, standing on a crocodile, still companions the winged lion on the opposing pillar of the piazzetta. A church erected to this Saint is said to have occupied, before the ninth century, the site

of St. Mark's ; and the traveller, dazzled by the brilliancy of the great square, ought not to leave it without endeavouring to imagine its aspect in that early time, when it was a green field, cloister-like and quiet,[1] divided by a small canal, with a line of trees on each side ; and extending between the two churches of St. Theodore and St. Gemanium, as the little piazza of Torcello lies between its "palazzo" and cathedral.

But in the year 813, when the seat of government was finally removed to the Rialto, a Ducal Palace, built on the spot where the present one stands, with a Ducal Chapel beside it, gave a very different character to the Square of St. Mark ; and fifteen years later, the acquisition of the body of the Saint, and its deposition in the Ducal Chapel, perhaps not yet completed, occasioned the investiture of that Chapel with all possible splendour. St. Theodore was deposed from his patronship, and his church destroyed, to make room for the aggrandizement of the one attached to the Ducal Palace, and thenceforward known as " St. Mark's."

This first church was however destroyed by fire, when the Ducal Palace was burned in the revolt against Candiano, in 976. It was partly rebuilt by his successor, Pietro Orseolo, on a larger scale ; and, with the assistance of Byzantine architects, the fabric was carried on under successive Doges for nearly a hundred years; the main building being completed in 1071, but its incrustation with marble not till considerably later. It was consecrated on the 8th of October, 1085.

It was again injured by fire in 1106, but repaired ; and from that time to the fall of Venice there was probably no Doge who did not in some slight degree embellish or alter the fabric, so that few parts of it can be pronounced boldly to be of any given date. Two periods of interference are, however, notable above the rest : the first, that in which the Gothic school had superseded the Byzantine towards the close of the fourteenth century,

[1] St. Mark's Place, "partly covered by turf, and planted with a few trees ; and on account of its pleasant aspect called Brollo or Broglio, that is to say, Garden." The canal passed through it, over which is built the bridge of the Malpassi. Galliciolli, lib. i., cap. viii.

when the pinnacles, upper archivolts, and window traceries were added to the exterior, and the great screen, with various chapels and tabernacle-work, to the interior; the second, when the Renaissance school superseded the Gothic, and the pupils of Titian and Tintoret substituted, over one half of the church, their own compositions for the Greek mosaics with which it was originally decorated; happily, though with no good-will, having left enough to enable us to imagine and lament what they destroyed.

We have seen that the main body of the church may be broadly stated to be of the eleventh century, the Gothic additions of the fourteenth, and the restored mosaics of the seventeenth. There is no difficulty in distinguishing at a glance the Gothic portions from the Byzantine; but there is considerable difficulty in ascertaining how long, during the course of the twelfth and thirteenth centuries, additions were made to the Byzantine church, which cannot be easily distinguished from the work of the eleventh century, being purposely executed in the same manner. Two of the most important pieces of evidence on this point are, a mosaic in the south transept, and another over the northern door of the façade; the first representing the interior, the second the exterior, of the ancient church.

The existing building was consecrated by the Doge Vital Falier. A peculiar solemnity was given to that of consecration, in the minds of the Venetian people, by what appears to have been one of the best arranged and most successful impostures ever attempted. The body of St. Mark had, without doubt, perished in the conflagration of 976; but the revenues of the church depended too much upon the devotion excited by these relics to permit the confession of their loss. The following is the account given by Corner, and believed to this day by the Venetians, of the pretended miracle by which it was concealed.

"After the repairs undertaken by the Doge Orseolo, the place in which the body of the holy Evangelist rested had been

altogether forgotten; so that the Doge Vital Falier was entirely ignorant of the place of the venerable deposit. This was no light affliction, not only to the pious Doge, but to all the citizens and people; so that at last, moved by confidence in the Divine mercy, they determined to implore, with prayer and fasting, the manifestation of so great a treasure, which did not now depend upon any human effort. A general fast being therefore proclaimed, and a solemn procession appointed for the 25th day of June, while the people assembled in the church interceded with God in fervent prayers for the desired boon, they beheld, with as much amazement as joy, a slight shaking in the marbles of a pillar (near the place where the altar of the Cross is now), which, presently falling to the earth, exposed to the view of the rejoicing people the chest of bronze in which the body of the Evangelist was laid."

Of the main facts of this tale there is no doubt. They were embellished afterwards, as usual, by many fanciful traditions; as, for instance, that, when the sarcophagus was discovered, St. Mark extended his hand out of it, with a gold ring on one of the fingers, which he permitted a noble of the Dolfin family to remove. But the fast and the discovery of the coffin, by whatever means effected, are facts; and they are recorded in one of the best-preserved mosaics of the north transept, executed very certainly not long after the event had taken place, closely resembling in its treatment that of the Bayeux tapestry, and showing, in a conventional manner, the interior of the church, as it then was, filled by the people, first in prayer, then in thanksgiving, the pillar standing open before them, and the Doge, in the midst of them, distinguished by his crimson bonnet embroidered with gold, but more unmistakably by the inscription " Dux " over his head, as uniformly is the case in the Bayeux tapestry, and most other pictorial works of the period. The church is, of course, rudely represented, and the two upper stories of it reduced to a small scale in order to form a background to the figures; one of those bold pieces of picture history which

we in our pride of perspective, and a thousand things besides, never dare attempt. We should have put in a column or two, of the real or perspective size, and subdued it into a vague background : the old workman crushed the church together that he might get it all in, up to the cupolas ; and has, therefore, left us some useful notes of its ancient form, though any one who is familiar with the method of drawing employed at the period will not push the evidence too far. The two pulpits are there, however, as they are at this day, and the fringe of mosaic flower-work which then encompassed the whole church, but which modern restorers have destroyed, all but one fragment still left in the south aisle. There is no attempt to represent the other mosaics on the roof, the scale being too small to admit of their being represented with any success ; but some at least of those mosaics had been executed at that period, and their absence in the representation of the entire church is especially to be observed, in order to show that we must not trust to any negative evidence in such works. M. Lazari has rashly concluded that the central archivolt of St. Mark's *must* be posterior to the year 1205, because it does not appear in the representation of the exterior of the church over the northern door ; but he justly observes that this mosaic (which is the other piece of evidence we possess respecting the ancient form of the building) cannot itself be earlier than 1205, since it represents the bronze horses which were brought from Constantinople in that year. And this one fact renders it very difficult to speak with confidence respecting the date of any part of the exterior of St. Mark's ; for we have above seen that it was consecrated in the eleventh century, and yet here is one of its most important exterior decorations assuredly retouched, if not entirely added, in the thirteenth, although its style would have led us to suppose it had been an original part of the fabric. However, for all our purposes, it will be enough for the reader to remember that the earliest parts of the building belong to the eleventh, twelfth, and first part of the thirteenth century ; the Gothic portions to the fourteenth ; some of the

altars and embellishments to the fifteenth and sixteenth; and the modern portion of the mosaics to the seventeenth.

This, however, I only wish him to recollect in order that I may speak generally of the Byzantine architecture of St. Mark's, without leading him to suppose the whole church to have been built and decorated by Greek artists. Its later portions, with the single exception of the seventeenth-century mosaics, have been so dexterously accommodated to the original fabric that the general effect is still that of a Byzantine building.

And now I wish that the reader, before I bring him into St. Mark's Place, would imagine himself for a little time in a quiet English cathedral town, and walk with me to the west front of its cathedral. Let us go together up the more retired street, at the end of which we can see the pinnacles of one of the towers, and then through the low grey gateway, with its battlemented top and small latticed window in the centre, into the inner private-looking road or close, where nothing goes in but the carts of the tradesmen who supply the bishop and the chapter, and where there are little shaven grass-plots, fenced in by neat rails, before old-fashioned groups of somewhat diminutive and excessively trim houses, with little oriel and bay windows, jutting out here and there, and deep wooden cornices and eaves painted cream colour and white, and small porches to their doors in the shape of cockle-shells, or little, crooked, thick, indescribable wooden gables warped a little on one side; and so forward till we come to larger houses, also old-fashioned, but of red brick, and with garden behind them, and fruit walls, which show here and there, among the nectarines, the vestiges of an old cloister arch or shaft, and looking in front on the cathedral square itself, laid out in rigid divisions of smooth grass and gravel walk, yet not uncheerful, especially on the sunny side, where the canons' children are walking with their nurserymaids. And so, taking care not to tread on the grass, we will go along the straight walk to the west front, and there stand for a time, looking up at its deep-pointed porches and the dark places between their pillars

where there were statues once, and where the fragments, here and there, of a stately figure are still left, which has in it the likeness of a king, perhaps indeed a king on earth, perhaps a saintly king long ago in heaven; and so higher and higher up to the great mouldering wall of rugged sculpture and confused arcades, shattered, and grey, and grisly with heads of dragons and mocking fiends, worn by the rain and swirling winds into yet unseemlier shape, and coloured on their stony scales by the deep russet-orange lichen, melancholy gold; and so, higher still, to the bleak towers, so far above that the eye loses itself among the bosses of their traceries, though they are rude and strong, and only sees like a drift of eddying black points, now closing, now scattering, and now settling suddenly into invisible places among the bosses and flowers, the crowd of restless birds that fill the whole square with that strange clangour of theirs, so harsh and yet so soothing, like the cries of birds on a solitary coast between the cliffs and sea.

Think for a little while of that scene, and the meaning of all its small formalisms, mixed with its serene sublimity. Estimate its secluded, continuous, drowsy felicities, and its evidence of the sense and steady performance of such kind of duties as can be regulated by the cathedral clock; and weigh the influence of those dark towers on all who have passed through the lonely square at their feet for centuries, and on all who have seen them rising far away over the wooded plain, or catching on their square masses the last rays of the sunset, when the city at their feet was indicated only by the mist at the bend of the river. And then let us quickly recollect that we are in Venice, and land at the extremity of the Calle Lunga San Moisè,[1] which may be considered as there answering to the secluded street that led us to our English cathedral gateway.

We find ourselves in a paved alley, some seven feet wide where it is widest, full of people, and resonant with cries of

[1] Since 1880, the Calle Lunga XXII Marzo, in commemoration of the declaration of the short-lived Republic in 1848 by Daniele Manin. Ed.

itinerant salesmen,—a shriek in their beginning, and dying away into a kind of brazen ringing, all the worse for its confinement between the high houses of the passage along which we have to make our way. Overhead an inextricable confusion of rugged shutters, and iron balconies and chimney flues pushed out on brackets to save room, and arched windows with projecting sills of Istrian stone, and gleams of green leaves here and there where a fig-tree branch escapes over a lower wall from some inner cortile, leading the eye up to the narrow stream of blue sky high over all. On each side, a row of shops, as densely set as may be, occupying, in fact, intervals between the square stone shafts, about eight feet high, which carry the first floors : intervals of which one is narrow and serves as a door ; the other is, in the more respectable shops, wainscotted to the height of the counter and glazed above, but in those of the poorer tradesmen left open to the ground, and the wares laid on benches and tables in the open air, the light in all cases entering at the front only, and fading away in a few feet from the threshold into a gloom which the eye from without cannot penetrate, but which is generally broken by a ray or two from a feeble lamp at the back of the shop, suspended before a print of the Virgin.

A yard or two farther, we pass the hostelry of the Black Eagle,[1] and glancing as we pass through the square door of marble, deeply moulded, in the outer wall, we see the shadows of its pergola of vines resting on an ancient well, with a pointed shield carved on its side ; and so presently emerge on the bridge and Campo San Moisè, whence to the entrance into St. Mark's Place, called the Bocca di Piazza (mouth of the square), the Venetian character is nearly destroyed, first by the frightful façade of San Moisè and then by the modernising of the shops as they near the piazza, and the mingling with the lower Venetian populace of lounging groups of English and Austrians. We will push fast through them into the shadow of the pillars at the end of the " Bocca di Piazza," and then we forget them all ; for

[1] Now the Bauer Grünwald Hotel. Ed.

between those pillars there opens a great light, and, in the midst
of it, as we advance slowly, the vast tower of St. Mark seems to
lift itself visibly forth from the level field of chequered stones;
and, on each side, the countless arches prolong themselves into
ranged symmetry, as if the rugged and irregular houses that
pressed together above us in the dark alley had been struck back
into sudden obedience and lovely order, and all their rude
casements and broken walls had been transformed into arches
charged with goodly sculpture, and fluted shafts of delicate stone.

And well may they fall back, for beyond those troops of
ordered arches there rises a vision out of the earth, and all the
great square seems to have opened from it in a kind of awe, that
we may see it far away;—a multitude of pillars and white domes,
clustered into a long low pyramid of coloured light; a treasure-
heap, it seems, partly of gold, and partly of opal and mother-of-
pearl, hollowed beneath into five great vaulted porches, ceiled
with fair mosaic, and beset with sculpture of alabaster, clear as
amber and delicate as ivory,—sculpture fantastic and involved,
of palm leaves and lilies, and grapes and pomegranates, and birds
clinging and fluttering among the branches, all twined together
into an endless network of buds and plumes; and in the midst
of it, the solemn forms of angels, sceptred, and robed to the feet,
and leaning to each other across the gates, their figures indistinct
among the gleaming of the golden ground through the leaves
beside them, interrupted and dim, like the morning light as it
faded back among the branches of Eden, when first its gates
were angel-guarded long ago. And round the walls of the
porches there are set pillars of variegated stones, jasper and
porphyry, and deep-green serpentine spotted with flakes of snow,
and marbles, that half refuse and half yield to the sunshine,
Cleopatra-like, "their bluest veins to kiss"—the shadow, as it
steals back from them, revealing line after line of azure undula-
tion, as a receding tide leaves the waved sand; their capitals
rich with interwoven tracery, rooted knots of herbage, and
drifting leaves of acanthus and vine, and mystical signs, all

beginning and ending in the Cross; and above them, in the broad archivolts, a continuous chain of language and of life—angels, and the signs of heaven, and the labours of men, each in its appointed season upon the earth; and above these, another range of glittering pinnacles, mixed with white arches edged with scarlet flowers,—a confusion of delight, amidst which the breasts of the Greek horses are seen blazing in their breadth of golden strength, and the St. Mark's lion, lifted on a blue field covered with stars, until at last, as if in ecstasy, the crests of the arches break into a marble foam, and toss themselves far into the blue sky in flashes and wreaths of sculptured spray, as if the breakers on the Lido shore had been frost-bound before they fell, and the sea-nymphs had inlaid them with coral and amethyst.

Between that grim cathedral of England and this, what an interval! There is a type of it in the very birds that haunt them; for, instead of the restless crowd, hoarse-voiced and sable-winged, drifting on the bleak upper air, the St. Mark's porches are full of doves, that nestle among the marble foliage, and mingle the soft iridescence of their living plumes, changing at every motion, with the tints, hardly less lovely, that have stood unchanged for seven hundred years.

And what effect has this splendour on those who pass beneath it? You may walk from sunrise to sunset, to and fro, before the gateway of St. Mark's, and you will not see an eye lifted to it, nor a countenance brightened by it. Priest and layman, soldier and civilian, rich and poor, pass by it alike regardlessly. Up to the very recesses of the porches, the meanest tradesmen of the city push their counters; nay, the foundations of its pillars are themselves the seats—not "of them that sell doves" for sacrifice, but of the vendors of toys and caricatures. Round the whole square in front of the church there is almost a continuous line of cafés, where the idle Venetians of the middle classes lounge, and read empty journals; in its centre the Austrian bands play during the time of vespers, their martial music jarring with the organ notes,—the march drowning the

miserere, and the sullen crowd thickening round them,—a crowd, which, if it had its will, would stiletto every soldier that pipes to it. And in the recesses of the porches, all day long, knots of men of the lowest classes, unemployed and listless, lie basking in the sun like lizards ; and unregarded children,—every heavy glance of their young eyes full of desperation and stony depravity, and their throats hoarse with cursing,—gamble, and fight, and snarl, and sleep, hour after hour, clashing their bruised centesimi upon the marble ledges of the church porch. And the images of Christ and His angels look down upon it continually.

Let us enter the church. It is lost in still deeper twilight, to which the eye must be accustomed for some moments before the form of the building can be traced ; and then there opens before us a vast cave, hewn out into the form of a Cross, and divided into shadowy aisles by many pillars. Round the domes of its roof the light enters only through narrow apertures like large stars ; and here and there a ray or two from some far-away casement wanders into the darkness, and casts a narrow phosphoric stream upon the waves of marble that heave and fall in a thousand colours along the floor. What else there is of light is from torches, or silver lamps, burning ceaselessly in the recesses of the chapels ; the roof sheeted with gold, and the polished walls covered with alabaster, give back at every curve and angle some feeble gleaming to the flames ; and the glories round the heads of the sculptured saints flash out upon us as we pass them, and sink again into the gloom. Under foot and over head, a continual succession of crowded imagery, one picture passing into another, as in a dream ; forms beautiful and terrible mixed together ; dragons and serpents, and ravening beasts of prey, and graceful birds that in the midst of them drink from running fountains and feed from vases of crystal ; the passions and the pleasures of human life symbolised together, and the mystery of its redemption ; for the mazes of interwoven lines and changeful pictures lead always at last to the Cross, lifted and carved in every place and upon every stone ; sometimes with the serpent of

eternity wrapt round it, sometimes with doves beneath its arms, and sweet herbage growing forth from its feet ; but conspicuous most of all on the great rood that crosses the church before the altar, raised in bright blazonry against the shadow of the apse.

Now the first broad characteristic of the building, and the root nearly of every other important peculiarity in it, is its confessed *incrustation*. It is the purest example in Italy of the great school of architecture in which the ruling principle is the incrustation of brick with more precious materials ; and it is necessary, before we proceed to criticise any one of its arrangements, that the reader should carefully consider the principles which are likely to have influenced, or might legitimately influence the architects of such a school, as distinguished from those whose designs are to be executed in massive materials. This incrusted school appears *insincere* at first to a Northern builder, because, accustomed to build with solid blocks of freestone, he is in the habit of supposing the external superficies of a piece of masonry to be some criterion of its thickness. But, as soon as he gets acquainted with the incrusted style, he will find that the Southern builders had no intention to deceive him. He will see that every slab of facial marble is fastened to the next by a confessed *rivet*, and that the joints of the armour are so visibly and openly accommodated to the contours of the substance within that he has no more right to complain of treachery than a savage would have, who, for the first time in his life seeing a man in armour, had supposed him to be made of solid steel. Acquaint him with the customs of chivalry, and with the uses of the coat of mail, and he ceases to accuse of dishonesty either the panoply or the knight.

These laws and customs of the St. Mark's architectural chivalry it must be our business to develop.

First, consider the natural circumstances which give rise to such a style. Suppose a nation of builders, placed far from any quarries of available stone, and having precarious access to the mainland where they exist ; compelled therefore either to build

entirely with brick, or to import whatever stone they use from great distances, in ships of small tonnage, and, for the most part, dependent for speed on the oar rather than the sail. The labour and cost of carriage are just as great, whether they import common or precious stone, and therefore the natural tendency would always be to make each shipload as valuable as possible. But in proportion to the preciousness of the stone, is the limitation of its possible supply; limitation not determined merely by cost, but by the physical conditions of the material, for of many marbles pieces above a certain size are not to be had for money. There would also be a tendency in such circumstances to import as much stone as possible ready sculptured, in order to save weight; and therefore, if the traffic of their merchants led them to places where there were ruins of ancient edifices, to ship the available fragments of them home. Out of this supply of marble, partly composed of pieces of so precious a quality that only a few tons of them could be on any terms obtained, and partly of shafts, capitals, and other portions of foreign buildings, the island architect has to fashion, as best he may, the anatomy of his edifice. It is at his choice either to lodge his few blocks of precious marble here and there among his masses of brick, and to cut out of the sculptured fragments such new forms as may be necessary for the observance of fixed proportions in the new building; or else to cut the coloured stones into thin pieces, of extent sufficient to face the whole surface of the walls, and to adopt a method of construction irregular enough to admit the insertion of fragmentary sculptures; rather with a view of displaying their intrinsic beauty, than of setting them to any regular service in the support of the building.

An architect who cared only to display his own skill, and had no respect for the works of others, would assuredly have chosen the former alternative, and would have sawn the old marbles into fragments in order to prevent all interference with his own designs. But an architect who cared for the preservation of noble work, whether his own or others', and more

regarded the beauty of his building than his own fame, would have done what those old builders of St. Mark's did for us, and saved every relic with which he was entrusted.

But these were not the only motives which influenced the Venetians in the adoption of their method of architecture. It might, under all the circumstances above stated, have been a question with other builders, whether to import one shipload of costly jaspers, or twenty of chalk flints ; and whether to build a small church faced with porphyry and paved with agate, or to raise a vast cathedral in freestone. But with the Venetians it could not be a question for an instant ; they were exiles from ancient and beautiful cities, and had been accustomed to build with their ruins, not less in affection than in admiration ; they had thus not only grown familiar with the practice of inserting older fragments in modern buildings, but they owed to that practice a great part of the splendour of their city, and whatever charm of association might aid its change from a Refuge into a Home. The practice which began in the affections of a fugitive nation, was prolonged in the pride of a conquering one ; and besides the memorials of departed happiness, were elevated the trophies of returning victory. The ship of war brought home more marble in triumph than the merchant vessel in speculation ; and the front of St. Mark's became rather a shrine at which to dedicate the splendour of miscellaneous spoil, than the organized expression of any fixed architectural law or religious emotion.

It is on its value as a piece of perfect and unchangeable colouring, that the claims of this edifice to our respect are finally rested ; and a deaf man might as well pretend to pronounce judgment on the merits of a full orchestra, as an architect trained in the composition of form only, to discern the beauty of St. Mark's. It possesses the charm of colour in common with the greater part of the architecture, as well as of the manufactures, of the East ; but the Venetians deserve especial note as the only European people who appear to have sympathized to the full with the great instinct of the Eastern races. They indeed were

compelled to bring artists from Constantinople to design the mosaics of the vaults of St. Mark's, and to group the colours of its porches; but they rapidly took up and developed, under more masculine conditions, the system of which the Greeks had shown them the example : while the burghers and barons of the North were building their dark streets and grisly castles of oak and sandstone, the merchants of Venice were covering their palaces with porphyry and gold; and at last, when her mighty painters had created for her a colour more priceless than gold or porphyry, even this, the richest of her treasures, she lavished upon walls whose foundations were beaten by the sea ; and the strong tide, as it runs beneath the Rialto, is reddened to this day by the reflection of the frescoes of Giorgione.

If, therefore, the reader does not care for colour, I must protest against his endeavour to form any judgment whatever of this church of St. Mark's. But, if he both cares for and loves it let him remember that the school of incrusted architecture is *the only one in which perfect and permanent chromatic decoration is possible;* and let him look upon every piece of jasper and alabaster given to the architect as a cake of very hard colour, of which a certain portion is to be ground down or cut off, to paint the walls with. Once understand this thoroughly, and accept the condition that the body and availing strength of the edifice are to be in brick, and that this under muscular power of brickwork is to be clothed with the defence and the brightness of the marble, as the body of an animal is protected and adorned by its scales or its skin, and all the consequent fitnesses and laws of the structure will be easily discernible.

There are those who suppose the mosaics of St. Mark's, and others of the period, to be utterly barbarous as representations of religious history. Let it be granted that they are so ; we are not for that reason to suppose they were ineffective in religious teaching. The whole church may be seen as a great Book of Common Prayer; the mosaics were its illuminations, and the common people of the time were taught their Scripture history

by means of them, more impressively perhaps, though far less fully, than ours are now by Scripture reading. They had no other Bible, and—Protestants do not often enough consider this —*could* have no other. We find it somewhat difficult to furnish our poor with printed Bibles ; consider what the difficulty must have been when they could be given only in manuscript. The walls of the church necessarily became the poor man's Bible, and a picture was more easily read upon the walls than a chapter. Under this view, and considering them merely as the Bible pictures of a great nation in its youth, I have to deprecate the idea of their execution being in any sense barbarous. I have conceded too much to modern prejudice, in permitting them to be rated as mere childish efforts at coloured portraiture : they have characters in them of a very noble kind ; nor are they by any means devoid of the remains of the science of the later Roman empire. The character of the features is almost always fine, the expression stern and quiet, and very solemn, the attitudes and draperies always majestic in the single figures, and in those of the groups which are not in violent action ; while the bright colouring and disregard of chiaroscuro cannot be regarded as imperfections, since they are the only means by which the figures could be rendered clearly intelligible in the distance and darkness of the vaulting. So far am I from considering them barbarous, that I believe of all works of religious art whatsoever, these, and such as these, have been the most effective.

Missal-painting could not, from its minuteness, produce the same sublime impressions, and frequently merged itself in mere ornamentation of the page. Modern book illustration has been so little skilful as hardly to be worth naming. Sculpture, though in some positions it becomes of great importance, has always a tendency to lose itself in architectural effect ; and was probably seldom deciphered, in all its parts, by the common people, still less the traditions annealed in the purple burning of the painted window. Finally, tempera pictures and frescoes were often of

limited size or of feeble colour. But the great mosaics of the twelfth and thirteenth centuries covered the walls and roofs of the churches with inevitable lustre; they could not be ignored or escaped from; their size rendered them majestic, their distance mysterious, their colour attractive. They did not pass into confused or inferior decorations; neither were they adorned with any evidences of skill or science, such as might withdraw the attention from their subjects. They were before the eyes of the devotee at every interval of his worship; vast shadowings forth of scenes to whose realization he looked forward, or of spirits whose presence he invoked. And the man must be little capable of receiving a religious impression of any kind, who, to this day, does not acknowledge some feeling of awe, as he looks up to the pale countenances and ghastly forms which haunt the dark roofs of the Baptisteries of Parma and Florence, or remains altogether untouched by the majesty of the colossal images of apostles, and of Him who sent apostles, that look down from the darkening gold of the domes of Venice and Pisa.

PART TWO

The Gothic Period

THE NATURE OF GOTHIC

WE ARE now about to enter upon the examination of that school of Venetian architecture which forms an intermediate step between the Byzantine and Gothic forms; but which I find may be conveniently considered in its connection with the latter style. In order that we may discern the tendency of each step of this change, it will be wise in the outset to endeavour to form some general idea of its final result. We know already what the Byzantine architecture is from which the transition was made, but we ought to know something of the Gothic architecture into which it led. I shall endeavour therefore to give the reader in this chapter an idea, at once broad and definite, of the true nature of *Gothic* architecture, properly so called; not of that of Venice only, but of universal Gothic.

The principal difficulty in doing this arises from the fact that every building of the Gothic period differs in some important respect from every other; and many include features which, if they occurred in other buildings, would not be considered Gothic at all; so that all we have to reason upon is merely, if I may be allowed so to express it, a greater or less degree of *Gothicness* in each building we examine. And it is this Gothicness,

—the character which, according as it is found more or less in a building, makes it more or less Gothic,—of which I want to define the nature ; and I feel the same kind of difficulty in doing so which would be encountered by any one who undertook to explain, for instance, the Nature of Redness, without any actually red thing to point to, but only orange and purple things. Suppose he had only a piece of heather and a dead oak-leaf to do it with. He might say, the colour which is mixed with the yellow in this oak-leaf, and with the blue in this heather, would be red, if you had it separate ; but it would be difficult, nevertheless, to make the abstraction perfectly intelligible ; and it is so in a far greater degree to make the abstraction of the Gothic character intelligible, because that character itself is made up of many mingled ideas, and can consist only in their union. That is to say, pointed arches do not constitute Gothic, nor vaulted roofs, nor flying buttresses, nor grotesque sculptures ; but all or some of these things, and many other things with them, when they come together so as to have life.

Observe also, that, in the definition proposed, I shall only endeavour to analyze the idea which I suppose already to exist in the reader's mind. We all have some notion, most of us a very determined one, of the meaning of the term Gothic ; but I know that many persons have this idea in their minds without being able to define it : that is to say, understanding generally that Westminster Abbey is Gothic, and St. Paul's is not, that Strasburg Cathedral is Gothic, and St. Peter's is not, they have, nevertheless, no clear notion of what it is that they recognize in the one or miss in the other, such as would enable them to say how far the work at Westminster or Strasburg is good and pure of its kind ; still less to say of any nondescript building, like St. James's Palace or Windsor Castle, how much right Gothic element there is in it, and how much wanting. And I believe this inquiry to be a pleasant and profitable one ; and that there will be found something more than usually interesting in tracing out this grey, shadowy, many-pinnacled image of the Gothic

spirit within us ; and discerning what fellowship there is between it and our Northern hearts. And if, at any point of the inquiry, I should interfere with any of the reader's previously formed conceptions, and use the term Gothic in any sense which he would not willingly attach to it, I do not ask him to accept, but only to examine and understand, my interpretation, as necessary to the intelligibility of what follows in the rest of the work.

We have, then, the Gothic character submitted to our analysis, just as the rough mineral is submitted to that of the chemist, entangled with many other foreign substances, itself perhaps in no place pure, or ever to be obtained or seen in purity for more than an instant ; but nevertheless a thing of definite and separate nature ; however inextricable or confused in appearance. Now observe : the chemist defines his mineral by two separate kinds of character ; one external, its crystalline form, hardness, lustre, etc. ; the other internal, the proportions and nature of its constituent atoms. Exactly in the same manner, we shall find that Gothic architecture has external forms and internal elements. Its elements are certain mental tendencies of the builders, legibly expressed in it ; as fancifulness, love of variety, love of richness, and such others. Its external forms are pointed arches, vaulted roofs, etc. And unless both the elements and the forms are there, we have no right to call the style Gothic. It is not enough that it has the Form, if it have not also the power and life. It is not enough that it has the Power, if it have not the form. We must therefore inquire into each of these characters successively ; and determine first, what is the Mental Expression, and secondly, what the Material Form of Gothic architecture, properly so called.

1st. Mental Power or Expression. What characters, we have to discover, did the Gothic builders love, or instinctively express in their work, as distinguished from all other builders ?

Let us go back for a moment to our chemistry, and note that, in defining a mineral by its constituent parts, it is not one nor another of them, that can make up the mineral, but the union

of all : for instance, it is neither in charcoal, nor in oxygen, nor
in lime, that there is the making of chalk, but in the combination
of all three in certain measures ; they are all found in very
different things from chalk, and there is nothing like chalk either
in charcoal or in oxygen, but they are nevertheless necessary to
its existence.

So in the various mental characters which make up the soul
of Gothic. It is not one nor another that produces it ; but their
union in certain measures. Each one of them is found in many
other architectures beside Gothic ; but Gothic cannot exist
where they are not found, or, at least, where their place is not
in some way supplied. Only there is this great difference between
the composition of the mineral and of the architectural style,
that if we withdraw one of its elements from the stone, its form
is utterly changed, and its existence as such and such a mineral
is destroyed ; but if we withdraw one of its mental elements
from the Gothic style, it is only a little less Gothic than it was
before, and the union of two or three of its elements is enough
already to bestow a certain Gothicness of character, which gains
in intensity as we add the others, and loses as we again withdraw
them.

I believe, then, that the characteristic or moral elements of
Gothic are the following, placed in the order of their importance :

 1. Savageness.
 2. Changefulness.
 3. Naturalism.
 4. Grotesqueness.
 5. Rigidity.
 6. Redundance.

These characters are here expressed as belonging to the
building ; as belonging to the builder, they would be expressed
thus :—1. Savageness or Rudeness. 2. Love of Change.
3. Love of Nature. 4. Disturbed Imagination. 5. Obstinacy.
6. Generosity. And I repeat, that the withdrawal of any one,
or any two, will not at once destroy the Gothic character of a

building, but the removal of a majority of them will. I shall proceed to examine them in their order.

Savageness—I am not sure when the word "Gothic" was first generically applied to the architecture of the North; but I presume that, whatever the date of its original usage, it was intended to imply reproach, and express the barbaric character of the nations among whom that architecture arose. It never implied that they were literally of Gothic lineage, far less that their architecture had been originally invented by the Goths themselves; but it did imply that they and their buildings together exhibited a degree of sternness and rudeness, which, in contra-distinction to the character of Southern and Eastern nations, appeared like a perpetual reflection of the contrast between the Goth and the Roman in their first encounter. And when that fallen Roman, in the utmost impotence of his luxury, and insolence of his guilt, became the model for the imitation of civilized Europe, at the close of the so-called Dark ages, the word Gothic became a term of unmitigated contempt, not unmixed with aversion. From that contempt, by the exertion of the antiquaries and architects of this century, Gothic architecture has been sufficiently vindicated; and perhaps some among us, in our admiration of the magnificent science of its structure, and sacredness of its expression, might desire that the term of ancient reproach should be withdrawn, and some other, of more apparent honourableness, adopted in its place. There is no chance, as there is no need, of such a substitution. As far as the epithet was used scornfully, it was used falsely; but there is no reproach in the word, rightly understood; on the contrary, there is a profound truth, which the instinct of mankind almost unconsciously recognizes. It is true, greatly and deeply true, that the architecture of the North is rude and wild; but it is not true, that, for this reason, we are to condemn it, or despise. Far otherwise: I believe it is in this very character that it deserves our profoundest reverence.

The charts of the world which have been drawn up by

modern science have thrown into a narrow space the expression
of a vast amount of knowledge, but I have never yet seen any
one pictorial enough to enable the spectator to imagine the kind
of contrast in physical character which exists between Northern
and Southern countries. We know the differences in detail, but
we have not that broad glance and grasp which would enable
us to feel them in their fulness. We know that gentians grow
on the Alps, and olives on the Apennines ; but we do not
enough conceive for ourselves that variegated mosaic of the
world's surface which a bird sees in its migration, that difference
between the district of the gentian and of the olive which the
stork and the swallow see far off, as they lean upon the sirocco
wind. Let us, for a moment, try to raise ourselves even above
the level of their flight, and imagine the Mediterranean lying
beneath us like an irregular lake, and all its ancient promontories
sleeping in the sun : here and there an angry spot of thunder,
a grey stain of storm, moving upon the burning field ; and here
and there a fixed wreath of white volcano smoke, surrounded
by its circle of ashes ; but for the most part a great peacefulness
of light, Syria and Greece, Italy and Spain, laid like pieces of a
golden pavement into the sea-blue, chased, as we stoop nearer
to them, with bossy beaten work of mountain chains, and
glowing softly with terraced gardens, and flowers heavy with
frankincense, mixed among masses of laurel, and orange, and
plumy palm, that abate with their grey-green shadows the
burning of the marble rocks, and of the ledges of porphyry
sloping under lucent sand. Then let us pass farther towards the
north, until we see the orient colours change gradually into a
vast belt of rainy green, where the pastures of Switzerland, and
poplar valleys of France, and dark forests of the Danube and
Carpathians stretch from the mouths of the Loire to those of
the Volga, seen through clefts in grey swirls of rain-cloud and
flaky veils of the mist of the brooks, spreading low along the
pasture lands : and then, farther north still, to see the earth
heave into mighty masses of leaden rock and heathy moor,

bordering with a broad waste of gloomy purple that belt of field and wood, and splintering into irregular and grisly islands amidst the northern seas, beaten by storm, and chilled by ice-drift, and tormented by furious pulses of contending tide, until the roots of the last forests fail from among the hill ravines, and the hunger of the north wind bites their peaks into barrenness ; and, at last, the wall of ice, durable like iron, sets, deathlike, its white teeth against us out of the polar twilight. And, having once traversed in thought this gradation of the zoned iris of the earth in all its material vastness, let us go down nearer to it, and watch the parallel change in the belt of animal life ; the multitudes of swift and brilliant creatures that glance in the air and sea, or tread the sands of the southern zone ; striped zebras and spotted leopards, glistening serpents, and birds arrayed in purple and scarlet. Let us contrast their delicacy and brilliancy of colour, and swiftness of motion, with the frost-cramped strength, and shaggy covering, and dusky plumage of the northern tribes ; contrast the Arabian horse with the Shetland, the tiger and leopard with the wolf and bear, the antelope with the elk, the bird of paradise with the osprey : and then, submissively acknowledging the great laws by which the earth and all that it bears are ruled throughout their being, let us not condemn, but rejoice in the expression by man of his own rest in the statues of the lands that gave him birth. Let us watch him with reverence as he sets side by side the burning gems, and smooths with soft sculpture the jasper pillars, that are to reflect a ceaseless sunshine, and rise into a cloudless sky : but not with less reverence let us stand by him, when, with rough strength and hurried stroke, he smites an uncouth animation out of the rocks which he has torn from among the moss of the moorland, and heaves into the darkened air of the pile of iron buttress and rugged wall, instinct with a work of an imagination as wild and wayward as the northern sea ; creations of ungainly shape and rigid limb, but full of wolfish life ; fierce as the winds that beat, and changeful as the clouds that shade them.

There is, I repeat, no degradation, no reproach in this, but all dignity and honourableness : and we should err grievously in refusing either to recognize as an essential character of the existing architecture of the North, or to admit as a desirable character in that which it yet may be, this wildness of thought, and roughness of work ; this look of mountain brotherhood between the cathedral and the Alp ; this magnificence of sturdy power, put forth only the more energetically because the fine finger-touch was chilled away by the frosty wind, and the eye dimmed by the moor-mist, or blinded by the hail ; this out-speaking of the strong spirit of men who may not gather redundant fruitage from the earth, nor bask in dreamy benignity of sunshine, but must break the rock for bread, and cleave the forest for fire, and show, even in what they did for their delight, some of the hard habits of the arm and heart that grew on them as they swung the axe or pressed the plough.

The second mental element above named was *Changefulness*, or Variety.

I have already enforced the allowing independent operation to the inferior workman, simply as a duty *to him*, and as ennobling the architecture by rendering it more Christian. We have now to consider what reward we obtain for the performance of this duty, namely, the perpetual variety of every feature of the building.

Wherever the workman is utterly enslaved, the parts of the building must of course be absolutely like each other ; for the perfection of his execution can only be reached by exercising him in doing one thing, and giving him nothing else to do. The degree in which the workman is degraded may be thus known at a glance, by observing whether the several parts of the building are similar or not ; and if, as in Greek work, all the capitals are alike, and all the mouldings unvaried, then the degradation is complete ; if, as in Egyptian or Ninevite work, though the manner of executing certain figures is always the same, the order of design is perpetually varied, the degradation

is less total; if, as in Gothic work, there is perpetual change both in design and execution, the workman must have been altogether set free.

How much the beholder gains from the liberty of the labourer may perhaps be questioned in England, where one of the strongest instincts in nearly every mind is that Love of Order which makes us desire that our house windows should pair like our carriage horses, and allows us to yield our faith unhesitatingly to architectural theories which fix a form for everything, and forbid variation from it. I would not impeach love of order: it is one of the most useful elements of the English mind; it helps us in our commerce and in all purely practical matters; and it is in many cases one of the foundation stones of morality. Only do not let us suppose that love of order is love of art. It is true that order, in its highest sense, is one of the necessities of art, just as time is a necessity of music; but love of order has no more to do with our right enjoyment of architecture or painting, than love of punctuality with the appreciation of an opera. Experience, I fear, teaches us that accurate and methodical habits in daily life are seldom characteristic of those who either quickly perceive, or richly possess, the creative powers of art; there is, however, nothing inconsistent between the two instincts, and nothing to hinder us from retaining our business habits, and yet fully allowing and enjoying the noblest gifts of Invention. We already do so, in every other branch of art except architecture, and we only do *not* so there because we have been taught that it would be wrong. Our architects gravely inform us that, as there are four rules of arithmetic, there are five orders of architecture; we, in our simplicity, think that this sounds consistent, and believe them. They inform us also that there is one proper form for Corinthian capitals, another for Doric, and another for Ionic. We, considering that there is also a proper form for the letters A, B, and C, think that this also sounds consistent, and accept the proposition. Understanding, therefore, that one form of the said

capitals is proper, and no other, and having a conscientious horror of all impropriety, we allow the architect to provide us with the said capitals, of the proper form, in such and such a quantity, and in all other points to take care that the legal forms are observed ; which having done, we rest in forced confidence that we are well housed.

But our higher instincts are not deceived. We take no pleasure in the building provided for us, resembling that which we take in a new book or a new picture. We may be proud of its size, complacent in its correctness, and happy in its convenience. We may take the same pleasure in its symmetry and workmanship as in a well-ordered room, or a skilful piece of manufacture. And this we suppose to be all the pleasure that architecture was ever intended to give us. The idea of reading a building as we would read Milton or Dante, and getting the same kind of delight out of the stones as out of the stanzas, never enters our mind for a moment. And for good reason ;—There is indeed rhythm in the verses, quite as strict as the symmetries or rhythm of the architecture, and a thousand times more beautiful, but there is something else than rhythm. The verses were neither made to order, nor to match, as the capitals were ; and we have therefore a kind of pleasure in them other than a sense of propriety. But it requires a strong effort of common sense to shake ourselves quit of all that we have been taught for the last two centuries, and wake to the perception of a truth just as simple and certain as it is new : that great art, whether expressing itself in words, colours, or stones, does *not* say the same thing over and over again ; that the merit of architectural, as of every other art, consists in its saying new and different things ; that to repeat itself is no more a characteristic of genius in marble than it is of genius in print ; and that we may, without offending any laws of good taste, require of an architect, as we do of a novelist, that he should be not only correct, but entertaining.

Yet all this is true, and self-evident ; only hidden from us, as many other self-evident things are, by false teaching. Nothing

is a great work of art, for the production of which either rules or models can be given. Exactly so far as architecture works on known rules, and from given models, it is not an art, but a manufacture; and it is, of the two procedures, rather less rational (because more easy) to copy capitals or mouldings from Phidias, and call ourselves architects, than to copy heads and hands from Titian and call ourselves painters.

Let us then understand at once that change or variety is as much a necessity to the human heart and brain in buildings as in books; that there is no merit, though there is some occasional use, in monotony; and that we must no more expect to derive either pleasure or profit from an architecture whose ornaments are of one pattern, and whose pillars are of one proportion, than we should out of a universe in which the clouds were all of one shape, and the trees all of one size.

And this we confess in deeds, though not in words. All the pleasure which the people of the nineteenth century take in art, is in pictures, sculpture, minor objects of virtu or mediæval architecture, which we enjoy under the term picturesque: no pleasure is taken anywhere in modern buildings, and we find all men of true feeling delighting to escape out of modern cities into natural scenery: hence that peculiar love of landscape which is characteristic of the age. It would be well, if, in all other matters, we were as ready to put up with what we dislike, for the sake of compliance with established law, as we are in architecture.

How so debased a law ever came to be established, we shall see when we come to describe the Renaissance schools; here we have only to note, as a second most essential element of the Gothic spirit, that it broke through that law wherever it found it in existence; it not only dared, but delighted in, the infringement of every servile principle; and invented a series of forms of which the merit was, not merely that they were new, but that they were *capable of perpetual novelty*. The pointed arch was not merely a bold variation from the round, but it admitted of

millions of variations in itself; for the proportions of a pointed arch are changeable to infinity, while a circular arch is always the same. The grouped shaft was not merely a bold variation from the single one, but it admitted of millions of variations in its grouping, and in the proportions resultant from its grouping. The introduction of tracery was not only a startling change in the treatment of window lights, but admitted endless changes in the interlacement of the tracery bars themselves. So that, while in all living Christian architecture the love of variety exists, the Gothic schools exhibited that love in culminating energy; and their influence, wherever it extended itself, may be sooner and farther traced by this character than by any other; the tendency to the adoption of Gothic types being always first shown by greater irregularity and richer variation in the forms of the architecture it is about to supersede, long before the appearance of the pointed arch or of any other recognizable *outward* sign of the Gothic mind.

The variety of the Gothic schools is the more healthy and beautiful, because in many cases it is entirely unstudied, and results, not from mere love of change, but from practical necessities. For in one point of view Gothic is not only the best, but the *only rational* architecture, as being that which can fit itself most easily to all services, vulgar or noble. Undefined in its slope of roof, height of shaft, breadth of arch, or disposition of ground plan, it can shrink into a turret, expand into a hall, coil into a staircase, or spring into a spire, with undegraded grace and unexhausted energy; and whenever it finds occasion for change in its form or purpose, it submits to it without the slightest sense of loss either to its unity or majesty,—subtle and flexible like a fiery serpent, but ever attentive to the voice of the charmer. And it is one of the chief virtues of the Gothic builders, that they never suffered ideas of outside symmetries and consistencies to interfere with the real use and value of what they did. If they wanted a window, they opened one; a room, they added one; a buttress, they built one; utterly regardless of any

established conventionalities of external appearance, knowing (as indeed it always happened) that such daring interruptions of the formal plan would rather give additional interest to its symmetry than injure it. So that, in the best times of Gothic, a useless window would rather have been opened in an unexpected place for the sake of the surprise, than a useful one forbidden for the sake of symmetry. Every successive architect, employed upon a great work, built the pieces he added in his own way, utterly regardless of the style adopted by his predecessors ; and if two towers were raised in nominal correspondence at the sides of a cathedral front, one was nearly sure to be different from the other, and in each the style at the top to be different from the style at the bottom.

The third constituent element of the Gothic mind was stated to be *Naturalism*; that is to say, the love of natural objects for their own sake, and the effort to represent them frankly, unconstrained by artistical laws.

This characteristic of the style partly follows in necessary connection with those named above. For, so soon as the workman is left free to represent what subjects he chooses, he must look to the nature that is round him for material, and will endeavour to represent it as he sees it, with more or less accuracy according to the skill he possesses, and with much play of fancy, but with small respect for law. There is, however, a marked distinction between the imaginations of the Western and Eastern races, even when both are left free ; the Western, or Gothic, delighting most in the representation of facts, and the Eastern (Arabian, Persian, and Chinese) in the harmony of colours and forms.

The Gothic builders were of that central class which unites fact with design ; but the part of the work which was more especially their own was the truthfulness. Their power of artistical invention or arrangement was not greater than that of Romanesque and Byzantine workmen : by those workmen they were taught the principles, and from them received their models,

of design ; but to the ornamental feeling and rich fancy of the
Byzantine the Gothic builder added a love of *fact* which is never
found in the South. Both Greek and Roman used conventional
foliage in their ornament, passing into something that was not
foliage at all, knotting itself into strange cup-like buds or clusters,
and growing out of lifeless rods instead of stems ; the Gothic
sculptor received these types, at first, as things that ought to be,
just as we have a second time received them ; but he could not
rest in them. He saw there was no veracity in them, no know-
ledge, no vitality. Do what he would, he could not help liking
the true leaves better ; and cautiously, a little at a time, he put
more of nature into his work, until at last it was all true, retaining,
nevertheless, every valuable character of the original well-
disciplined and designed arrangement.

Nor is it only in external and visible subject that the Gothic
workman wrought for truth : he is as firm in his rendering of
imaginative as of actual truth ; that is to say, when an idea
would have been by a Roman, or Byzantine, symbolically repre-
sented, the Gothic mind realizes it to the utmost. For instance,
the purgatorial fire is represented in the mosaic of Torcello
(Romanesque) as a red stream, longitudinally striped like a
riband, descending out of the throne of Christ, and gradually
extending itself to envelop the wicked. When we are once
informed what this means, it is enough for its purpose ; but the
Gothic inventor does not leave the sign in need of interpretation.
He makes the fire as like real fire as he can ; and in the porch
of St. Maclou at Rouen the sculptured flames burst out of the
Hades gate, and flicker up, in writhing tongues of stone, through
the interstices of the niches, as if the church itself were on fire.
This is an extreme instance, but it is all the more illustrative of
the entire difference in temper and thought between the two
schools of art, and of the intense love of veracity which influenced
the Gothic design.

In the second place, Gothic work, when referred to the
arrangement of all art, as purist, naturalist, or sensualist, is

naturalist. This character follows necessarily on its extreme love of truth, prevailing over the sense of beauty, and causing it to take delight in portraiture of every kind, and to express the various characters of the human countenance and form, as it did the varieties of leaves and the ruggedness of branches. And this tendency is both increased and ennobled by the same Christian humility which we saw expressed in the first character of Gothic work, its rudeness. For as that resulted from a humility which confessed the imperfection of the workman, so this naturalist portraiture is rendered more faithful by the humility which confesses the imperfection of the subject. The Greek sculptor could neither bear to confess his own feebleness, nor to tell the faults of the forms that he portrayed. But the Christian workman, believing that all is finally to work together for good, freely confesses both, and neither seeks to disguise his own roughness of work, nor his subject's roughness of make. Yet this frankness being joined, for the most part, with depth of religious feeling in other directions, and especially with charity, there is sometimes a tendency to Purism in the best Gothic sculpture ; so that it frequently reaches great dignity of form and tenderness of expression, yet never so as to lose the veracity of portraiture wherever portraiture is possible ; not exalting its kings into demi-gods, nor its saints into archangels, but giving what kingliness and sanctity was in them, to the full, mixed with due record of their faults ; and this in the most part with a great indifference like that of Scripture history, which sets down, with unmoved and unexcusing resoluteness, the virtues and errors of all men of whom it speaks, often leaving the reader to form his own estimate of them, without an indication of the judgment of the historian. And this veracity is carried out by the Gothic sculptors in the minuteness and generality, as well as the equity, of their delineation : for they do not limit their art to the portraiture of saints and kings, but introduce the most familiar scenes and most simple subjects : filling up the backgrounds of Scripture histories with vivid and curious representations of the

commonest incidents of daily life, and availing themselves of every occasion in which, either as a symbol, or an explanation of a scene or time, the things familiar to the eye of the workman could be introduced and made of account. Hence Gothic sculpture and painting are not only full of valuable portraiture of the greatest men, but copious records of all the domestic customs and inferior arts of the ages in which it flourishes.

There is, however, one direction in which the Naturalism of the Gothic workmen is peculiarly manifested; and this direction is even more characteristic of the school than the Naturalism itself; I mean their peculiar fondness for the forms of Vegetation. To the Gothic workman the living foliage became a subject of intense affection, and he struggled to render all its characters with as much accuracy as was compatible with the laws of his design and the nature of his material, not unfrequently tempted in his enthusiasm to transgress the one and disguise the other.

There is a peculiar significance in this, indicative both of higher civilization and gentler temperament, than had before been manifested in architecture. Rudeness, and the love of change, which we have insisted upon as the first elements of Gothic, are also elements common to all healthy schools. But here is a softer element mingled with them, peculiar to the Gothic itself. The rudeness of ignorance which would have been painfully exposed in the treatment of the human form, is still not so great as to prevent the successful rendering of the wayside herbage; and the love of change, which becomes morbid and feverish in following the haste of the hunter and the rage of the combatant, is at once soothed and satisfied as it watches the wandering of the tendril, and the budding of the flower. Nor is this all: the new direction of mental interest marks an infinite change in the means and the habits of life. The nations whose chief support was in the chase, whose chief interest was in the battle, whose chief pleasure was in the banquet, would take small care respecting the shapes of leaves and flowers; and

notice little in the forms of the forest trees which sheltered them, except the signs indicative of the wood which would make the toughest lance, the closest roof, or the clearest fire. The affectionate observation of the grace and outward character of vegetation is the sure sign of a more tranquil and gentle existence, sustained by the gifts, and gladdened by the splendour, of the earth. In that careful distinction of species, and richness of delicate and undisturbed organization, which characterize the Gothic design, there is the history of rural and thoughtful life, influenced by habitual tenderness, and devoted to subtle inquiry ; and every discriminating and delicate touch of the chisel, as it rounds the petal or guides the branch, is a prophecy of the development of the entire body of the natural sciences, beginning with that of medicine, of the recovery of literature, and the establishment of the most necessary principles of domestic wisdom and national peace.

The fourth essential element of the Gothic mind was above stated to be the sense of the *Grotesque* ; but I shall defer the endeavour to define this most curious and subtle character until we have occasion to examine one of the divisions of the Renaissance schools, which was morbidly influenced by it. It is the less necessary to insist upon it here, because every reader familiar with Gothic architecture must understand what I mean, and will, I believe, have no hesitation in admitting that the tendency to delight in fantastic and ludicrous, as well as in sublime, images, is a universal instinct of the Gothic imagination.

The fifth element above named was *Rigidity* ; and this character I must endeavour carefully to define, for neither the word I have used, nor any other that I can think of, will express it accurately. For I mean, not merely stable, but *active* rigidity ; the peculiar energy which gives tension to movement, and stiffness to resistance, which makes the fiercest lightning forked rather than curved, and the stoutest oak-branch angular rather than bending, and is as much seen in the quivering of the lance as in the glittering of the icicle.

I have before had occasion to note some manifestations of this energy of fixedness; but it must be still more attentively considered here, as it shows itself throughout the whole structure and decoration of Gothic work. Egyptian and Greek buildings stand, for the most part, by their own weight and mass, one stone passively incumbent on another; but in the Gothic vaults and traceries there is a stiffness analogous to that of the bones of a limb, or fibres of a tree; an elastic tension and communication of force from part to part, and also a studious expression of this throughout every visible line of the building. And, in like manner, the Greek and Egyptian ornament is either mere surface engraving, as if the face of the wall had been stamped with a seal, or its lines are flowing, lithe, and luxuriant; in either case, there is no expression of energy in the framework of the ornament itself. But the Gothic ornament stands out in prickly independence, and frosty fortitude, jutting into crockets, and freezing into pinnacles; here starting up into a monster, there germinating into a blossom, anon knitting itself into a branch, alternately thorny, bossy, and bristly, or writhed into every form of nervous entanglement; but, even when most graceful, never for an instant languid, always quickset: erring, if at all, ever on the side of brusquerie.

The feelings or habits in the workman which give rise to this character in the work, are more complicated and various than those indicated by any other sculptural expression hitherto named. There is, first, the habit of hard and rapid working; the industry of the tribes of the North, quickened by the coldness of the climate, and giving an expression of sharp energy to all they do as opposed to the languor of the Southern tribes, however much of fire there may be in the heart of that languor, for lava itself may flow languidly. There is also the habit of finding enjoyment in the signs of cold, which is never found, I believe, in the inhabitants of countries south of the Alps. Cold is to them an unredeemed evil, to be suffered and forgotten as soon as may be; but the long winter of the North forces the Goth

(I mean the Englishman, Frenchman, Dane, or German), if he would lead a happy life at all, to find sources of happiness in foul weather as well as fair, and to rejoice in the leafless as well as in the shady forest. And this we do with all our hearts; finding perhaps nearly as much contentment by the Christmas fire as in the summer sunshine, and gaining health and strength on the ice-fields of winter, as well as among the meadows of spring. So that there is nothing adverse or painful to our feelings in the cramped and stiffened structure of vegetation checked by cold; and instead of seeking, like the Southern sculptor, to express only the softness of leafage nourished in all tenderness, and tempted into all luxuriance by warm winds and glowing rays, we find pleasure in dwelling upon the crabbed, perverse, and morose animation of plants that have known little kindness from earth or heaven, but, season after season, have had their best efforts palsied by frost, their brightest buds buried under snow, and their goodliest limbs lopped by tempest.

There are many subtle sympathies and affections which join to confirm the Gothic mind in this peculiar choice of subject; and when we add to the influence of these, the necessities consequent upon the employment of a rougher material, compelling the workman to seek for vigour of effect, rather than refinement of texture or accuracy of form, we have direct and manifest causes for much of the difference between the northern and southern cast of conception: but there are indirect causes holding a far more important place in the Gothic heart, though less immediate in their influence on design. Strength of will, independence of character, resoluteness of purpose, impatience of undue control, and that general tendency to set the individual reason against authority, and the individual deed against destiny, which, in the Northern tribes, has opposed itself throughout all ages to the languid submission, in the Southern, of thought to tradition, and purpose to fatality, are all more or less traceable in the rigid lines, vigorous and various masses, and daringly projecting and independent structure of the Northern Gothic

ornament : while the opposite feelings are in like manner legible in the graceful and softly guided waves and wreathed bands, in which Southern decoration is constantly disposed ; in its tendency to lose its independence, and fuse itself into the surface of the masses upon which it is traced ; and in the expression seen so often, in the arrangement of those masses themselves, of an abandonment of their strength to an inevitable necessity, or a listless repose.

Last, because the least essential, of the constituent elements of this noble school, was placed that of *Redundance* ; the un-calculating bestowal of the wealth of its labour. There is, indeed, much Gothic, and that of the best period, in which this element is hardly traceable, and which depends for its effect almost exclusively on loveliness of simple design and grace of uninvolved proportion : still, in the most characteristic buildings, a certain portion of their effect depends upon accumulation of ornament ; and many of those which have most influence on the minds of men, have attained it by means of this attribute alone. And although, by careful study of the school, it is possible to arrive at a condition of taste which shall be better contented by a few perfect lines than by a whole façade covered with fretwork, the building which only satisfies such a taste is not to be considered the best. For the very first requirement of Gothic architecture being, as we saw above, that it shall both admit the aid, and appeal to the admiration, of the rudest as well as the most refined minds, the richness of the work is, paradoxical as the statement may appear, a part of its humility. No architecture is so haughty as that which is simple ; which refuses to address the eye, except in a few clear and forceful lines ; which implies, in offering so little to our regards, that all it has offered is perfect ; and disdains, either by the complexity or the attractiveness of its features, to embarrass our investigation, or betray us into delight. That humility, which is the very life of the Gothic school, is shown not only in the imperfection, but in the accumulation, of ornament. The inferior rank of the workman is often

shown as much in the richness, as the roughness, of his work ; and if the co-operation of every hand, and the sympathy of every heart, are to be received, we must be content to allow the redundance which disguises the failure of the feeble, and wins the regard of the inattentive. There are, however, far nobler interests mingling, in the Gothic heart, with the rude love of decorative accumulation : a magnificent enthusiasm, which feels as if it never could do enough to reach the fulness of its ideal ; an unselfishness of sacrifice, which would rather cast fruitless labour before the altar than stand idle in the market ; and, finally, a profound sympathy with the fulness and wealth of the material universe, rising out of that Naturalism whose operation we have already endeavoured to define. The sculptor who sought for his models among the forest leaves, could not but quickly and deeply feel that complexity need not involve the loss of grace, nor richness that of repose ; and every hour which he spent in the study of the minute and various work of Nature, made him feel more forcibly the barrenness of what was best in that of man : nor is it to be wondered at, that, seeing her perfect and exquisite creations poured forth in a profusion which conception could not grasp nor calculation sum, he should think that it ill became him to be niggardly of his own rude craftsmanship ; and where he saw throughout the universe a faultless beauty lavished on measureless spaces of broidered field and blooming mountain, to grudge his poor and imperfect labour to the few stones that he had raised one upon another, for habitation or memorial. The years of his life passed away before his task was accomplished ; but generation succeeded generation with unwearied enthusiasm, and the cathedral front was at last lost in the tapestry of its traceries, like a rock among the thickets and herbage of spring.

We have now, I believe, obtained a view approaching to completeness of the various moral or imaginative elements which composed the inner spirit of Gothic architecture. We have, in the second place, to define its outward form.

Now, as the Gothic spirit is made up of several elements, some of which may, in particular examples, be wanting, so the Gothic form is made up of minor conditions of form, some of which may, in particular examples, be imperfectly developed.

We cannot say, therefore, that a building is either Gothic or not Gothic in form, any more than we can in spirit. We can only say that it is more or less Gothic, in proportion to the number of Gothic forms which it unites.

There have been made lately many subtle and ingenious endeavours to base the definition of Gothic form entirely upon the roof-vaulting ; endeavours which are both forced and futile : for many of the best Gothic buildings in the world have roofs of timber, which have no more connection with the main structure of the walls of the edifice than a hat has with that of the head it protects ; and other Gothic buildings are merely enclosures of spaces, as ramparts and walls, or enclosures of gardens or cloisters, and have no roofs at all, in the sense in which the word "roof" is commonly accepted. But every reader who has ever taken the slightest interest in architecture must know that there is a great popular impression on this matter, which maintains itself stiffly in its old form, in spite of all ratiocination and definition ; namely, that a flat lintel from pillar to pillar is Grecian, a round arch Norman or Romanesque, and a pointed arch Gothic.

And the old popular notion, as far as it goes, is perfectly right, and can never be bettered. The most striking outward feature in all Gothic architecture is, that it is composed of pointed arches, as in Romanesque that it is in like manner composed of round ; and this distinction would be quite as clear, though the roofs were taken off every cathedral in Europe. And yet if we examine carefully into the real force and meaning of the term "roof," we shall perhaps be able to retain the old popular idea in a definition of Gothic architecture which shall also express whatever dependence that architecture has upon true forms of roofing.

The reader will remember that roofs were considered as generally divided into two parts : the roof proper, that is to say, the shell, vault, or ceiling, internally visible ; and the roof mask, which protects this lower roof from the weather. In some buildings these parts are united in one framework ; but, in most, they are more or less independent of each other, and in nearly all Gothic buildings there is a considerable interval between them.

Now it will often happen, as above noticed, that owing to the nature of the apartments required, or the materials at hand, the roof proper may be flat, coved, or domed, in buildings which in their walls employ pointed arches, and are, in the straitest sense of the word, Gothic in all other respects. Yet so far forth as the roofing alone is concerned, they are not Gothic unless the pointed arch be the principal form adopted either in the stone vaulting or the timbers of the roof proper.

I shall say then, in the first place, that " Gothic architecture is that which uses, if possible, the pointed arch in the roof proper." This is the first step in our definition.

Secondly, although there may be many advisable or necessary forms for the lower roof or ceiling, there is, in cold countries exposed to rain and snow, only one advisable form of the roof-mask, and that is the gable, for this alone will throw off both rain and snow from all parts of its surface as speedily as possible. Snow can lodge on the top of a dome, not on the ridge of a gable. And thus, as far as roofing is concerned, the gable is a far more essential feature of Northern architecture than the pointed vault, for the one is a thorough necessity, the other often a graceful conventionality ; the gable occurs in the timber roof of every dwelling-house and every cottage, but not the vault ; and the gable built on a polygonal or circular plan, is the origin of the turret and spire ; and all the so-called aspiration of Gothic architecture is nothing more than its development. So that we must add to our definition another clause, which will be, at

present, by far the most important, and it will stand thus :
" Gothic architecture is that which uses the pointed arch for the
roof proper, and the gable for the roof-mask."

The reader will also remember that I carefully extended my
definition of a roof so as to include more than is usually under-
stood by the term. It was there said to be the covering of a
space, *narrow or wide*. It does not in the least signify, with respect
to the real nature of the covering, whether the space protected
be two feet wide, or ten ; though in the one case we call the
protection an arch, in the other a vault or roof. But the real
point to be considered is, the manner in which this protection
stands, and not whether it is narrow or broad. We call the
vaulting of a bridge "an arch," because it is narrow with respect
to the river it crosses ; but if it were built above us on the ground,
we should call it a waggon vault, because then we should feel
the breadth of it. The real question is the nature of the curve, not
the extent of space over which it is carried : and this is more
the case with respect to Gothic than to any other architecture ;
for, in the greater number of instances, the form of the roof is
entirely dependent on the ribs ; the domical shells being con-
structed in all kinds of inclinations, quite indeterminable by the
eye, and all that is definite in their character being fixed by the
curves of the ribs.

Let us then consider our definition as including the narrowest
arch or tracery bar, as well as the broadest roof, and it will be
nearly a perfect one. For the fact is, that all good Gothic is
nothing more than the development, in various ways, and on
every conceivable scale, of the group formed by the *pointed arch
for the bearing line* below, and *the gable for the protecting line* above ;
and from the huge, grey, shaly slope of the cathedral and with
its elastic pointed vaults beneath, to the slight crown-line points
that enrich the smallest niche of its doorway, one law and one
expression will be found in all. The modes of support and of
decoration are infinitely various, but the real character of the
building, in all good Gothic, depends upon the single lines of

the gable over the pointed arch, Fig. XVII, endlessly rearranged or repeated.

Let us try whether we cannot get the forms of the other great architectures of the world broadly expressed by relations of the same lines into which we have compressed the Gothic. We may easily do this if the reader will first allow me to remind him of the true nature of the pointed arch. It was said that it ought to be called a "curved gable," for, strictly speaking, an "arch" cannot be "pointed." The so-called pointed arch ought always to be considered as a gable, with its sides curved in order to enable them to bear pressure from without. Thus considering it, there are but three ways in which an interval between piers can be bridged,—the three ways represented by A, B, and C, Fig. XVIII, the next page,—A, the lintel ; B, the round arch ; C, the gable. All the architects in the world will never discover any other ways of bridging a space than these three ; they may vary the curve of the arch, or curve the sides of the gable or break them ; but in doing this they are merely modifying or subdividing not adding to the generic forms.

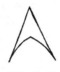

FIG. XVII

Now there are three good architectures in the world, and there never can be more, correspondent to each of these three simple ways of covering in a space, which is the original function of all architectures. And those three architectures are *pure* exactly in proportion to the simplicity and directness with which they express the condition of roofing on which they are founded. They have many interesting varieties, according to their scale, manner of decoration, and character of the nations by whom they are practised, but all their varieties are finally referable to the three great heads—

A. Greek : Architecture of the Lintel.

B. Romanesque : Architecture of the Round Arch.

C. Gothic : Architecture of the Gable.

The three names, Greek, Romanesque, and Gothic, are indeed

inaccurate when used in this vast sense, because they imply national limitations; but the three architectures may nevertheless not unfitly receive their names from those nations by whom they were carried to the highest perfection. We may thus briefly state their existing varieties.

A. *Greek*: Lintel Architecture. The worst of the three; and, considered with reference to stone construction, always in some measure barbarous. Its simplest type is Stonehenge;

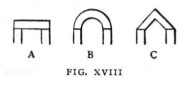

FIG. XVIII

its most refined, the Parthenon; its noblest, the Temple of Karnak.

In the hands of the Egyptian, it is sublime; in those of the Greek, pure; in those of the Roman, rich; and in those of the Renaissance builder, effeminate.

B. *Romanesque:* Round-arch Architecture. Never thoroughly developed until Christian times. It falls into two great branches, Eastern and Western, or Byzantine and Lombardic; changing respectively in process of time, with certain helps from each other, into Arabian Gothic, and Teutonic Gothic. Its most perfect Lombardic type is the Duomo of Pisa; its most perfect Byzantine type (I believe), St. Mark's at Venice. Its highest glory is, that it has no corruption. It perishes in giving birth to another architecture as noble as itself.

C. *Gothic:* Architecture of the Gable. The daughter of the Romanesque; and, like the Romanesque, divided into two great branches, Western and Eastern, or Pure Gothic and Arabian Gothic; of which the latter is called Gothic, only because it has many Gothic forms, pointed arches, vaults, etc., but its spirit remains Byzantine, more especially in the form of the roof-mask, of which, with respect to these three great families, we have next to determine the typical form.

For, observe, the distinctions we have hitherto been stating depend on the form of the stones first laid from pier to pier;

that is to say, of the simplest condition of roofs proper. Adding the relations of the roof-mask to these lines, we shall have the perfect type of form for each school.

In the Greek, the Western Romanesque, and Western Gothic, the roof-mask is the gable; in the Eastern Romanesque, and Eastern Gothic, it is the dome : but I have not studied the roofing of either of these last two groups, and shall not venture to generalise them in a diagram. But the three groups, in the hands of the Western builders, may be thus simply represented : *a*, Fig. XIX, Greek; *b*, Western Romanesque; *c*, Western, or true, Gothic.

Now, observe, first, that the relation of the roof-mask to the roof proper, in the Greek type, forms that pediment which gives its most striking character to the temple, and is the principal recipient of its sculptural decoration. The relation of these lines, therefore, is just as important in the Greek as in the Gothic schools.

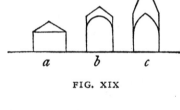

FIG. XIX

Secondly, the reader must observe the difference of steepness in the Romanesque and Gothic gables. This is not an unimportant distinction, nor an undecided one. The Romanesque gable does not pass gradually into the more elevated form ; there is a great gulf between the two ; the whole effect of all Southern architecture being dependent upon the use of the flat gable, and of all Northern upon that of the acute. I need not here dwell upon the difference between the lines of an Italian village, or the flat tops of most Italian towers, and the peaked gables and spires of the North, attaining their most fantastic development, I believe, in Belgium : but it may be well to state the law of separation, namely, that a Gothic gable *must* have all its angles acute, and a Romanesque one *must* have the upper one obtuse ; or, to give the reader a simple practical rule, take any

gable, *a* or *b*, Fig. XX, and strike a semicircle on its base ; if its top rises above the semicircle, as at *b*, it is a Gothic gable ; if it falls beneath it, a Romanesque one, but the best forms in each group are those which are distinctly steep, or distinctly low. In the figure, *f* is, perhaps, the average of Romanesque slope, and *g* of Gothic.

We have thus determined the relation of Gothic to the other architectures of the world, as far as regards the main lines of its construction ; but there is still one word which needs to be

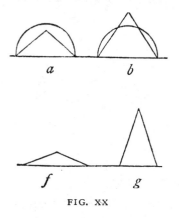

a *b*

f *g*

FIG. XX

added to our definition of its form, with respect to a part of its decoration, which rises out of that construction. We have seen that the first condition of its form is, that it shall have pointed arches. When Gothic is perfect, therefore, it will follow that the pointed arches must be built in the strongest possible manner.

The subject of the masonry of the pointed arch has already been discussed at length, and the conclusion deduced, that of all possible forms of the pointed arch (a certain weight of material being given), that generically represented at *e*, Fig. XXI, is the strongest. In fact, the reader can see in a moment that the weakness of the pointed arch is in its flanks, and that by merely thickening them gradually at this point all chance of fracture is removed. Or, perhaps, more simply still :—Suppose a gable built of stone, as at *a*, and pressed upon from without by a weight in the direction of the arrow, clearly it would be liable to fall in, as at *b*. To prevent this, we make a pointed arch of it, as at *c* ; and now it cannot fall inwards, but if pressed upon from above may give way outwards, as at *d*. But at last we build it as at *e*, and now it can neither fall out nor in.

The forms of arch thus obtained, with a pointed projection called a cusp on each side, must for ever be delightful to the human mind, as being expressive of the utmost strength and permanency obtainable with a given mass of material. But it was not by any such process of reasoning, nor with any reference to laws of construction, that the cusp was originally invented. It is merely the special application to the arch of the great ornamental system of FOLIATION; or the adaptation of the forms of leafage which has been above insisted upon as the principal characteristic of Gothic Naturalism. This love of foliage was exactly proportioned, in its intensity, to the increase of strength in the Gothic spirit: in the Southern Gothic it is *soft* leafage that is most loved; in the Northern, *thorny* leafage. And if we take up any Northern illuminated manuscript of the great Gothic time, we shall find every one of its leaf ornaments surrounded by a thorny structure laid round it in gold or in colour.

FIG. XXI

The system, then, of what is called Foliation, whether simple, as in the cusped arch, or complicated, as in tracery, rose out of this love of leafage; not that the form of the arch is intended to *imitate* a leaf, but *to be invested with the same characters of beauty which the designer had discovered in the leaf.* Observe, there is a wide difference between these two intentions. The idea that large Gothic structure, in arches and roofs, was intended to imitate vegetation, is untenable for an instant in the front of facts. But

the Gothic builder perceived that, in the leaves which he copied for his minor decorations, there was a peculiar beauty, arising from certain characters of curvature in outline, and certain methods of subdivision and of radiation in structure. On a small scale, in his sculptures and his missal-painting, he copied the leaf or thorn itself; on a large scale he adopted from it its abstract sources of beauty, and gave the same kind of curvatures and the same species of subdivision to the outline of his arches, so far as was consistent with their strength, never, in any single instance, suggesting the resemblance to leafage by irregularity of outline, but keeping the structure perfectly simple, and, as we have seen, so consistent with the best principles of masonry, that in the finest Gothic designs of arches, which are always single-cusped (the cinquefoiled arch being licentious, though in early work often very lovely), it is literally impossible, without consulting the context of the building, to say whether the cusps have been added for the sake of beauty or of strength; nor, though in mediæval architecture they were, I believe, assuredly first employed in mere love of their picturesque form, am I absolutely certain that their earliest invention was not a structural effort.

It is evident, however, that the structural advantage of the cusp is available only in the case of arches on a comparatively small scale. If the arch becomes very large, the projections under the flanks must become too ponderous to be secure; the suspended weight of stone would be liable to break off, and such arches are therefore never constructed with heavy cusps, but rendered secure by general mass of masonry; and what additional appearance of support may be thought necessary (sometimes a considerable degree of *actual* support) is given by means of tracery.

Tracery began in the use of penetrations through the stone-work of windows or walls, cut into forms which looked like stars when seen from within, and like leaves when seen from without; the name foil or feuille being universally applied to the separate lobes of their extremities, and the pleasure received

186

from them being the same as
that which we feel in the triple,
quadruple, or other radiated
leaves of vegetation, joined with
the perception of a severely
geometrical order and sym-
metry. A few of the most com-
mon forms are represented, un-
confused by exterior mouldings,
in Fig. XXII, and the best
traceries are nothing more than
close clusters of such forms,
with mouldings following their
outlines.

The term " foliated," there-
fore, is equally descriptive of
the most perfect conditions
both of the simple arch and
of the traceries by which in
later Gothic it is filled : and this

FIG. XXII

foliation is an essential character of the style. No Gothic is either
good or characteristic, which is not foliated either in its arches
or apertures. Sometimes the bearing arches are foliated, and the
ornamentation above composed of figure sculpture ; sometimes
the bearing arches are plain, and the ornamentation above them
is composed of foliated apertures. But the element of foliation
must enter somewhere, or the style is imperfect. And our final
definition of Gothic will, therefore, stand thus :—" *Foliated*
Architecture, which uses the pointed arch for the roof proper,
and the gable for the roof-mask."

We have now, I believe, obtained a sufficiently accurate
knowledge both of the spirit and form of Gothic architecture ;
but it may, perhaps, be useful to the general reader, if, in con-
clusion, I set down a few plain and practical rules for determining,
in every instance, whether a given building be good Gothic or

not, and, if not Gothic, whether its architecture is of a kind which will probably reward the pains of careful examination.

First, look if the roof rises in a steep gable, high above the walls. If it does not do this, there is something wrong : the building is not quite pure Gothic, or has been altered.

Secondly, look if the principal windows and doors have pointed arches with gables over them. If not pointed arches, the building is not Gothic ; if they have not any gables over them, it is either not pure, or not first-rate.

If, however, it has the steep roof, the pointed arch, and gable all united, it is nearly certain to be a Gothic building of a very fine time.

Thirdly, look if the arches are cusped, or apertures foliated. If the building has met the first two conditions, it is sure to be foliated somewhere ; but, if not everywhere, the parts which are unfoliated are imperfect, unless they are large bearing arches, or small and sharp arches in groups, forming a kind of foliation by their own multiplicity, and relieved by sculpture and rich mouldings. The upper windows, for instance, in the east end of Westminster Abbey are imperfect for want of foliation. If there be no foliation anywhere, the building is assuredly imperfect Gothic.

Fourthly, if the building meets all the first three conditions, look if its arches in general, whether of windows and doors, or of minor ornamentation, are carried on *true shafts with bases and capitals*. If they are, then the building is assuredly of the finest Gothic style. It may still, perhaps, be an imitation, a feeble copy, or a bad example, of a noble style ; but the manner of it, having met all these four conditions, is assuredly first-rate.

If its apertures have not shafts and capitals, look if they are plain openings in the walls, studiously simple, and unmoulded at the sides. If so, the buildings may still be of the finest Gothic adapted to some domestic or military service. But if the sides of the window be moulded, and yet there are no capitals at the spring of the arch, it is assuredly of an inferior school.

This is all that is necessary to determine whether the building be of fine Gothic style. The next tests to be applied are in order to discover whether it be good architecture or not; for it may be very impure Gothic, and yet very noble architecture; or it may be very pure Gothic, and yet if a copy, or originally raised by an ungifted builder, very bad architecture.

If it belong to any of the great schools of colour, its criticism becomes as complicated, and needs as much care, as that of a piece of music, and no general rules for it can be given; but if not—

First, see if it looks as if it had been built by strong men; if it has the sort of roughness, and largeness, and nonchalance, mixed in places with the exquisite tenderness which seems always to be the sign-manual of the broad vision, and massy power of men who can see *past* the work they are doing, and betray here and there something like disdain for it. If the building has this character, it is much already in its favour; it will go hard but it proves a noble one. If it has not this, but is altogether accurate, minute, and scrupulous in its workmanship, it must belong to either the very best or the very worst of schools: the very best, in which exquisite design if wrought out with untiring and conscientious care, as in the Giottesque Gothic; or the very worst, in which mechanism has taken the place of design. It is more likely, in general, that it should belong to the worst than the best: so that, on the whole, very accurate workmanship is to be esteemed a bad sign; and if there is nothing remarkable about the building but its precision, it may be passed at once with contempt.

Secondly, observe if it be irregular, its different parts fitting themselves to different purposes, no one caring what becomes of them, so that they do their work. If one part always answers accurately to another part, it is sure to be a bad building; and the greater and more conspicuous the irregularities, the greater the chances are that it is a good one. For instance, in the Ducal Palace, of which a rough drawing is given on Plate IV, facing

page 193, the general idea is sternly symmetrical; but two windows are lower than the rest of the six; and if the reader will count the arches of the small arcade as far as to the great balcony, he will find it is not in the centre, but set to the right-hand side by the whole width of one of those arches. We may be pretty sure that the building is a good one; none but a master of his craft would have ventured to do this.

Thirdly, observe if all the traceries, capitals, and other ornaments are of perpetually varied design. If not, the work is assuredly bad.

Lastly, *Read* the sculpture. Preparatory to reading it, you will have to discover whether it is legible (and, if legible, it is nearly certain to be worth reading). On a good building, the sculpture is *always* so set, and on such a scale, that at the ordinary distance from which the edifice is seen, the sculpture shall be thoroughly intelligible and interesting. In order to accomplish this, the uppermost statues will be ten or twelve feet high, and the upper ornamentation will be colossal, increasing in fineness as it descends, till on the foundation it will often be wrought as if for a precious cabinet in a king's chamber; but the spectator will not notice that the upper sculptures are colossal. He will merely feel that he can see them plainly, and make them all out at his ease.

And having ascertained this, let him set himself to read them. Thenceforward the criticism of the building is to be conducted precisely on the same principles as that of a book; and it must depend on the knowledge, feeling, and not a little on the industry and perseverance of the reader, whether, even in the case of the best works, he either perceive them to be great, or feel them to be entertaining.

CHAPTER V

THE DUCAL PALACE

" The chapter on the Ducal Palace . . .
quite one of the most important pieces of
work done in my life. . . ." *Ruskin in* 1879

THE BUILDINGS out of the remnants of which we have
endeavoured to recover some conception of the appearance of
Venice during the Byzantine period, contribute hardly anything
at this day to the effect of the streets of the city. They are too
few and too much defaced to attract the eye or influence the
feelings. The charm which Venice still possesses, and which for
the last fifty years[1] has rendered it the favourite haunt of all the
painters of picturesque subject, is owing to the effect of the
palaces belonging to the period we have now to examine,
mingled with those of the Renaissance.

This effect is produced in two different ways. The Renaissance
palaces are not more picturesque in themselves than the club-
houses of Pall Mall ; but they become delightful by the contrast
of their severity and refinement with the rich and rude confusion
of the sea-life beneath them, and of their white and solid masonry
with the green waves. Remove from beneath them the orange
sails of the fishing-boats, the black gliding of the gondolas, the
cumbered decks and rough crews of the barges of traffic, and the
fretfulness of the green water along their foundations, and the
Renaissance palaces possess no more interest than those of
London or Paris. But the Gothic palaces are picturesque in
themselves, and wield over us an independent power. Sea and

[1] Written in 1853. Ed.

sky, and every other accessory, might be taken away from them, and still they would be beautiful and strange. They are not less striking in the loneliest streets of Padua and Vicenza (where many were built during the period of the Venetian authority in those cities) than in the most crowded thoroughfares of Venice itself; and if they could be transported into the midst of London, they would still not altogether lose their power over the feelings.

The best proof of this is in the perpetual attractiveness of all pictures, however poor in skill, which have taken for their subject the principal of these Gothic buildings, the Ducal Palace. In spite of all architectural theories and teachings, the paintings of this building are always felt to be delightful; we cannot be wearied by them, though often sorely tried; but we are not put to the same trial in the case of the palaces of the Renaissance. They are never drawn singly, or as the principal subject, nor can they be. The building which faces the Ducal Palace on the opposite side of the Piazzetta is celebrated among architects, but it is not familiar to our eyes; it is painted only incidentally, for the completion, not the subject, of a Venetian scene; and even the Renaissance arcades of St. Mark's Place, though frequently painted, are always treated as a mere avenue to its Byzantine church and colossal tower. And the Ducal Palace itself owes the peculiar charm which we have hitherto felt, not so much to its greater size as compared with other Gothic buildings, or nobler design (for it never yet has been rightly drawn), as to its comparative isolation. The other Gothic structures are as much injured by the continual juxtaposition of the Renaissance palaces, as the latter are aided by it; they exhaust their own life by breathing it into the Renaissance coldness: but the Ducal Palace stands comparatively alone, and fully expresses the Gothic power.

And it is just that it should be so seen, for it is the original of nearly all the rest. It is not the elaborate and more studied development of a national style, but the great and sudden

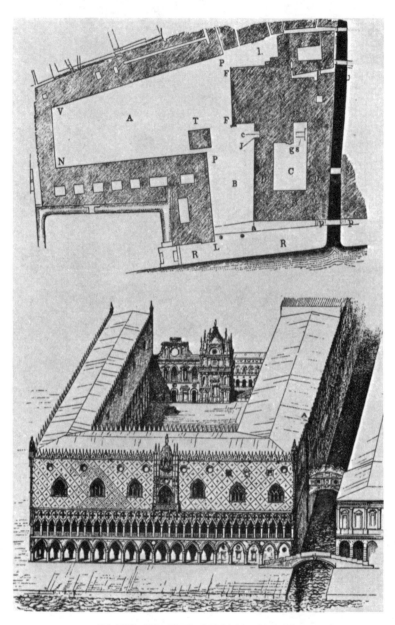

PLATE IV: THE DUCAL PALACE

(a) ground-plan; (b) general view

invention of one man, instantly forming a national style, and becoming the model for the imitation of every architect in Venice for upwards of a century. It was the determination of this one fact which occupied me the greater part of the time I spent in Venice. It had always appeared to me most strange that there should be in no part of the city any incipient or imperfect types of the form of the Ducal Palace; it was difficult to believe that so mighty a building had been the conception of one man, not only in disposition and detail, but in style; and yet impossible, had it been otherwise, but that some early examples of approximate Gothic form must exist. There is not one. The palaces built between the final cessation of the Byzantine style, about 1300, and the date of the Ducal Palace (1320–1350), are all completely distinct in character; and there is literally *no* transitional form between them and the perfection of the Ducal Palace. Every Gothic building in Venice which resembles the latter is a copy of it.

The fact is, that the Ducal Palace was the great work of Venice at this period, itself the principal effort of her imagination, employing her best architects in its masonry, and her best painters in its decoration, for a long series of years; and we must receive it as a remarkable testimony to the influence which it possessed over the minds of those who saw it in its progress, that, while in the other cities of Italy every palace and church was rising in some original and daily more daring form, the majesty of this single building was able to give pause to the Gothic imagination in its full career; stayed the restlessness of innovation in an instant, and forbade the powers which had created it thenceforth to exert themselves in new directions, or endeavour to summon an image more attractive.

The reader will hardly believe that while the architectural invention of the Venetians was thus lost, Narcissus-like, in self-contemplation, the various accounts of the progress of the building thus admired and beloved are so confused as frequently to leave it doubtful to what portion of the palace they refer; and

that there is actually, at the time being, a dispute between the best Venetian antiquaries, whether the main façade of the palace be of the fourteenth or fifteenth century.

Before the reader can enter upon any inquiry into the history of this building, it is necessary that he should be thoroughly familiar with the arrangement and names of its principal parts, as it at present stands. I must do what I can, by the help of a rough plan and bird's-eye view, to give him the necessary topographical knowledge :

Plate IVa, (p. 193) is a rude ground-plan of the buildings round St. Mark's Place ; and the following references will clearly explain their relative positions :

A. St. Mark's Place.

B. Piazzetta.

P. V. Procuratie Vecchie.

P. N. (opposite) Procuratie Nuove.

P. L. Libreria Vecchia.

1. Piazzetta de' Leoni.

T. Tower of St. Mark.

F F. Great Façade of St. Mark's Church.

M. St. Mark's. (It is so united with the Ducal Palace, that the separation cannot be indicated in the plan, unless all the walls had been marked, which would have confused the whole.)

D D D. Ducal Palace.

C. Court of Ducal Palace.

c. Porta della Carta.

p. p. Ponte della Paglia (Bridge of Straw).

S. Ponte de' Sospiri (Bridge of Sighs).

R R. Riva de' Schiavoni.

g s. Giant's stair.

J. Judgment angle.

a. Fig-tree angle.

The reader will observe that the Ducal Palace is arranged

somewhat in the form of a hollow square, of which one side faces the Piazzetta, B, and another the quay called the Riva de' Schiavoni, R R ; the third is on the dark canal called the " Rio del Palazzo," and the fourth joins the Church of St. Mark.

Of this fourth side, therefore, nothing can be seen. Of the other three sides we shall have to speak constantly ; and they will be respectively called, that towards the Piazzetta, the " Piazzetta Façade ;" that towards the Riva de' Schiavoni, the " Sea Façade ;" and that towards the Rio del Palazzo, the " Rio Façade." This Rio, or canal, is usually looked upon by the traveller with great respect, or even horror, because it passes under the Bridge of Sighs. It is, however, one of the principal thoroughfares of the city ; and the bridge and its canal together occupy, in the mind of a Venetian, very much the position of Fleet Street and Temple Bar[1] in that of a Londoner,—at least, at the time when Temple Bar was occasionally decorated with human heads. The two buildings closely resemble each other in form.

We must now proceed to obtain some rough idea of the appearance and distribution of the palace itself ; but its arrangement will be better understood by supposing ourselves raised some hundred and fifty feet above the point in the lagoon in front of it, so as to get a general view of the Sea Façade and Rio Façade and to look down into its interior court. Plate IVb roughly represents such a view, omitting all details on the roofs, in order to avoid confusion. In this drawing we have merely to notice that, of the two bridges seen on the right, the uppermost, above the black canal, is the Bridge of Sighs ; the lower one is the Ponte della Paglia, the regular thoroughfare from quay to quay, and, I believe, called the Bridge of Straw, because the boats which brought straw from the mainland used to sell it at this place. The corner of the palace, rising above this bridge, and formed by the meeting of the Sea Façade and Rio Façade, will always be called the Vine angle, because it is decorated by a

[1] Not removed from Fleet Street until 1878. Ed.

sculpture of the drunkenness of Noah. The angle opposite will
be called the Fig-tree angle, because it is decorated by a sculpture
of the Fall of Man. The long and narrow range of building, of
which the roof is seen in perspective behind this angle, is the
part of the palace fronting the Piazzetta; and the angle under
the pinnacle most to the left of the two which terminate it will
be called, for a reason presently to be stated, the Judgment angle.
Within the square formed by the building is seen its interior
court (with one of its wells), terminated by small and fantastic
buildings of the Renaissance period, which face the Giant's
Stair, of which the extremity is seen sloping down on the right.

The great façade which fronts the spectator looks south-
ward. Hence the two traceried windows lower than the rest, and
to the right of the spectator, may be conveniently distinguished
as the " Eastern Windows." There are two others like them,
filled with tracery, and at the same level, which look upon the
narrow canal between the Ponte della Paglia and the Bridge of
Sighs : these we may conveniently call the " Canal Windows."
The reader will observe a vertical line, marked A, in this dark
side of the palace, separating its nearer and plainer wall from a
long four-storied range of rich architecture. This more distant
range is entirely Renaissance : its extremity is not indicated,
because I have no accurate sketch of the small buildings and
bridges beyond it, and we shall have nothing whatever to do
with this part of the palace in our present inquiry.[1] The nearer
and undecorated wall is part of the older palace, though much
defaced by modern opening of common windows, refittings of
the brick-work, etc.

It will be observed that the façade is composed of a smooth
mass of wall, sustained on two tiers of pillars, one above the
other. The manner in which these support the whole fabric
will be understood at once by the rough section, Fig. XXIII,
which is supposed to be taken right through the palace to the
interior court, from near the middle of the Sea Façade. Here

[1] But see pp. 231-2. Ed.

a and *d* are the rows of shafts, both in the inner court and on the façade, which carry the main walls; *b*, *c* are solid walls variously strengthened with pilasters. A, B, C are the three stories of the interior of the palace.

The reader sees that it is impossible for any plan to be more simple, and that if the inner floors and walls of the stories, A, B were removed, there would be left merely the form of a basilica, —two high walls, carried on ranges of shafts, and roofed by a low gable.

The stories A, B are entirely modernised, and divided into confused ranges of small apartments, among which what vestiges remain of ancient masonry are entirely undecipherable, except by investigations such as I have had neither the time nor, as in most cases they would involve the removal of modern plastering, the opportunity, to make. With the subdivisions of this story, therefore, I shall not trouble the reader; but those of the great upper story, C, are highly important.

In the bird's-eye view above, Plate IVb, it will be noticed that the two windows on the right are lower than the other four of the façade. In this arrangement there is one of the most remarkable instances I know of the daring sacrifice of symmetry to convenience, which was noticed as one of the chief noblenesses of the Gothic schools.

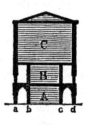

FIG. XXIII

The part of the palace in which the two lower windows occur was first built, and arranged in four stories in order to obtain the necessary number of apartments. Owing to circumstances, of which we shall presently give an account, it became necessary, in the beginning of the fourteenth century, to provide another large and magnificent chamber for the meeting of the Senate. That chamber was added at the side of the older building; but, as only one room was wanted, there was no need to divide the added portion into two stories. The entire height was given to

the single chamber, being indeed not too great for just harmony with its enormous length and breadth. And then came the question how to place the windows, whether on a line with the two others, or above them.

The ceiling of the new room was to be adorned by the paintings of the best masters in Venice, and it became of great importance to raise the light near that gorgeous roof, as well as to keep the tone of illumination in the Council Chamber serene ; and therefore to introduce light rather in simple masses than in many broken streams. A modern architect, terrified at the idea of violating external symmetry, would have sacrificed both the pictures and the peace of the Council. He would have placed the larger windows at the same level with the other two, and have introduced above them smaller windows, like those of the upper story in the older building, as if that upper story had been continued along the façade. But the old Venetian thought of the honour of the paintings, and the comfort of the Senate, before his own reputation. He unhesitatingly raised the large windows to their proper position with reference to the interior of the chamber, and suffered the external appearance to take care of itself. And I believe the whole pile rather gains than loses in effect by the variation thus obtained in the spaces of wall above and below the windows.

On the party wall, between the second and third windows, which faces the eastern extremity of the Great Council Chamber, is painted the Paradise of Tintoret ; and this wall will therefore be hereafter called the " Wall of the Paradise."

In nearly the centre of the Sea Façade, and between the first and second windows of the Great Council Chamber, is a large window to the ground, opening on a balcony, which is one of the chief ornaments of the palace, and will be called in future the " Sea Balcony."

The façade which looks on the Piazzetta is very nearly like this to the Sea, but the greater part of it was built in the fifteenth century, when people had become studious of their symmetries.

Its side windows are all on the same level. Two light the west end of the Great Council Chamber, one lights a small room anciently called the Quarantia Civil Nuova; the other three, and the central one, with a balcony like that to the Sea, light another large chamber, called Sala del Scrutinio, or "Hall of Inquiry," which extends to the extremity of the palace above the Porta della Carta.

The reader is now well enough acquainted with the topography of the existing building, to be able to follow the accounts of its history.

We have seen above, that there were three principal styles of Venetian architecture; Byzantine, Gothic, and Renaissance.

The Ducal Palace, which was the great work of Venice, was built successively in the three styles. There was a Byzantine Ducal Palace, a Gothic Ducal Palace, and a Renaissance Ducal Palace. The second superseded the first totally: a few stones of it (if indeed so much) are all that is left. But the third superseded the second in part only, and the existing building is formed by the union of the two.

We shall review the history of each in succession.

1. *The Byzantine Palace*—In the year of the death of Charlemagne, 813, the Venetians determined to make the island of Rialto the seat of the government and capital of their state. Their Doge, Angelo or Agnello Participazio, instantly took vigorous means for the enlargement of the small group of buildings which were to be the nucleus of the future Venice. He appointed persons to superintend the raising of the banks of sand, so as to form more secure foundations, and to build wooden bridges over the canals. For the offices of religion, he built the Church of St. Mark; and on, or near, the spot where the Ducal Palace now stands, he built a palace for the administration of the government.

The history of the Ducal Palace, therefore, begins with the birth of Venice, and to what remains of it, at this day, is entrusted the last representation of her power.

Of the exact position and form of this palace of Participazio little is ascertained. Sansovino says that it was " built near the Ponte della Paglia, and answeringly on the Grand Canal,"[1] towards San Giorgio ; that is to say, in the place now occupied by the Sea Façade ; but this was merely the popular report of his day. We know, however, positively, that it was somewhere upon the site of the existing palace ; and that it had an important front towards the Piazzetta, with which the present palace at one period was incorporated. We know, also, that it was a pile of some magnificence, from the account given by Sagornino of the visit paid by the Emperor Otho the Great, to the Doge Pietro Orseolo II. The chronicler says that the emperor " beheld carefully all the beauty of the palace;" and the Venetian historians express pride in the building's being worthy of an emperor's examination. This was after the palace had been much injured by fire in the revolt against Candiano IV, and just repaired, and richly adorned by Orseolo himself, who is spoken of by Sagornino as having also "adorned the chapel of the Ducal Palace" (St. Mark's) with ornaments of marble and gold. There can be no doubt whatever that the palace at this period resembled and impressed the other Byzantine edifices of the city, such as the Fondaco de' Turchi, etc., and that, like them, it was covered with sculpture, and richly adorned with gold and colour.

In the year 1106, it was for the second time injured by fire, but repaired before 1116, when it received another emperor, Henry V (of Germany), and was again honoured by imperial praise. Between 1173 and the close of the century, it seems to have been again repaired and much enlarged by the Doge Sebastian Ziani. Sansovino says that this Doge not only repaired it, but "enlarged it in every direction ;" and, after this enlarge-

[1] What I call the Sea, was called "the Grand Canal" by the Venetians, as well as the great water street of the city; but I prefer calling it "the Sea," in order to distinguish between that street and the broad water in front of the Ducal Palace, which, interrupted only by the island of San Giorgio, stretches for many miles to the south, and for more than two to the boundary of the Lido. It was the deeper channel, just in front of the Ducal Palace, continuing the line of the great water street itself which the Venetians spoke of as "the Grand Canal."

ment, the palace seems to have remained untouched for a hundred years, until, in the commencement of the fourteenth century, the works of the Gothic Palace were begun. As, therefore, the old Byzantine building was, at the time when those works first interfered with it, in the form given to it by Ziani, I shall hereafter always speak of it as the *Ziani* Palace ; and this the rather, because the only chronicler whose words are perfectly clear respecting the existence of part of this palace so late as the year 1422, speaks of it as built by Ziani. The old " Palace, of which half remains to this day, was built, as we now see it, by Sebastian Ziano."

So far, then, of the Byzantine Palace.

2. *The Gothic Palace*—The important change in the Venetian government which gave stability to the aristocratic power took place about the year 1297, under the Doge Pietro Gradenigo, a man thus characterised by Sansovino :—" A prompt and prudent man, of unconquerable determination and great eloquence, who laid, so to speak, the foundations of the eternity of this republic, by the admirable regulations which he introduced into the government."

We may now, with some reason, doubt of their admirableness ; but their importance, and the vigorous will and intellect of the Doge, are not to be disputed. Venice was in the zenith of her strength, and the heroism of her citizens was displaying itself in every quarter of the world. The acquiescence in the secure establishment of the aristocratic power was an expression, by the people, of respect for the families which had been chiefly instrumental in raising the commonwealth to such a height of prosperity.

The Serrar del Consiglio fixed the numbers of the Senate within certain limits, and it conferred upon them a dignity greater than they had ever before possessed. It was natural that the alteration in the character of the assembly should be attended by some change in the size, arrangement, or decoration of the chamber in which they sat.

We accordingly find it recorded by Sansovino, that "in 1301 another saloon was begun on the Rio del Palazzo, *under the Doge Gradenigo*, and finished in 1309, *in which year the Grand Council first sat in it*." In the first year, therefore, of the fourteenth century, the Gothic Ducal Palace of Venice was begun; and as the Byzantine Palace was, in its foundation, coeval with that of the state, so the Gothic Palace was, in its foundation, coeval with that of the aristocratic power. Considered as the principal representation of the Venetian school of architecture, the Ducal Palace is the Parthenon of Venice, and Gradenigo its Pericles.

Sansovino, with a caution very frequent among Venetian historians, when alluding to events connected with the Serrar del Consiglio, does not specially mention the cause for the requirement of the new chamber; but the Sivos Chronicle is a little more distinct in expression. "In 1301, it was determined to build a great saloon *for the assembling* of the Great Council, and the room was built which is *now* called the Sala del Scrutinio." *Now*, that is to say, at the time when the Sivos Chronicle was written: the room has long ago been destroyed, and its name given to another chamber on the opposite side of the palace: but I wish the reader to remember the date 1301, as marking the commencement of a great architectural epoch, in which took place the first appliance of the energy of the aristocratic power, and of the Gothic style, to the works of the Ducal Palace. The operations then begun were continued, with hardly an interruption, during the whole period of the prosperity of Venice. We shall see the new buildings consume, and take the place of, the Ziani Palace, piece by piece; and when the Ziani Palace was destroyed, they fed upon themselves; being continued round the square, until, in the sixteenth century, they reached the point where they had been begun in the fourteenth, and pursued the track they had then followed some distance beyond the junction; destroying or hiding their own commencement, as the serpent, which is the type of eternity, conceals its tail in its jaws.

We cannot, therefore, *see* the extremity, wherein lay the sting

and force of the whole creature,—the chamber, namely, built by the Doge Gradenigo ; but the reader must keep that commencement and the date of it carefully in his mind. The body of the Palace Serpent will soon become visible to us.

The Gradenigo Chamber was somewhere on the Rio Façade, behind the present position of the Bridge of Sighs ; *i.e.*, about the point marked on the roof by the dotted lines in the drawing : it is not known whether low or high, but probably on a first story. The great façade of the Ziani Palace being, as above mentioned, on the Piazzetta, this chamber was as far back and out of the way as possible ; secrecy and security being obviously the points first considered.

But the newly constituted Senate had need of other additions to the ancient palace besides the Council Chamber. A short, but most significant, sentence is added to Sansovino's account of the construction of that room. " There were, *near it*," he says, " the Cancellaria, and the *Gheba* or *Gabbia*, afterwards called the Little Tower."[1]

Gabbia means a "cage ;" and there can be no question that certain apartments were at this time added at the top of the palace and on the Rio Façade, which were to be used as prisons. Whether any portion of the old Torresella still remains is a doubtful question ; but the apartments at the top of the palace, in its fourth story, were still used for prisons as late as the beginning of the seventeenth century. I wish the reader especially to notice that a separate tower or range of apartments was built for this purpose, in order to clear the government of the accusations so constantly made against them, by ignorant or partial historians, of wanton cruelty to prisoners. The stories commonly told respecting the "piombi" of the Ducal Palace are utterly false. Instead of being, as usually reported, small furnaces under the leads of the palace, they were comfortable rooms with good flat roofs of larch, and carefully ventilated. The new chamber,

[1] A small square tower is seen above the Vine angle in the view of Venice dated 1500, and attributed to Albert Durer. It appears about 25 feet square, and is very probably the Torresella in question.

then, and the prisons, being built, the Great Council first sat in their retired chamber on the Rio in the year 1309.

Now, observe the significant progress of events. They had no sooner thus established themselves in power than they were disturbed by the conspiracy of the Tiepolos, in the year 1310. In consequence of that conspiracy the Council of Ten was created, still under the Doge Gradenigo ; who, having finished his work and left the aristocracy of Venice armed with this terrible power, died in the year 1312, some say by poison. He was succeeded by the Doge Marino Giorgio, who reigned only one year ; and then followed the prosperous government of John Soranzo. There is no mention of any additions to the Ducal Palace during his reign, but he was succeeded by that Francesco Dandolo, the sculptures on whose tomb, still existing in the cloisters of the Salute, may be compared by any traveller with those of the Ducal Palace. Of him it is recorded in the Savina Chronicle : " This Doge also had the great gate built which is at the entry of the palace, above which is his statue kneeling, with the gonfalon in hand, before the feet of the Lion of St. Mark's."

It appears, then, that after the Senate had completed their Council Chamber and the prisons, they required a nobler door than that of the old Ziani Palace for their Magnificences to enter by. This door is twice spoken of in the government accounts of expenses, which are fortunately preserved, in the following terms :—

1335, June 1. We, Andrew Dandolo and Mark Moredano, procurators of St. Mark's, have paid to Martin the stone-cutter and his associates . . . , for a stone of which the lion is made which is put over the gate of the palace.
1344, November 4. We have paid thirty-five golden ducats for making gold leaf, to gild the lion which is over the door of the palace stairs.

The position of this door is disputed, and is of no consequence

to the reader, the door itself having long ago disappeared, and been replaced by the Porta della Carta.

But before it was finished, occasion had been discovered for further improvements. The Senate found their new Council Chamber inconveniently small, and, about thirty years after its completion, began to consider where a larger and more magnificent one might be built. The government was now thoroughly established, and it was probably felt that there was some meanness in the retired position, as well as insufficiency in the size, of the Council Chamber on the Rio. The first definite account which I find of their proceedings, under these circumstances, is in the Caroldo Chronicle:

1340. On the 28th of December, in the preceding year, Master Marco Erizzo, Nicolo Soranzo, and Thomas Gradenigo, were chosen to examine where a new saloon might be built in order to assemble therein the Greater Council. . . . On the 3rd of June, 1341, the Great Council elected two procurators of the work of this saloon, with a salary of eighty ducats a year.

It appears from the entry still preserved in the Archivio, and quoted by Cadorin, that it was on the 28th of December, 1340, that the commissioners appointed to decide on this important matter gave in their report to the Grand Council, and that the decree passed thereupon for the commencement of a new Council Chamber on the grand Canal.

The room then begun is the one now in existence, and its building involved the building of all that is best and most beautiful in the present Ducal Palace, the rich arcades of the lower stories being all prepared for sustaining this Sala del Gran Consiglio.

In saying that it is the same now in existence, I do not mean that it has undergone no alterations; it has been refitted again and again, and some portions of its walls rebuilt; but in the place and form in which it first stood, it still stands; and by a

glance at the position which its windows occupy, as shown in Plate IVb (p. 193), the reader will see at once that whatever can be known respecting the design of the Sea Façade, must be gleaned out of the entries which refer to the building of this Great Council Chamber.

Cadorin quotes two of great importance made during the progress of the work in 1342 and 1344; then one of 1349, resolving that the works at the Ducal Palace, which had been discontinued during the plague, should be resumed; and finally one in 1362, which speaks of the Great Council Chamber as having been neglected and suffered to fall into "great desolation," and resolves that it shall be forthwith completed.

The interruption had not been caused by the plague only, but by the conspiracy of Faliero, and the violent death of the master builder, Calendario. The work was resumed in 1362, and completed within the next three years, at least so far as that Guariento was enabled to paint his Paradise on the walls; so that the building must, at any rate, have been roofed by this time. Its decorations and fittings, however, were long in completion; the paintings on the roof being only executed in 1400. They represented the heavens covered with stars, this being, says Sansovino, the bearings of the Doge Steno. Almost all ceilings and vaults were at this time in Venice covered with stars, without any reference to armorial bearings; but Steno claims, under his noble title of Stellifer, an important share in completing the chamber, in an inscription upon two square tablets, now inlaid in the walls on each side of the great window towards the sea:

" *Mille quadringenti currebant quatuor anni*
Hoc opus illustris Michael dux stellifer auxit."

And in fact it is to this Doge that we owe the beautiful balcony of that window, though the work above it is partly of more recent date; and I think the tablets bearing this important inscription have been taken out and reinserted in the newer masonry. The labour of these final decorations occupied a total

period of sixty years. The Grand Council sat in the finished chamber for the first time in 1423. In that year the Gothic Ducal Palace of Venice was completed. It had taken, to build it, the energies of the entire period which I have above described as the central one of her life.

3. *The Renaissance Palace*—I must go back a step or two, in order to be certain that the reader understands clearly the state of the palace in 1423. The works of addition or renovation had now been proceeding, at intervals, during a space of a hundred and twenty-three years. Three generations at least had been accustomed to witness the gradual advancement of the form of the Ducal Palace into more steady symmetry, and to contrast the works of sculpture and painting with which it was decorated,— full of the life, knowledge, and hope of the fourteenth century,— with the rude Byzantine chiselling of the palace of the Doge Ziani. The magnificent fabric just completed, of which the new Council Chamber was the nucleus, was now habitually known in Venice as the " Palazzo Nuovo "; and the old Byzantine edifice, now ruinous, and more manifest in its decay by its contrast with the goodly stones of the building which had been raised at its side, was of course known as the " Palazzo Vecchio." That fabric, however, still occupied the principal position in Venice. The new Council Chamber had been erected by the side of it towards the sea ; but there was not then the wide quay in front, the Riva dei Schiavoni, which now renders the Sea Façade as important as that to the Piazzetta. There was only a narrow walk between the pillars and the water ; and the *old* palace of Ziani still faced the Piazzetta, and interrupted, by its decrepitude, the magnificence of the square where the nobles daily met. Every increase of the beauty of the new palace rendered the discrepancy between it and the companion building more painful ; and then began to arise in the minds of all men a vague idea of the necessity of destroying the old palace, and completing the front of the Piazzetta with the same splendour as the Sea Façade. But no such sweeping measure of renovation

had been contemplated by the Senate when they first formed the plan of their new Council Chamber. First a single additional room, then a gateway, then a larger room; but all considered merely as necessary additions to the palace, not as involving the entire reconstruction of the ancient edifice. The exhaustion of the treasury, and the shadows upon the political horizon, rendered it more than imprudent to incur the vast additional expense which such a project involved; and the Senate, fearful of itself, and desirous to guard against the weakness of its own enthusiasm, passed a decree, like the effort of a man fearful of some strong temptation to keep his thoughts averted from the point of danger. It was a decree, not merely that the old palace should not be rebuilt, but that no one should *propose* rebuilding it. The feeling of the desirableness of doing so was too strong to permit fair discussion, and the Senate knew that to bring forward such a motion was to carry it.

The decree, thus passed in order to guard against their own weakness, forbade anyone to speak of rebuilding the old palace, under the penalty of a thousand ducats. But they had rated their own enthusiasm too low: there was a man among them whom the loss of a thousand ducats could not deter from proposing what he believed to be for the good of the state.

Some excuse was given him for bringing forward the motion by a fire which occurred in 1419, and which injured both the Church of St. Mark's, and part of the old palace fronting the Piazzetta. What followed, I shall relate in the words of Sanuto.

" Therefore they set themselves with all diligence and care to repair and adorn sumptuously, first God's house: but in the Prince's house things went on more slowly, *for it did not please the Doge[1] to restore it in the form in which it was before;* and they could not rebuild it altogether in a better manner, so great was the parsimony of these old fathers; because it was forbidden by laws, which condemned in a penalty of a thousand ducats anyone

[1] Tomaso Mocenigo.

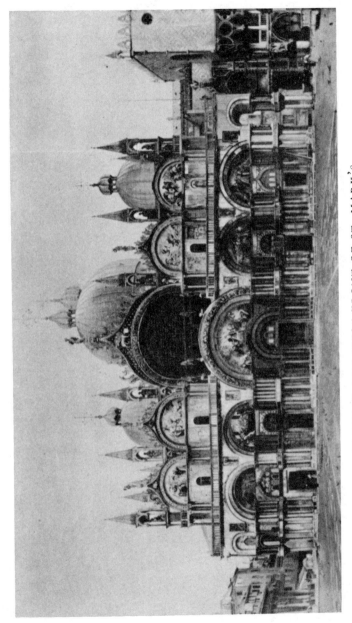

PLATE V: THE WEST FRONT OF ST. MARK'S

From an oil painting by J. W. Bunney, now in the Ruskin Museum, Sheffield. This was commissioned by Ruskin and intended as a strictly accurate architectural record. The artist is said to have spent 600 days constant labour on it

who should propose to throw down the *old* palace, and to rebuild it more richly and with greater expense. But the Doge, who was magnanimous, and who desired above all things what was honourable to the city, had the thousand ducats carried into the Senate Chamber, and then proposed that the palace should be rebuilt; saying: that, 'since the late fire had ruined in great part the Ducal habitation (not only his own private palace, but all the places used for public business), this occasion was to be taken for an admonishment sent from God, that they ought to rebuild the palace more nobly, and in a way more befitting the greatness to which, by God's grace, their dominions had reached; and that his motive in proposing this was neither ambition, nor selfish interest: that, as for ambition, they might have seen in the whole course of his life, through so many years, that he had never done anything for ambition, either in the city, or in foreign business; but in all his actions had kept justice first in his thoughts, and then the advantage of the state, and the honour of the Venetian name: and that, as far as regarded his private interest, if it had not been for this accident of the fire, he would never have thought of changing anything in the palace into either a more sumptuous or a more honourable form; and that during the many years in which he had lived in it, he had never endeavoured to make any change, but had always been content with it as his predecessors had left it; and that he knew well that, if they took in hand to build it as he exhorted and besought them, being now very old, and broken down with many toils, God would call him to another life before the walls were raised a pace from the ground. And that therefore they might perceive that he did not advise them to raise this building for his own convenience, but only for the honour of the city and its Dukedom; and that the good of it would never be felt by him, but by his successors.' Then he said, that 'in order, as he had always done, to observe the laws, . . . he had brought with him the thousand ducats which had been appointed as the penalty for proposing such a measure, so that he might prove openly to all

men that it was not his own advantage that he sought, but the dignity of the state.'" There was no one (Sanuto goes on to tell us) who ventured, or desired, to oppose the wishes of the Doge; and the thousand ducats were unanimously devoted to the expenses of the work. "And they set themselves with much diligence to the work; and the palace was begun in the form and manner in which it is at present seen; but, as Mocenigo had prophesied, not long after, he ended his life, and not only did not see the work brought to a close, but hardly even begun."

There are one or two expressions in the above extracts which, if they stood alone, might lead the reader to suppose that the whole palace had been thrown down and rebuilt. We must however remember, that, at this time, the new Council Chamber, which had been one hundred years in building, was actually unfinished, the Council had not yet sat in it; and it was just as likely that the Doge should then propose to destroy and rebuild it, as in this year, 1853, it is that anyone should propose in our House of Commons to throw down the New Houses of Parliament, under the title of the "old palace," and rebuild *them*.

The manner in which Sanuto expresses himself will at once be seen to be perfectly natural, when it is remembered that although we now speak of the whole building as the "Ducal Palace," it consisted, in the minds of the old Venetians, of four distinct buildings. There were in it the palace, the state prisons, the senate-house, and the offices of public business; in other words, it was Buckingham Palace, the Tower of olden days, the Houses of Parliament, and Downing Street, all in one; and any of these four portions might be spoken of, without involving an allusion to any other. "Il Palazzo" was the Ducal residence, which, with most of the public offices, Mocenigo *did* propose to pull down and rebuild, and which was actually pulled down and rebuilt. But the new Council Chamber, of which the whole façade to the Sea consisted, never entered into either his or

Sanuto's mind for an instant, as necessarily connected with the Ducal residence.

I said that the new Council Chamber, at the time when Mocenigo brought forward his measure, had never yet been used. It was in the year 1422 that the decree passed to rebuild the palace : Mocenigo died in the following year, and Francesco Foscari was elected in his room. The Great Council Chamber was used for the first time on the day when Foscari entered the Senate as Doge, and, the following year, on the 27th of March, the first hammer was lifted up against the old palace of Ziani.

That hammer stroke was the first act of the period properly called the " Renaissance." It was the knell of the architecture of Venice,—and of Venice herself.

The central epoch of her life was past ; the decay had already begun : I dated its commencement above from the death of Mocenigo. A year had not yet elapsed since that great Doge had been called to his account : his patriotism, always sincere, had been in this instance mistaken ; in his zeal for the honour of future Venice, he had forgotten what was due to the Venice of long ago. A thousand palaces might be built upon her burdened islands, but none of them could take the place, or recall the memory, of that which was first built upon her unfrequented shore. It fell ; and, as if it had been the talisman of her fortunes, the city never flourished again.

I have no intention of following out, in their intricate details, the operations which were begun under Foscari, and continued under succeeding Doges, till the palace assumed its present form, for I am not in this work concerned, except by occasional reference, with the architecture of the fifteenth century ; but the main facts are the following. The palace of Ziani was destroyed ; the existing façade to the Piazzetta built, so as both to continue and to resemble, in most particulars, the work of the Great Council Chamber. It was carried back from the Sea as far as the Judgment angle ; beyond which is the Porta della Carta, begun

in 1439, and finished in two years, under the Doge Foscari ; the interior buildings connected with it were added by the Doge Christopher Moro in 1462.

By reference to the Plate the reader will see that we have now gone the round of the palace, and that the new work of 1462 was close upon the first piece of the Gothic palace, the *new* Council Chamber of 1301. Some remnants of the Ziani Palace were perhaps still left between the two extremities of the Gothic Palace ; or, as is more probable, the last stones of it may have been swept away after the fire of 1419, and replaced by new apartments for the Doge. But whatever buildings, old or new, stood on this spot at the time of the completion of the Porta della Carta were destroyed by another great fire in 1479, together with so much of the palace on the Rio, that, though the saloon of Gradenigo, then known as the Sala de' Pregadi, was not destroyed, it became necessary to reconstruct the entire façades of the portion of the palace behind the Bridge of Sighs, both towards the court and canal. This work was entrusted to the best Renaissance architects of the close of the fifteenth and opening of the sixteenth centuries ; Antonio Ricci executing the Giant's staircase, and, on his absconding with a large sum of the public money, Pietro Lombardo taking his place. The whole work must have been completed towards the middle of the sixteenth century. The architects of the palace, advancing round the square and led by fire, had more than reached the point from which they had set out ; and the work of 1560 was joined to the work of 1301–1340, at the point marked by the vertical line in Plate IVb (p. 193) on the Rio Façade.

But the palace was not long permitted to remain in this finished form. Another terrific fire, commonly called the great fire, burst out in 1574, and destroyed the inner fittings and all the precious pictures of the Great Council Chamber, and of all the upper rooms on the Sea Façade, and most of those on the Rio Façade, leaving the building a mere shell, shaken and blasted by the flames. It was debated in the Great Council whether the

ruin should not be thrown down, and an entirely new palace built in its stead. The opinions of all the leading architects of Venice were taken, respecting the safety of the walls, or the possibility of repairing them as they stood. These opinions, given in writing, have been preserved, and published by the Abbé Cadorin, and they form one of the most important series of documents connected with the Ducal Palace.

I cannot help feeling some childish pleasure in the accidental resemblance to my own name in that of the architect whose opinion was first given in favour of the ancient fabric, Giovanni Rusconi. Others, especially Palladio, wanted to pull down the old palace, and execute designs of their own; but the best architects in Venice, and, to his immortal honour, chiefly Francesco Sansovino, energetically pleaded for the Gothic pile, and prevailed. It was successfully repaired, and Tintoret painted his noblest picture on the wall from which the " Paradise " of Guariento had withered before the flames.

The repairs necessarily undertaken at this time were however extensive, and interfere in many directions with the earlier work of the palace : still the only serious alteration in its form was the transposition of the prisons, formerly at the top of the palace, to the other side of the Rio del Palazzo ; and the building of the Bridge of Sighs, to connect them with the palace, by Antonio da Ponte. The completion of this work brought the whole edifice into its present form ; with the exception of alterations in doors, partitions, and staircases among the inner apartments, not worth noticing, and such barbarisms and defacements as have been suffered within the last fifty years, by, I suppose, nearly every building of importance in Italy.

Now, therefore, we are at liberty to examine some of the details of the Ducal Palace, without any doubt about their dates. First, then, looking back to the drawing at the beginning of this chapter, the reader will observe that, as the building was very nearly square on the ground plan, a peculiar prominence and importance were given to its angles, which rendered it necessary

that they should be enriched and softened by sculpture. I do not suppose that the fitness of this arrangement will be questioned ; but if the reader will take the pains to glance over any series of engravings of church towers or other four-square buildings in which great refinement of form has been attained, he will at once observe how their effect depends on some modification of the sharpness of the angle, either by groups of buttresses, or by turrets and niches rich in sculpture. It is to be noted also that this principle of breaking the angle is peculiarly Gothic, arising partly out of the necessity of strengthening the flanks of enormous buildings, where composed of imperfect materials, by buttresses or pinnacles ; partly out of the conditions of Gothic warfare, which generally required a tower at the angle ; partly out of the natural dislike of the meagreness of effect in buildings which admitted large surfaces of wall, if the angle were entirely unrelieved. The Ducal Palace, in its acknowledgment of this principle, makes a more definite concession to the Gothic spirit than any of the previous architecture of Venice. No angle, up to the time of its erection, had been otherwise decorated than by a narrow fluted pilaster of red marble, and the sculpture was reserved always, as in Greek and Roman work, for the plane surfaces of the building, with, as far as I recollect, two exceptions only, both in St. Mark's ; namely, the bold and grotesque gargoyle on its north-west angle, and the angles which project from the four inner angles under the main cupola ; both of these arrangements being plainly made under Lombardic influence. And if any other instances occur, which I may have at present forgotten, I am very sure the Northern influence will always be distinctly traceable in them.

The Ducal Palace, however, accepts the principle in its completeness, and throws the main decoration upon its angles. The central window, which looks rich and important in the drawing, was entirely restored in the Renaissance time, as we have seen, under the Doge Steno ; so that we have no traces of its early treatment ; and the principal interest of the older palace is con-

centrated in the angle sculpture, which is arranged in the following manner. The pillars of the two bearing arcades are much enlarged in thickness at the angles, and their capitals increased in depth, breadth, and fulness of subject : above each capital, on the angle of the wall, a sculptural subject is introduced, consisting, in the great lower arcade, of two or more figures of the size of life ; in the upper arcade, of a single angel holding a scroll : above these angels rise the twisted pillars with their crowning niches, thus forming an unbroken line of decoration from the ground to the top of the angle. (See Plate III, p. 112.)

It was before noticed that one of the corners of the palace joins the irregular outer buildings connected with St. Mark's, and is not generally seen. There remain, therefore, to be decorated, only the three angles, above distinguished as the Vine angle, the Fig-tree angle, and the Judgment angle ; and at these we have, according to the arrangement just explained,—

First, Three great bearing capitals (lower arcade).

Secondly, Three figure subjects of sculpture above them (lower arcade).

Thirdly, Three smaller bearing capitals (upper arcade).

Fourthly, Three angels above them (upper arcade).

Fifthly, Three spiral shafts with niches.

The first point to which the reader's attention ought to be directed is the choice of subject in the great figure sculptures above the capitals. These, observe, are the very corner stones of the edifice, and in them we may expect to find the most important evidences of the feeling, as well as of the skill, of the builder. If he has anything to say to us of the purpose with which he built the palace, it is sure to be said here ; if there was any lesson which he wished principally to teach to those for whom he built, here it is sure to be inculcated ; if there was any sentiment which they themselves desired to have expressed in the principal edifice of their city, this is the place in which we may be secure of finding it legibly inscribed.

Now the first two angles, of the Vine and Fig-tree, belong

to the old, or true Gothic, Palace ; the third angle belongs to the Renaissance imitation of it : therefore, at the first two angles, it is the Gothic spirit which is going to speak to us ; and, at the third, the Renaissance spirit.

Whereas the reader remembers, I trust, that the most characteristic sentiment of all that we traced in the working of the Gothic heart, was the frank confession of its own weakness, the principal element in the Renaissance spirit is its firm confidence in its own wisdom.

Hear, then, the two spirits speak for themselves.

The first main sculpture of the Gothic Palace is on what I have called the angle of the Fig-tree :

Its subject is the FALL OF MAN.

The second sculpture is on the angle of the Vine :

Its subject is the DRUNKENNESS OF NOAH.

The Renaissance sculpture is on the Judgment angle :

Its subject is the JUDGMENT OF SOLOMON.

It is impossible to overtake, or to regard with too much admiration, the significance of this single fact. It is as if the palace had been built at various epochs, and preserved uninjured to this day, for the sole purpose of teaching us the difference in the temper of the two schools.

I have called the sculpture on the Fig-tree angle the principal one ; because it is at the central bend of the palace, where it turns to the Piazzetta (the façade upon the Piazzetta being, as we saw above, the more important one in ancient times). The great capital, which sustains this Fig-tree angle, is also by far more elaborate than the head of the pilaster under the Vine angle, marking the pre-eminence of the former in the architect's mind. It is impossible to say which was first executed, but that of the Fig-tree angle is somewhat rougher in execution, and more stiff in the design of the figures, so that I rather suppose it to have been the earliest completed.

In both the subjects, of the Fall and the Drunkenness, the tree, which forms the chiefly decorative portion of the sculpture,

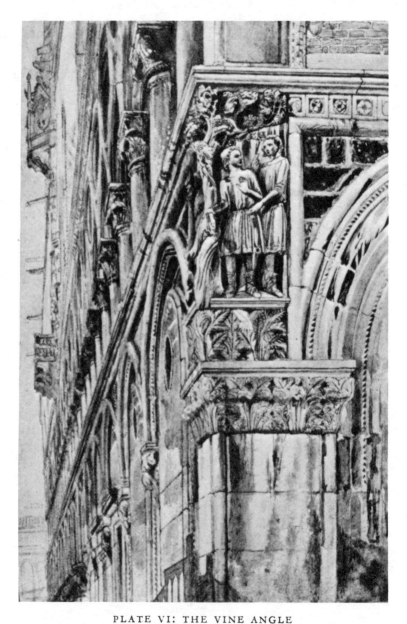

PLATE VI: THE VINE ANGLE

*This characteristic Ruskin drawing has been substituted
for his detailed drawing, showing only the heads and foliage,
which appeared in the original edition*

—fig in the one case, vine in the other,—was a necessary adjunct. Its trunk, in both sculptures, forms the true outer angle of the palace; boldly cut separate from the stonework behind, and branching out above the figures so as to enwrap each side of the angle, for several feet, with its deep foliage. Nothing can be more masterly or superb than the sweep of this foliage on the Fig-tree angle; the broad leaves lapping round the budding fruit, and sheltering from sight, beneath their shadows, birds of the most graceful form and delicate plumage. The branches are, however, so strong, and the masses of stone hewn into leafage so large, that, notwithstanding the depth of the undercutting, the work remains nearly uninjured; not so at the Vine angle, where the natural delicacy of the vine-leaf and tendril having tempted the sculptor to greater effort, he has passed the proper limits of his art, and cut the upper stems so delicately that half of them have been broken away by the casualties to which the situation of the sculpture necessarily exposes it. What remains is, however, so interesting in its extreme refinement, that I have chosen it for the subject of my illustration on Plate VI rather than the nobler masses of the fig-tree, which ought to be rendered on a larger scale. Although half of the beauty of the composition is destroyed by the breaking away of its central masses, there is still enough in the distribution of the variously bending leaves, and in the placing of the birds on the lighter branches, to prove to us the power of the designer. It is a remarkable instance of the Gothic Naturalism; and, indeed, it is almost impossible for the copying of nature to be carried further than in the fibres of the marble branches, and the careful finishing of the tendrils: note especially the peculiar expression of the knotty joints of the vine in the light branch which rises highest. Yet only half the finish of the work can be seen in the Plate: for, in several cases, the sculptor has shown the under sides of the leaves turned boldly to the light, and has literally *carved every rib and vein upon them in relief;* not merely the main ribs which sustain the lobes of the leaf, and actually project in nature, but the irregular and

sinuous veins which chequer the membranous tissues between them, and which the sculptor has represented conventionally as relieved like the others, in order to give the vine-leaf its peculiar tessellated effect upon the eye.

As must always be the case in early sculpture, the figures are much inferior to the leafage ; yet so skilful in many respects, that it was a long time before I could persuade myself that they had indeed been wrought in the first half of the fourteenth century. Fortunately, the date is inscribed upon a monument in the Church of San Simeon Grande, bearing a recumbent statue of the saint, of far finer workmanship, in every respect, than those figures of the Ducal Palace, yet so like them, that I think there can be no question that the head of Noah was wrought by the sculptor of the palace in emulation of that of the statue of St. Simeon. In this latter sculpture, the face is represented in death ; the mouth partly open, the lips thin and sharp, the teeth carefully sculptured beneath ; the face full of quietness and majesty, though very ghastly ; the hair and beard flowing in luxuriant wreaths, disposed with the most masterly freedom, yet severity, of design, far down upon the shoulders ; the hands crossed upon the body, carefully studied, and the veins and sinews perfectly and easily expressed, yet without any attempt at extreme finish or display of technical skill. This monument bears the date 1317, and its sculptor was justly proud of it ; thus recording his name :

Celavit Marcus opus hoc insigne Romanus
Laudibus non parcis est sua digna manus.

The head of the Noah on the Ducal Palace, evidently worked in emulation of this statue, has the same profusion of flowing hair and beard, but wrought in smaller and harder curls ; and the veins on the arms and breast are more sharply drawn, the sculptor being evidently more practised in keen and fine lines of vegetation than in those of the figure ; so that, which is most remarkable in a workman of this early period, he has failed in

telling his story plainly, regret and wonder being so equally marked on the features of all the three brothers, that it is impossible to say which is intended for Ham. Two of the heads of the brothers are seen in the Plate; the third figure is not with the rest of the group, but set at a distance of about twelve feet, on the other side of the arch which springs from the angle capital.

It may be observed, as a farther evidence of the date of the group, that, in the figures of all the three youths, the feet are protected simply by a bandage arranged in crossed folds round the ankle and lower part of the limb; a feature of dress which will be found in nearly every piece of figure sculpture in Venice, from the year 1300 to 1380, and of which the traveller may see an example within three hundred yards of this very group, in the bas-reliefs on the tomb of the Doge Andrea Dandolo (in St. Mark's), who died in 1354.

The figures of Adam and Eve, sculptured on each side of the Fig-tree angle, are more stiff than those of Noah and his sons, but are better fitted for their architectural service; and the trunk of the tree, with the angular body of the serpent writhed around it, is more nobly treated as a terminal group of lines than that of the vine.

The Renaissance sculptor of the figures of the Judgment of Solomon has very nearly copied the fig-tree from this angle, placing its trunk between the executioner and the mother, who leans forward to stay his hand. But, though the whole group is much more free in design than those of the earlier palace, and in many ways excellent in itself, so that it always strikes the eye of a careless observer more than the others, it is of immeasurably inferior spirit in the workmanship; the leaves of the tree, though far more studiously varied in flow than those of the fig-tree from which they are partially copied, have none of its truth to nature; they are ill set on the stems, bluntly defined on the edges, and their curves are not those of growing leaves, but of wrinkled drapery. Above these three sculptures are set, in the upper

arcade, the statues of the archangels Raphael, Michael, and Gabriel.

Such are the subjects of the main sculptures decorating the angles of the palace; notable, observe, for their simple expression of two feelings, the consciousness of human frailty, and the dependence upon Divine guidance and protection. We can examine the course of divinity and of natural history embodied by the old sculptor in the great series of capitals which support the lower arcade of the palace; and which, being at a height of little more than eight feet above the eye, might be read, like the pages of a book, by those (the noblest men in Venice) who habitually walked beneath the shadow of this great arcade at the time of their first meeting each other for morning converse.

The principal sculptures of the capitals consist of personifications of the Virtues and art, at this period, in all the cities of Italy. There are, in all, thirty-six great pillars supporting the lower story and these are to be counted from right to left, because then the more ancient of them come first: thus arranged, the first, which is not a shaft, but a pilaster, will be the support of the Vine angle; the eighteenth will be the great shaft of the Fig-tree angle; and the thirty-sixth, that of the Judgment angle.

All their capitals, except that of the first, are octagonal, and are decorated by sixteen leaves, differently enriched in every capital, but arranged in the same way; eight of them rising to the angles, and there forming volutes; the eight others set between them, on the sides, rising half-way up the bell of the capital; there nodding forward, and showing above them, rising out of their luxuriance, the groups or single figures which we have to examine. In some instances, the intermediate or lower leaves are reduced to eight sprays of foliage; and the capital is left dependent for its effect on the bold position of the figures.

The capitals of the upper arcade are exceedingly various in

their character; their design is formed, as in the lower series, of eight leaves, thrown into volutes at the angles, and sustaining figures at the flanks; but these figures have no inscriptions, and though evidently not without meaning, cannot be interpreted without more knowledge than I possess of ancient symbolism. Many of the capitals towards the Sea appear to have been restored, and to be rude copies of the ancient ones; others, though apparently original, have been somewhat carelessly wrought; but those of them which are both genuine and carefully treated are even finer in composition than any, except the eighteenth, in the lower arcade. The traveller in Venice ought to ascend into the corridor, and examine with great care the series of capitals which extend on the Piazzetta side from the Fig-tree angle to the pilaster which carries the party wall of the Sala del Gran Consiglio. As examples of graceful composition in massy capitals meant for hard service and distant effect, these are among the finest things I know in Gothic art; and that above the fig-tree is remarkable for its sculptures of the four winds; each on the side turned towards the wind represented. Levante, the east wind; a figure with rays round its head, to show that it is always clear weather when that wind blows, raising the sun out of the sea: Hotro, the south wind; crowned, holding the sun in its right hand: Ponente, the west wind; plunging the sun into the sea: and Tramontana, the north wind; looking up at the north star.

I may also especially point out the bird feeding its three young ones on the seventh pillar on the Piazzetta side; but there is no end to the fantasy of these sculptures; and the traveller ought to observe them all carefully, until he comes to the great pilaster or complicated pier which sustains the party wall of the Sala del Consiglio; that is to say, the forty-seventh capital of the whole series, counting from the pilaster of the Vine angle inclusive, as in the series of the lower arcade.

This early sculpture of the Ducal Palace, then, represents the state of Gothic work in Venice at its central and proudest period,

i.e., circa 1350. After this time, all is decline. And as, under the shadow of these nodding leaves, we bid farewell to the great Gothic spirit, here also we may cease our examination of the details of the Ducal Palace ; for above its upper arcade there are only the four traceried windows, and one or two on the Rio Façade, which can be depended upon as exhibiting the original workmanship of the older palace. I examined the capitals of the four other windows on the façade, and of those on the Piazzetta, one by one, with great care, and I found them all to be of far inferior workmanship to those which retain their traceries : I believe the stone framework of these windows must have been so cracked and injured by the flames of the great fire, as to render it necessary to replace it by new traceries : and that the present mouldings and capitals are base imitations of the original ones. The traceries were at first, however, restored in their complete form, as the holes for the bolts which fastened the bases of their shafts are still to be seen in the window-sills, as well as the marks of the inner mouldings on the soffits. How much the stone facing of the façade, the parapets, and the shafts and niches of the angles retain of their original masonry, it is also impossible to determine ; but there is nothing in the workmanship of any of them demanding especial notice ; still less in the large central windows on each façade, which are entirely of Renaissance execution. All that is admirable in these portions of the building is the disposition of their various parts and masses, which is without doubt the same as in the original fabric, and calculated, when seen from a distance, to produce the same impression.

Not so in the interior. All vestige of the earlier modes of decoration was here, of course, destroyed by the fires ; and the severe and religious work of Guariento and Bellini has been replaced by the wildness of Tintoret and the luxury of Veronese. But in this case, though widely different in temper, the art of the renewal was at least intellectually as great as that which had perished ; and though the halls of the Ducal Palace are no more

representative of the character of the men by whom it was built, each of them is still a colossal casket of priceless treasure ; a treasure whose safety has till now depended on its being despised, and which at this moment, and as I write, is piece by piece being destroyed for ever.[1]

[1] " Restoration . . . means the most total destruction, a destruction out of which no remnants can be gathered, a destruction accompanied with false description of the thing destroyed." Ruskin in the *Seven Lamps of Architecture*. Ed.

The Renaissance Period

CHAPTER VI

EARLY RENAISSANCE

I TRUST that the reader has been enabled, by the preceding chapters, to form some conception of the magnificence of the streets of Venice during the course of the thirteenth and fourteenth centuries. Yet by all this magnificence she was not supremely distinguished above the other cities of the middle ages. Her early edifices have been preserved to our times by the circuit of her waves; while continual recurrences of ruin have defaced the glory of her sister cities. But such fragments as are still left in their lonely squares, and in the corners of their streets, so far from being inferior to the buildings of Venice, are even more rich, more finished, more admirable in invention, more exuberant in beauty. And although, in the North of Europe, civilisation was less advanced, and the knowledge of the arts was more confined to the ecclesiastical orders, so that, for domestic architecture, the period of perfection must be there placed much later than in Italy, and considered as extending to the middle of the fifteenth century; yet, as each city reached a certain point in civilisation, its streets became decorated with the same magnificence, varied only in style according to the materials at hand, and temper of the people. And I am not

aware of any town of wealth and importance in the middle ages, in which some proof does not exist that, at its period of greatest energy and prosperity, its streets were inwrought with rich sculpture, and even (though in this, as before noticed, Venice always stood supreme) glowing with colour and with gold. Now, therefore, let the reader,—forming for himself as vivid and real a conception as he is able, either of a group of Venetian palaces in the fourteenth century, or, if he likes better, of one of the more fantastic but even richer street scenes of Rouen, Antwerp, Cologne, or Nuremberg, and keeping this gorgeous image before him,—go out into any thoroughfare representative, in a general and characteristic way, of the feeling for domestic architecture in modern times : let him, for instance, if in London, walk once up and down Harley Street, or Baker Street, or Gower Street ; and then, looking upon this picture and on this, set himself to consider (for this is to be the subject of our following and final inquiry) what have been the causes which have induced so vast a change in the European mind.

Renaissance architecture is the school which has conducted men's inventive and constructive faculties from the Grand Canal to Gower Street ; from the marble shaft, and the lancet arch, and the wreathed leafage, and the glowing and melting harmony of gold and azure, to the square cavity in the brick wall. We have now to consider the causes and the steps of this change ; and, as we endeavoured above to investigate the nature of Gothic, here to investigate also the nature of Renaissance.

Although Renaissance architecture assumes very different forms among different nations, it may be conveniently referred to three heads :—Early Renaissance, consisting of the first corruptions introduced into the Gothic schools : Central or Roman Renaissance, which is the perfectly formed style ; and Grotesque Renaissance, which is the corruption of the Renaissance itself.

Now, in order to do full justice to the adverse cause, we will consider the abstract *nature* of the school with reference only to

its best or Central examples. The forms of building which must be classed generally under the term *Early* Renaissance are, in many cases, only the extravagances and corruptions of the languid Gothic, for whose errors the classical principle is in nowise answerable.

Against this degraded Gothic, then, came up the Renaissance armies; and their first assault was in the requirement of universal perfection. For the first time since the destruction of Rome, the world had seen, in the work of the greatest artists of the fifteenth century,—in the painting of Ghirlandajo, Masaccio, Francia, Perugino, Pinturicchio, and Bellini; in the sculpture of Mino da Fiesole, of Ghiberti, and Verrocchio,—a perfection of execution and fullness of knowledge which cast all previous art into the shade, and which, being in the work of those men united with all that was great in that of former days, did indeed justify the utmost enthusiasm with which their efforts were, or could be, regarded. But when this perfection had once been exhibited in anything, it was required in everything; the world could no longer be satisfied with less exquisite execution, or less disciplined knowledge. The first thing that it demanded in all work was, that it should be done in a consummate and learned way; and men altogether forgot that it was possible to consummate what was contemptible, and to know what was useless. Imperatively requiring dexterity of touch, they gradually forgot to look for tenderness of feeling; imperatively requiring accuracy of knowledge, they gradually forgot to ask for originality of thought. The thought and the feeling which they despised departed from them, and they were left to felicitate themselves on their small science and their neat fingering. This is the history of the first attack of the Renaissance upon the Gothic schools, and of its rapid results; more fatal and immediate in architecture than in any other art, because there the demand for perfection was less reasonable, and less consistent with the capabilities of the workman; being utterly opposed to that rudeness or savageness on which, as we saw above, the

nobility of the elder schools in great part depends. But, inasmuch as the innovations were founded on some of the most beautiful examples of art, and headed by some of the greatest men that the world ever saw, and as the Gothic with which they interfered was corrupt and valueless, the first appearance of the Renaissance feeling had the appearance of a healthy movement. A new energy replaced whatever weariness or dullness had affected the Gothic mind; an exquisite taste and refinement, aided by extended knowledge, furnished the first models of the new school; and over the whole of Italy a style arose, generally now known as cinque-cento, which in sculpture and painting, as I just stated, produced the noblest masters whom the world ever saw, headed by Michael Angelo, Raphael, and Leonardo; but which failed of doing the same in architecture, because, as we have seen above, perfection is therein not possible, and failed more totally than it would otherwise have done, because the classical enthusiasm had destroyed the best types of architectural form.

For, observe here very carefully, the Renaissance principle, as it consisted in a demand for universal perfection, is quite distinct from the Renaissance principle as it consists in a demand for classical and Roman *forms* of perfection. And if I had space to follow out the subject as I should desire, I would first endeavour to ascertain what might have been the course of the art of Europe if no manuscripts of classical authors had been recovered, and no remains of classical architecture left, in the fifteenth century; so that the executive perfection to which the efforts of all great men had tended for five hundred years, and which now at last was reached, might have been allowed to develop itself in its own natural and proper form, in connection with the architectural structure of earlier schools. This refinement and perfection had indeed its own perils, and the history of later Italy, as she sank into pleasure and thence into corruption, would probably have been the same whether she had ever learned again to write pure Latin or not. Still the inquiry into the probable cause of the enervation which might naturally have

followed the highest exertion of her energies, is a totally distinct one from that into the particular form given to this enervation by her classical learning ; and it is matter of considerable regret to me that I cannot treat these two subjects separately : I must be content with marking them for separation in the mind of the reader.

The effect, then, of the sudden enthusiasm for classical literature, which gained strength during every hour of the fifteenth century, was, as far as respected atchitecture, to do away with the entire system of Gothic science. The pointed arch, the shadowy vault, the clustered shaft, the heaven-pointing spire, were all swept away ; and no structure was any longer permitted but that of the plain cross-beam from pillar to pillar, over the round arch, with square or circular shafts, and a low-gabled roof and pediment : two elements of noble form, which had fortunately existed in Rome, were, however, for that reason, still permitted ; the cupola, and, internally, the waggon vault.

These changes in form were all of them unfortunate ; and it is almost impossible to do justice to the occasionally exquisite ornamentation of the fifteenth century, on account of its being placed upon edifices of the cold and meagre Roman outline. There is, as far as I know, only one Gothic building in Europe, the Duomo of Florence, in which, though the ornament be of a much earlier school, it is yet so exquisitely finished as to enable us to imagine what might have been the effect of the perfect workmanship of the Renaissance, coming out of the hands of men like Verrocchio and Ghiberti, had it been employed on the magnificent framework of Gothic structure.

The changes effected in form, however, were the least part of the evil principles of the Renaissance. As I have just said, its main mistake, in its early stages, was the unwholesome demand for *perfection*, at any cost. I hope enough has been advanced, in the chapter on the Nature of Gothic, to show the reader that perfection is *not* to be had from the general workman, but at the cost of everything,—of his whole life, thought, and energy.

And Renaissance Europe thought this a small price to pay for manipulative perfection. Men like Verrocchio and Ghiberti were not to be had every day, nor in every place ; and to require from the common workman execution or knowledge like theirs, was to require him to become their copyist. Their strength was great enough to enable them to join science with invention, method with emotion, finish with fire ; but in them the invention and the fire were first, while Europe saw in them only the method and the finish. This was new to the minds of men, and they pursued it to the neglect of everything else. " This," they cried, " we must have in all our work henceforward :" and they were obeyed. The lower workman secured method and finish, and lost, in exchange for them, his soul.

Now, therefore, do not let me be misunderstood when I speak generally of the evil spirit of the Renaissance. The reader may look through all I have written, from first to last, and he will not find one word but of the most profound reverence for those mighty men who could wear the Renaissance armour of proof, and yet not feel it encumber their living limbs,— Leonardo and Michael Angelo, Ghirlandajo and Masaccio, Titian and Tintoret. But I speak of the Renaissance as an evil time, because, when it saw those men go burning forth into the battle, it mistook their armour for their strength ; and forthwith encumbered with the painful panoply every stripling who ought to have gone forth only with his own choice of three smooth stones out of the brook.

This, then, the reader must always keep in mind when he is examining for himself any examples of cinque-cento work. When it has been done by a truly great man, whose life and strength could not be oppressed, and who turned to good account the whole science of his day, nothing is more exquisite. I do not believe, for instance, that there is a more glorious work of sculpture existing in the world than that equestrian statue of Bartolomeo Colleone, by Verrocchio. But when the cinque-cento work has been done by those meaner men, who, in the

Gothic times, though in a rough way, would yet have found some means of speaking out what was in their hearts, it is utterly inanimate,—a base and helpless copy of more accomplished models ; or, if not this, a mere accumulation of technical skill, in gaining which the workman had surrendered all other powers that were in him.

There is, therefore, of course, an infinite gradation in the art of the period, from the Sistine Chapel down to modern upholstery ; but, for the most part, since in architecture the workman must be of an inferior order, it will be found that this cinque-cento painting and higher religious sculpture is noble, while the cinque-cento architecture, with its subordinate sculpture, is universally bad ; sometimes, however, assuming forms in which the consummate refinement almost atones for the loss of force.

This is especially the case with that second branch of the Renaissance which was engrafted at Venice on the Byzantine types. So soon as the classical enthusiasm required the banishment of Gothic forms, it was natural that the Venetian mind should turn back with affection to the Byzantine models in which the round arches and simple shafts, necessitated by recent law, were presented under a form consecrated by the usage of their ancestors. And, accordingly, the first distinct school of architecture which arose under the new dynasty was one in which the method of inlaying marble, and the general forms of shaft and arch, were adopted from the buildings of the twelfth century, and applied with the utmost possible refinements of modern skill. Both at Verona and Venice the resulting architecture is exceedingly beautiful. At Verona it is, indeed, less Byzantine, but possesses a character of richness and tenderness almost peculiar to that city. At Venice it is more severe, but yet adorned with sculpture which, for sharpness of touch and delicacy of minute form, cannot be rivalled, and rendered especially brilliant and beautiful by the introduction of those inlaid circles of coloured marble, serpentine, and porphyry, by

which Phillippe de Commynes was so much struck on his first entrance into the city. The two most refined buildings in this style in Venice are, the small Church of the Miracoli, and the Scuola di San Marco beside the Church of St. John and St. Paul. The noblest is the Rio Façade of the Ducal Palace. The Casa Dario, and Casa Manzoni, on the Grand Canal, are exquisite examples of the school, as applied to domestic architecture; and, in the reach of the Canal between the Casa Foscari and the Rialto, there are several palaces, of which the Casa Contarini (called "delle Figure") is the principal, belonging to the same group, though somewhat later, and remarkable for the association of the Byzantine principles of colour with the severest lines of the Roman pediment, gradually superseding the round arch. The precision of chiselling and delicacy of proportion in the ornament and general lines of these palaces cannot be too highly praised; and I believe that the traveller in Venice, in general, gives them rather too little attention than too much.

Before leaving these last palaces over which the Byzantine influence extended itself, there is one more lesson to be learned from them of much importance to us. Though in many respects debased in style, they are consummate in workmanship, and unstained in honour; there is no imperfection in them, and no dishonesty. That there is absolutely *no* imperfection, is indeed, as we have seen above, a proof of their being wanting in the highest qualities of architecture; but, as lessons in masonry, they have their value, and may well be studied for the excellence they display in methods of levelling stones, for the precision of their inlaying, and other such qualities, which in them are indeed too principal, yet very instructive in their particular way.

For instance, the Rio Façade of the Ducal Palace, though very sparing in colour, is yet, as an example of finished masonry in a vast building, one of the finest things, not only in Venice, but in the world. It differs from other work of the Byzantine Renaissance, in being on a very large scale; and it still retains one pure Gothic character, which adds not a little to its noble-

ness, that of perpetual variety. There is hardly one window of it, or one panel, that is like another ; and this continual change so increases its apparent size by confusing the eye, that, though presenting no bold features, or striking masses of any kind, there are few things in Italy more impressive than the vision of it over-head, as the gondola glides from beneath the Bridge of Sighs. And lastly (unless we are to blame these buildings for some pieces of very childish perspective), they are magnificently honest, as well as perfect. I do not remember even any gilding upon them ; all is pure marble, and of the finest kind.

ROMAN RENAISSANCE

OF all the buildings in Venice, later in date than the final additions to the Ducal Palace, the noblest is, beyond all question, that which, having been condemned by its proprietor, not many years ago, to be pulled down and sold for the value of its materials, was rescued by the Austrian Government, and appropriated—the Government officers having no other use for it— to the business of the Post Office; though still known to the gondolier by its ancient name, the Casa Grimani.[1] It is composed of three stories of the Corinthian order, at once simple, delicate, and sublime; but on so colossal a scale, that the three-storied palaces on its right and left only reach to the cornice which makes the level of its first floor. Yet it is not at first perceived to be so vast; and it is only when some expedient is employed to hide it from the eye, that by the sudden dwarfing of the whole reach of the Grand Canal, which it commands, we become aware that it is to the majesty of the Casa Grimani that the Rialto itself, and the whole group of neighbouring buildings, owe the greater part of their impressiveness. Nor is the finish of its details less notable than the grandeur of their scale. There is not an erring line, nor a mistaken proportion, throughout its noble front; and the exceeding fineness of the chiselling gives an appearance of lightness to the vast blocks of stone out of whose perfect union that front is composed. The decoration is sparing, but delicate: the first story only simpler than the rest, in that it has pilasters instead of shafts, but all with Corinthian capitals, rich in leafage,

[1] Now the Court of Appeal. Ed.

and fluted delicately; the rest of the walls flat and smooth, and their mouldings sharp and shallow, so that the bold shafts look like crystals of beryl running through a rock of quartz.

This palace is the principal type at Venice, and one of the best in Europe, of the central architecture of the Renaissance schools; that carefully studied and perfectly executed architecture to which those schools owe their principal claims to our respect, and which became the model of most of the important works subsequently produced by civilised nations. I have called it the Roman Renaissance, because it is founded, both in its principles of superimposition, and in the style of its ornament, upon the architecture of classic Rome at its best period. The revival of Latin literature both led to its adoption and directed its form; and the most important example of it which exists is the modern Roman basilica of St. Peter's. It had, at its Renaissance or new birth, no resemblance either to Greek, Gothic, or Byzantine forms, except in retaining the use of the round arch, vault, and dome; in the treatment of all details, it was exclusively Latin; the last links of connection with mediæval tradition having been broken by its builders in their enthusiasm for classical art, and the forms of true Greek or Athenian architecture being still unknown to them. The study of these noble Greek forms has induced various modifications of the Renaissance in our own times; but the conditions which are found most applicable to the uses of modern life are still Roman, and the entire style may most fitly be expressed by the term " Roman Renaissance."

It is this style, in its purity and fullest form,—represented by such buildings as the Casa Grimani at Venice (built by San Micheli), the Town Hall at Vicenza (by Palladio), St. Peter's at Rome (by Michael Angelo), St. Paul's and Whitehall in London (by Wren and Inigo Jones),—which is the true antagonist of the Gothic school. The intermediate, or corrupt conditions of it, though multiplied over Europe, are no longer admired by architects, or made the subjects of their study; but

the finished work of this central school is still, in most cases, the model set before the student of the nineteenth century, as opposed to those Gothic, Romanesque, or Byzantine forms which have long been considered barbarous, and are so still by most of the leading men of the day. That they are, on the contrary, most noble and beautiful, and that the antagonistic Renaissance is, in the main, unworthy and unadmirable, whatever perfection of a certain kind it may possess, it was my principal purpose to show, when first I undertook the labour of this work.

It will not be necessary for me to enter at length into any examination of its external form. It uses, whether for its roofs of aperture or roofs proper, the low gable or circular arch : but it differs from Romanesque work in attaching great importance to the horizontal lintel or architrave *above* the arch ; transferring the energy of the principal shafts to the supporting of this horizontal beam, and thus rendering the arch a subordinate, if not altogether a superfluous, feature. I might insist at length upon the absurdity of a construction in which the shorter shaft, which has the real weight of wall to carry, is split into two by the taller one, which has nothing to carry at all,—that taller one being strengthened, nevertheless, as if the whole weight of the building bore upon it ; and on the ungracefulness, never conquered in any Palladian work, of the two half-capitals glued, as it were, against the slippery round sides of the central shaft. But it is not the form of this architecture against which I would plead. Its defects are shared by many of the noblest forms of earlier building, and might have been entirely atoned for by excellence of spirit. But it is the moral nature of it which is corrupt.

The moral, or immoral, elements which unite to form the spirit of Central Renaissance architecture are, I believe, in the main, two,—Pride and Infidelity ; but the pride resolves itself into three main branches,—Pride of Science, Pride of State, and Pride of System.[1]

[1] The thirty thousand word essay on Renaissance Pride is omitted from this abridgment. Ed.

CHAPTER VIII

GROTESQUE RENAISSANCE

THE phases of transition in the moral temper of the falling
Venetians, during their fall, were from pride to infidelity, and
from infidelity to the unscrupulous *pursuit of pleasure.* During
the last years of the existence of the state, the minds both of the
nobility and the people seem to have been set simply upon the
attainment of the means of self-indulgence. There was not
strength enough in them to be proud, nor forethought enough
to be ambitious. One by one the possessions of the state were
abandoned to its enemies ; one by one the channels of its trade
were forsaken by its own languor, or occupied and closed against
it by its more energetic rivals ; and the time, the resources, and
the thoughts of the nation were exclusively occupied in the
invention of such fantastic and costly pleasures as might best
amuse their apathy, lull their remorse, or disguise their ruin.

The architecture raised at Venice during this period is among
the worst and basest ever built by the hands of men, being
especially distinguished by a spirit of brutal mockery and
insolent jest, which, exhausting itself in deformed and monstrous
sculpture, can sometimes be hardly otherwise defined than as the
perpetuation in stone of the ribaldries of drunkenness. On such
a period, and on such work, it is painful to dwell, and I had not
originally intended to do so ; but I found that the entire spirit
of the Renaissance could not be comprehended unless it was
followed to its consummation ; and that there were many most
interesting questions arising out of the study of this particular
spirit of jesting, with reference to which I have called it the

236

Grotesque Renaissance. For it is not this period alone which is distinguished by such a spirit. There is jest—perpetual, careless, and not unfrequently obscene—in the most noble work of the Gothic periods; and it becomes, therefore, of the greatest possible importance to examine into the nature and essence of the Grotesque itself, and to ascertain in what respect it is that the jesting of art in its highest flight differs from its jesting in its utmost degradation.

The place where we may best commence our inquiry is one renowned in the history of Venice, the space of ground before the Church of Santa Maria Formosa; a spot which, after the Rialto and St. Mark's Place, ought to possess a peculiar interest in the mind of the traveller, in consequence of its connection with the most touching and true legend of the Brides of Venice. That legend is related at length in every Venetian history, and, finally, has been told by the poet Rogers, in a way which renders it impossible for anyone to tell it after him. I have only, therefore, to remind the reader that the capture of the brides took place in the cathedral church, St. Pietro di Castello; and that this of Santa Maria Formosa is connected with the tale, only because it was yearly visited with prayers by the Venetian maidens, on the anniversary of their ancestors' deliverance. For that deliverance, their thanks were to be rendered to the Virgin; and there was no church then dedicated to the Virgin in Venice except this.

Neither of the cathedral church, nor of this dedicated to St. Mary the Beautiful, is one stone left upon another. But from that which has been raised on the site of the latter, we may receive a most important lesson, introductory to our immediate subject, if first we glance back to the traditional history of the church which has been destroyed.

No more honourable epithet than "traditional" can be attached to what is recorded concerning it, yet I should grieve to lose the legend of its first erection. The Bishop of Uderzo, driven by the Lombards from his bishopric, as he was praying

beheld in a vision the Virgin Mother, who ordered him to found a church in her honour, in the place where he should see a white cloud rest. And when he went out, the white cloud went before him; and on the place where it rested he built a church, and it was called the Church of St. Mary the Beautiful, from the loveliness of the form in which she appeared in the vision.

There is now but one landmark to guide the steps of the traveller to the place where the white cloud rested, and the shrine was built to St. Mary the Beautiful. Yet this spot is still worth his pilgrimage, for he may receive a lesson upon it, though a painful one. Let him first fill his mind with the fair images of the ancient festival, and then seek that landmark, the tower of the modern church, built upon the place where the daughters of Venice knelt yearly; and let him look at the head that is carved on the base of the tower,[1] still dedicated to St. Mary the Beautiful.

A head,—huge, inhuman, and monstrous,—leering in bestial degradation, too foul to be either pictured or described, or to be beheld for more than an instant: yet let it be endured for that instant; for in that head is embodied the type of the evil spirit to which Venice was abandoned in the fourth period of her decline; and it is well that we should see and feel the full horror of it on this spot, and know what pestilence it was that came and breathed upon her beauty, until it melted away like the white cloud from the ancient fields of Santa Maria Formosa.

This head is one of many hundreds which disgrace the latest buildings of the city, all more or less agreeing in their expression of sneering mockery, in most cases enhanced by thrusting out the tongue. Most of them occur upon the bridges, which were among the very last works undertaken by the republic, several, for instance, upon the Bridge of Sighs; and they are evidences of a delight in the contemplation of bestial vice, and the expression of low sarcasm, which is, I believe, the most hopeless state into which the human mind can fall. This spirit of idiotic mockery

[1] The keystone of the arch on its western side facing the canal.

is, as I have said, the most striking characteristic of the last period of the Renaissance, which, in consequence of the character thus imparted to its sculpture, I have called grotesque; but it must be our immediate task, and it will be a most interesting one, to distinguish between this base grotesqueness, and that magnificent condition of fantastic imagination, which was above noticed as one of the chief elements of the Northern Gothic mind. Nor is this a question of interesting speculation merely; for the distinction between the true and false grotesque is one which the present tendencies of the English mind have rendered it practically important to ascertain; and that in a degree which, until he has made some progress in the consideration of the subject, the reader will hardly anticipate.

But, first, I have to note one peculiarity in the late architecture of Venice, which will materially assist us in understanding the true nature of the spirit which is to be the subject of our inquiry; and this peculiarity, singularly enough, is first exemplified in the very façade of Santa Maria Formosa, which is flanked by the grotesque head to which our attention has just been directed. This façade, whose architect is unknown, consists of a pediment, sustained on four Corinthian pilasters, and is, I believe, the earliest in Venice which appears *entirely destitute of every religious symbol, sculpture, or inscription;* unless the cardinal's hat upon the shield in the centre of the pediment be considered a religious symbol. The entire façade is nothing else than a monument to the Admiral Vincenzo Cappello. Two tablets, one between each pair of flanking pillars, record his acts and honours; and, on the corresponding spaces upon the base of the church, are two circular trophies, composed of halberds, arrows, flags, tridents, helmets, and lances: sculptures which are just as valueless in a military as in an ecclesiastical point of view; for being all copied from the forms of Roman arms and armour, they cannot even be referred to for information respecting the costume of the period. Over the door, as the chief ornament of the façade, exactly in the spot which in the " barbarous " St. Mark's is

occupied by the figure of Christ, is the statue of Vincenzo Cappello, in Roman armour. He died in 1542; and we have, therefore, the latter part of the sixteenth century fixed as the period when, in Venice, churches were first built to the glory of man, instead of the glory of God.

Having taken sufficient note of all the baseness of mind which these facts indicate in the people, we shall not be surprised to find immediate signs of dotage in the conception of their architecture. The churches raised throughout this period are so grossly debased, that even the Italian critics of the present day, who are partially awakened to the true state of art in Italy, though blind, as yet, to its true cause, exhaust their terms of reproach upon these last efforts of the Renaissance builders. The two churches of San Moisè and Santa Maria Zobenigo, which are among the most remarkable in Venice for their manifestation of insolent atheism, are characterised by Lazari, the one as "culmine d' ogni follia architettonica," the other as "orrido ammasso di pietra d' Istria," with added expressions of contempt, as just as it is unmitigated.

Now both these churches, which I should like the reader to visit in succession, if possible, after that of Sta. Maria Formosa, agree with that church, and with each other, in being totally destitute of religious symbols, and entirely dedicated to the honour of two Venetian families.

When the traveller has sufficiently considered the meaning of these façades, he ought to visit the Church of St. Eustachio, remarkable for the dramatic effect of the group of sculpture on its façade, and then the Church of the Ospedaletto, noticing, on his way, the heads on the foundations of the Palazzo Corner della Regina, and the Palazzo Pesaro, and any other heads carved on the modern bridges, closing with those on the Bridge of Sighs.

He will then have obtained a perfect idea of the style and feeling of the Grotesque Renaissance, and we must now endeavour to ascertain the nature of the difference which exists

between that and the noble grotesque of the fourteenth-century Gothic.

The grotesque spirit is traceable through all the strength of the Venetian people, but it is necessary that we should carefully distinguish between it and the spirit of mere levity. The Venetians were distinctly a serious people; serious, that is to say, in the sense in which the English are a more serious people than the French; though the habitual intercourse of our lower classes in London has a tone of humour in it which I believe is untraceable in that of the Parisian populace. It is one thing to indulge in playful rest, and another to be devoted to the pursuit of pleasure: and gaiety of heart during the reaction after hard labour, and quickened by satisfaction in the accomplished duty or perfected result, is altogether compatible with, nay, even in some sort arises naturally out of, a deep internal seriousness of disposition; this latter being exactly the condition of mind which leads to the richest developments of the playful grotesque; while, on the contrary, the continual pursuit of pleasure deprives the soul of all alacrity and elasticity, and leaves it incapable of happy jesting, capable only of that which is bitter, base, and foolish. Thus, throughout the whole of the early career of the Venetians, though there is much jesting, there is no levity; on the contrary, there is an intense earnestness both in their pursuit of commercial and political successes, and in their devotion to religion, which led gradually to the formation of that highly wrought mingling of immovable resolution with secret thoughtfulness, which so strangely, sometimes so darkly, distinguishes the Venetian character at the time of their highest power, when the seriousness was left, but the conscientiousness destroyed. And if there be any one sign by which the Venetian countenance, as it is recorded for us, to the very life, by a school of portraiture which has never been equalled (chiefly because no portraiture ever had subjects so noble),—I say, if there be one thing more notable than another in the Venetian features, it is this deep pensiveness and solemnity. In other districts of Italy, the dignity

of the heads which occur in the most celebrated compositions is clearly owing to the feeling of the painter. He has visibly raised or idealised his models, and appears always to be veiling the faults or failings of the human nature around him, so that the best of his work is that which has most perfectly taken the colour of his own mind; and the least impressive, if not the least valuable, that which appears to have been unaffected and unmodified portraiture. But at Venice, all is exactly the reverse of this. The tone of mind in the painter appears often in some degree frivolous or sensual; delighting in costume, in domestic and grotesque incident, and in studies of the naked form. But the moment he gives himself definitely to portraiture, all is noble and grave; the more literally true his work, the more majestic; and the same artist who will produce little beyond what is commonplace in painting a Madonna or an apostle, will rise into unapproachable sublimity when his subject is a member of the Forty, or a Master of the Mint.

Such, then, were the general tone and progress of the Venetian mind, up to the close of the seventeenth century. First, serious, religious, and sincere; then, though serious still, comparatively deprived of conscientiousness, and apt to decline into stern and subtle policy: in the first case, the spirit of the noble grotesque not showing itself in art at all, but only in speech and action; in the second case, developing itself in painting, through accessories and vivacities of composition, while perfect dignity was always preserved in portraiture. A third phase rapidly developed itself.

Once more, and for the last time, let me refer the reader to the important epoch of the death of the Doge Tomaso Mocenigo in 1423, long ago indicated as the commencement of the decline of the Venetian power. That commencement is marked not merely by the words of the dying Prince, but by a great and clearly legible sign. It is recorded, that on the accession of his successor, Foscari, to the throne, " *Si festeggio dalla citta uno anno intero :*" " The city kept festival for a whole year." Venice had

in her childhood sown, in tears, the harvest she was to reap in rejoicing. She now sowed in laughter the seeds of death.

Thenceforward, year after year, the nation drank with deeper thirst from the fountains of forbidden pleasure, and dug for springs, hitherto unknown, in the dark places of the earth. In the ingenuity of indulgence, in the varieties of vanity, Venice surpassed the cities of Christendom, as of old she had surpassed them in fortitude and devotion; and as once the powers of Europe stood before her judgment seat, to receive the decisions of her justice, so now the youth of Europe assembled in the halls of her luxury, to learn from her the arts of delight.

It is as needless as it is painful to trace the steps of her final ruin. That ancient curse was upon her, the curse of the Cities of the Plain, " Pride, fulness of bread, and abundance of idleness." By the inner burning of her own passions, as fatal as the fiery rain of Gomorrah, she was consumed from her place among the nations; and her ashes are choking the channels of the dead, salt sea.

CONCLUSION

THE grotesques of the seventeenth and eighteenth centuries close the career of the architecture of Europe. They were the last evidences of any feeling consistent with itself, and capable of directing the efforts of the builder to the formation of anything worthy the name of a style or school. From that time to this, no resuscitation of energy has taken place, nor does any for the present appear possible.

If, though, any of my readers should determine, according to their means, to set themselves to the revival of a healthy school of architecture in England, and wish to know in few words how this may be done, the answer is clear and simple. First, let us cast out utterly whatever is connected with the Greek, Roman, or Renaissance architecture, in principle or in form. The whole mass of the architecture, founded on Greek and Roman models, which we have been in the habit of building for the last three centuries is utterly devoid of all life, virtue, honourableness, or power of doing good. It is base, unnatural, unfruitful, unenjoyable, and impious. Pagan in its origin, proud and unholy in its revival, paralysed in its old age, yet making prey in its dotage of all the good and living things that were springing around it in their youth, as the dying and desperate king, who had long fenced himself so strongly with the towers of it, is said to have filled his failing veins with the blood of children ;[1] an architecture invented, as it seems, to make

[1] Louis the Eleventh. " In the month of March, 1481, Louis was seized with a fit of apoplexy at *St. Benoît-du-lac-mort*, near Chinon. He remained speechless and bereft of reason three days ; and then, but very imperfectly restored, he languished in a miserable

plagiarists of its architects, slaves of its workmen, and sybarites of its inhabitants ; an architecture in which intellect is idle, invention impossible, but in which all luxury is gratified, and all insolence fortified ;—the first thing we have to do is to cast it out, and shake the dust of it from our feet for ever. Whatever has any connection with the five orders, or with any one of the orders,—whatever is Doric, or Ionic, or Tuscan, or Corinthian, or Composite, or in any wise Grecized or Romanized ; whatever betrays the smallest respect for Vitruvian laws, or conformity with Palladian work,—that we are to endure no more. To cleanse ourselves of these "cast clouts and rotten rags" is the first thing to be done in the court of our prison.

Then, to turn our prison into a palace is an easy thing. Exactly in the degree in which Greek and Roman architecture is lifeless, unprofitable, and unchristian, in that same degree our own ancient Gothic is animated, serviceable, and faithful. It is flexible to all duty, enduring to all time, instructive to all hearts, honourable and holy in all offices. It is capable alike of all lowliness and all dignity, fit alike for cottage porch or castle gateway ; in domestic service familiar, in religious, sublime ; simple, and playful, so that childhood may read it, yet clothed with a power that can awe the mightiest, and exalt the loftiest of human spirits : an architecture that kindles every faculty in its workman, and addresses every emotion in its beholder ; which, with every stone that is laid on its solemn walls, raises some human heart a step nearer heaven, and which from its birth has been incorporated with the existence, and in all its form is symbolical of the faith, of Christianity. In this architecture let us henceforward build alike the church, the palace, and the cottage ; but chiefly let us use it for our civil and domestic buildings. These once ennobled, our ecclesiastical work will be

state. . . . To cure him," says a contemporary historian, "wonderful and terrible medicines were compounded. It was reported among the people that his physicians opened the veins of little children, and made him drink their blood, to correct the poorness of his own."— *Bussey's History of France.* London, 1850.

exalted together with them; but churches are not the proper scenes for experiments in untried architecture, nor for exhibitions of unaccustomed beauty. It is certain that we must often fail before we can again build a natural and noble Gothic: let not our temples be the scenes of our failures. It is certain that we must offend many deep-rooted prejudices, before ancient Christian architecture can be again received by all of us: let not religion be the first source of such offence. We shall meet with difficulties in applying Gothic architecture to churches, which would in no-wise affect the designs of civil buildings, for the most beautiful forms of Gothic chapels are not those which are best fitted for Protestant worship. I am quite sure, for instance, that if such noble architecture as has been employed for the interior of the church just built in Margaret Street[1] had been seen in a civil building, it would have decided the question with many men at once; whereas, at present, it will be looked upon with fear and suspicion, as the expression of the ecclesiastical principles of a particular party. But, whether thus regarded or not, this church assuredly decides one question conclusively, that of our present capability of Gothic design. It is the first piece of architecture I have seen, built in modern days, which is free from all signs of timidity or incapacity. In general proportion of parts, in refinement and piquancy of mouldings, above all, in force, vitality, and grace of floral ornament, worked in a broad and masculine manner, it challenges fearless comparison with the noblest work of any time. Having done this, we may do any-thing; there need be no limits to our hope or our confidence; and I believe it to be possible for us, not only to equal, but far to surpass, in some respects, any Gothic yet seen in Northern countries. In the introduction of figure-sculpture, we must, indeed, for the present, remain utterly inferior, for we have no

[1] Mr. Hope's church, in Margaret Street, Portland Place [All Saints, designed by Butter-field]. I do not altogether like the arrangements of colour in the brickwork; but these will hardly attract the eye, where so much has been already done with precious and beautiful marble, and is yet to be done in fresco. Much will depend, however, upon the colouring of this latter portion. I wish that either Holman Hunt or Millais could be prevailed upon to do at least some of these smaller frescoes.

figures to study from. No architectural sculpture was ever good for anything which did not represent the dress and persons of the people living at the time; and our modern dress will *not* form decorations for spandrils and niches. But in floral sculpture we may go far beyond what has yet been done, as well as in refinement of inlaid work and general execution. For, although the glory of Gothic architecture is to receive the rudest work, it refuses not the best; and, when once we have been content to admit the handling of the simplest workman, we shall soon be rewarded by finding many of our simple workmen become cunning ones : and, with the help of modern wealth and science, we may do things like Giotto's campanile, instead of like our own rude cathedrals; but better than Giotto's campanile, insomuch as we may adopt the pure and perfect forms of the Northern Gothic, and work them out with the Italian refinement. It is hardly possible at present to imagine what may be the splendour of buildings designed in the forms of English and French thirteenth century *surface* Gothic, and wrought out with the refinement of Italian art in the details, and with a deliberate resolution, since we cannot have figure-sculpture, to display in them the beauty of every flower and herb of the English fields, each by each; doing as much for every tree that roots itself in our rocks, and every blossom that drinks our summer rains, as our ancestors did for the oak, the ivy, and the rose. Let this be the object of our ambition, and let us begin to approach it, not ambitiously, but in all humility, accepting help from the feeblest hands; and the London of the nineteenth century may yet become as Venice without her despotism, and as Florence without her dispeace.

INDEX

INDEX

NOTE.—Buildings are generally indexed under the place in which they are situated, e.g. Venice, St. Marks.